# strapless

"A stunner about a stunner."
*THE ATLANTA JOURNAL-CONSTITUTION*

⇒

"Compelling."
*PUBLISHERS WEEKLY*

⇒

"Impeccably researched and endlessly fascinating . . .
At its core lies an extraordinary double biography. The
intermingled fates of a famous artist and one of his most
famous subjects are explored with wit, precision, and
a delightful sense of counterpoint."

ANTON GILL,
AUTHOR OF *ART LOVER: A BIOGRAPHY OF PEGGY GUGGENHEIM*

⇒

"A fascinating commentary on the evanescence
of fame and beauty."

*KIRKUS REVIEWS*

⇒

"With a cool, knowing eye, Davis gives us a piquant and
detailed portrait of a great artist, a doomed beauty,
and a fabulous era."

NANCY SCHOENBERGER,
AUTHOR OF *DANGEROUS MUSE*

# Strapless

JEREMY P. TARCHER/PENGUIN

*a member of Penguin Group (USA) Inc.*

*New York*

# Strapless

John Singer Sargent

and the Fall of Madame X

DEBORAH DAVIS

Most Tarcher/Penguin books are available at special quantity discounts for bulk purchase for sales promotions, premiums, fund-raising, and educational needs. Special books or book excerpts also can be created to fit specific needs. For details, write Penguin Group (USA) Inc. Special Markets, 375 Hudson Street, New York, NY 10014.

Jeremy P. Tarcher/Penguin
a member of
Penguin Group (USA) Inc.
375 Hudson Street
New York, NY 10014
www.penguin.com

First trade paperback edition 2004

A list of credits and other information for the color reproductions can be found at the back of the book.

The Library of Congress catalogued the hardcover edition as follows:

Davis, Deborah, date.
Strapless : John Singer Sargent and the fall of Madame X / Deborah Davis.
p. cm.
Includes bibliographical references and index.
ISBN 1-58542-221-5
1. Sargent, John Singer, 1856–1925.
2. Painters—United States—Biography.
3. Sargent, John Singer, 1856–1925. Madame X.
4. Gautreau, Virginie Avegno, 1859–1915.
5. Artists' models—United States—Biography.
6. Americans—France—Paris—History—19th century.
I. Sargent, John Singer, 1856–1925. II. Title.
ND237.S3D38    2003              2003050724
759.13—dc21
ISBN 1-58542-336-X (paperback edition)

Printed in the United States of America
5  7  9  10  8  6  4

BOOK DESIGN BY AMANDA DEWEY

*For Mark, Oliver, Cleo, and my mother*

# Contents

INTRODUCTION 1

*La Louisiane* 7

*City of Light* 25

*A Professional Beauty* 47

*The Pupil* 61

*A Smashing Start* 75

*Brilliant Creatures* 99

Heat and Light    111

His Masterpiece    123

The Flying Dutchman    137

Finishing Touches    147

Dancing on a Volcano    155

Le Scandale    177

Calculated Moves    187

A Woman of a Certain Age    203

A Man of Prodigious Talent    219

Twilight of the Gods    237

AFTERWORD    257

NOTES    263

BIBLIOGRAPHY    283

INDEX    295

ACKNOWLEDGMENTS    307

# *Introduction*

The story of this book, like that of the painting *Madame X,* begins with a stunning black dress. Desperate for something new to wear to a Hollywood awards ceremony, I asked the designer Nino Cerruti if I could borrow one of his creations. His staff came up with a black evening gown with a revealing bodice, a discreet train, and slender metal shoulder straps that looked jeweled in the light. The instant I put it on, my posture changed, almost as if I were assuming a pose. The dress reminded me of something, and I soon realized that it was John Singer Sargent's painting *Madame X,* famous for its depiction of a voluptuous,

pale-skinned woman wearing a very similar black gown. I knew the image, but I knew nothing about the story behind it.

Curiosity prompted me to read about the portrait. *Madame X,* I discovered, is more than an artful depiction of a nineteenth-century woman. It is a record of a brilliant and misunderstood artist's collaboration with his extraordinary model. Virginie Amélie Avegno Gautreau, the striking French Creole woman who posed for the painting, was not conventionally attractive. Yet even with her unusual pallor and her exaggerated features, she was a celebrated beauty: Paris's hottest "it girl." Sargent, an ambitious young artist at the time he painted her, was never considered a passionate or romantic man, but clearly he was obsessed with his model when he portrayed her with one strap of her chic black dress falling suggestively off her shoulder. Surprisingly, it was that fallen strap that caused a huge scandal in Paris when the painting made its debut in 1884.

These contradictions convinced me that there was a remarkable story behind this famous canvas, and questions begging to be explored. Who was Gautreau, and how did she become famous? Why was Sargent infatuated with her? Did he want this woman whom he could never possess? Was the painting, with the scandal it generated, the deliberate machination of a sexually conflicted man?

I set out to find the answers to these questions—a potentially frustrating project, given that *Madame X* was painted more than a hundred years ago and that I had a great appreciation for, but no formal schooling in, art history. In New Orleans, where Gautreau was born, I met her descendants, the Avegnos and the

Parlanges, and saw firsthand how her legend has been maintained by family and fans, some of whom are almost cultish in their devotion. In Brittany, I found that the physical world that Gautreau and Sargent inhabited is still very much alive. At Les Chênes, the estate where *Madame X* was painted, I touched the antique oak banister that seemed to hold traces of the artist and his model, and stood in the drawing room that once echoed with the sounds of Gautreau's piano, her favorite possession. I persuaded a city official to take me to Gautreau's grave, where I saw her cracked headstone, which until only shortly before lay buried beneath inches of dirt. In Paris, I found the residences Gautreau and Sargent occupied, ate at restaurants where they dined, and combed the city for vestiges of their everyday lives.

There were no easy answers to my questions. *Madame X* was aptly titled, for Gautreau had become a sphinx: a woman who today no longer had a name, let alone a biography. Sargent, while the subject of hundreds of books and articles, was equally enigmatic when it came to his personal life. I probed my way deeper into the inner sanctums of the art world, where, in the back rooms and basements of museums and galleries, I questioned experts who knew everything about Sargent's work. They were helpful, but they knew only a handful of "facts" about Gautreau, most of them, it turned out, untrue. It was not until I started digging through old newspapers, legal documents, and forgotten memoirs and memorabilia scattered on two continents that the story behind the painting slowly emerged. An item in a nineteenth-century gossip column linked Sargent to Gautreau years before the artist started painting her portrait. A musty journal from the

1870s inadvertently exposed Gautreau's best-kept beauty secret. A calling card buried in an archive commemorated her scheduled teatime visit with a married man. Every discovery added detail, dimension, even drama, to the story.

With these facts came revelations. One memorable experience occurred at Adelson Galleries in New York City, where, in the company of esteemed Sargent experts, I identified the author of a letter they had purchased at auction. The letter was signed "Amélie Gautreau," but they did not know who that was. I shared with them a thrilling discovery I had made in various libraries in Paris: All her life, Gautreau called herself not Virginie but Amélie, her middle name.

The content of the letter was even more significant. Written by Gautreau and Sargent, on opposite sides of the same sheet of paper, and addressed to a friend of both, this document revealed for the first time Gautreau's true feelings about her portrait. She called it a masterpiece—evidence against the traditional assumption that Gautreau despised the painting.

Sargent and Gautreau were not the only characters in this behind-the-canvas tale of art, celebrity, infatuation, and betrayal. They were surrounded by individuals with stories as vivid and compelling as their own: Dr. Samuel Pozzi, a dashing and sexually adventurous gynecologist who was reputed to be Gautreau's lover; Judith Gautier, an unashamed art groupie, and one of Sargent's subjects and crushes; and Albert de Belleroche, a young and flirtatious artist who may have been the love of Sargent's life. More than just an image, *Madame X* is a window into a rich and

provocative world; it allows us to experience directly the brilliance, the decadence, the spectacle of Belle Époque Paris.

*Strapless* is the anatomy of a masterpiece, revealing the often surprising, always vivid drama of Sargent, Gautreau, and the painting that made them immortal. Every painting, even one that becomes a masterpiece, starts with its subject. The legendary "Madame X" entered the world as Virginie Amélie Avegno, and her story began in a setting as decadent and brilliant as the Paris she would later rule: New Orleans at the height of its antebellum splendor.

# La Louisiane

Eighteen fifty-seven was a good year for Anatole Avegno and a great year for New Orleans. Early that year, a group of enterprising locals had decided to revive and reinvent the age-old custom of Mardi Gras. The tradition had been imported to Louisiana earlier in the century by homesick French settlers who staged parades to remind themselves of the festivities they had enjoyed in their native land. During the three days preceding Ash Wednesday, the beginning of Lent, masked men would march in fantastic costumes and throw candy and confetti to the happy crowds who came to watch their antics. It was all very playful and innocent—until the spectators started throwing things back. At

first, the hecklers tossed flour, so that the streets looked as if they had been hit by a snowstorm. When flour became expensive, they used dust and mud. Eventually, a few reckless and mean-spirited sorts spoiled the festivities by tossing lime and bricks, injuring innocent people. Mardi Gras deteriorated into such a wild and dangerous event that decent citizens stayed home, closed their shutters and locked their doors; a writer for the *Daily Crescent* in 1849 admitted that he hoped to "have seen the last of Mardi Gras."

In early 1857, Avegno and some of his friends met secretly to plan an event that would, they hoped, bring the citizens of New Orleans back into the streets for Mardi Gras. They founded the city's first mystic order, a men's club dedicated to the celebration. Calling themselves the "Krewe of Comus," the men dressed in elaborate costumes and, on February 24, staged a surprise parade and a tableau entitled "The Demon Actors in Milton's *Paradise Lost.*" They marched through the streets late into the night, carrying torches and playing music, arriving eventually at the Gaiety theater. There they entertained the elite of Louisiana at a lavish costume ball that attracted the city's most beautiful young women. The event was a great success; one participant insisted that it had been better than festivities in Paris. The Krewe of Comus resolved to make their version of Mardi Gras an annual event, thereby launching the spectacular Carnival that is the heart and soul of New Orleans today.

"The city care forgot," New Orleans in the nineteenth century was considered by many the best place in America to have a good time. It was the counterpart of Paris, "the most glamorous

and the most decadent city" in the United States, the first city in the rough and tough New World to have its own opera season, the number-one destination for business travelers, European tourists, gamblers, and grifters. There were two renowned hotels in town to accommodate visitors, the St. Charles and the St. Louis, immense pleasure palaces built for two distinct segments of the community. The St. Charles attracted travelers and local men and women who thought of themselves as Americans. They spoke English and distanced themselves from the Old World. The European-style St. Louis, spanning an entire block in the Vieux Carré, or Old Quarter, was the opulent center of Creole society.

French Creoles, among them Anatole Avegno, were direct descendants of French settlers who immigrated to Louisiana. Proud of their heritage and determined to maintain their French identity despite their American birth, they lived in a tightly knit community and refused to speak English.

Both the St. Charles and the St. Louis had impressive restaurants with book-length menus. They hosted numerous fancy-dress and costume balls—so many that the social season, at its height during the winter, left participants exhausted the rest of the year. Until the mid-1860s, the hotels' vast rotundas also housed daily slave auctions.

Visitors to New Orleans in the mid-1800s would have been awed by the sophisticated atmosphere. There were glittering cosmopolitan touches at every corner, arcades of boutiques that stocked the latest fabrics, furniture, and decorative objects—all imported, as it was less expensive to bring luxury items from

France than it was to manufacture them in Louisiana. On Jackson Square were two Parisian-inspired apartment buildings built by the notorious Baroness Pontalba, a local woman whose avaricious European husband and father-in-law had, allegedly, repeatedly tried to kill her for her money.

New Orleans was a prime destination for international visitors, not only because it offered a festive atmosphere, but also because it was a highly accessible port of call for ships from the northern United States, Europe, South America, and other distances. Visitors may or may not have known, however, that their destination had the questionable distinction of being one of the unhealthiest cities in the world. The bustling port that routinely welcomed ocean vessels and lavishly appointed riverboats harbored an underworld of pestilence, sheltering rats and other vermin. To make matters worse, New Orleans was built on swampland. Its streets frequently flooded and became canals of water-soaked waste. Women's imported gowns may have been the height of fashion, but their hems were often filthy, after dragging in the mud. Omnipresent puddles of standing water bred disease-bearing mosquitoes. Thousands of people died in the cholera and yellow fever outbreaks of 1853, 1855, and 1858.

In 1857, between outbreaks, Anatole Avegno married the lovely Marie Virginie Ternant. They may have met at the Krewe of Comus ball, where young Creole men and women flirted with the full approval of their parents, because they were with their own kind. The wedding, held on May 14, 1857, at the Cathedral of Saint Louis, was a happy and advantageous union for both families. It confirmed that life was exactly as it should be, one

fine Creole clan joining bloodlines with another. Anatole was one of thirteen children, the eighth child of the New Orleans landowner Philippe Avegno and his wife, Catherine Genois. Philippe was wealthy and successful, and Catherine affluent and well connected in her own right: her brother Charles had been the mayor of the city from 1838 to 1840.

The Avegnos had invested heavily in New Orleans property, especially in the European-style neighborhoods of the Vieux Carré. They were thought to have the largest real estate holdings in the city. Their home at 927 Toulouse Street, in the French Quarter, was a landmark—one of New Orleans's earliest "skyscrapers," its four stories towering over other buildings in the area. It was elegantly designed, with a graceful center staircase inside and perfectly proportioned rooms framed by tall windows. Its intricate wrought-iron balconies were monogrammed with the master's initials, "P.A."

Dwellings in the French Quarter often featured walled and aromatic gardens that afforded their owners a private retreat from the offensive and sometimes dangerous world outside. During the steamy summers, people who could generally stayed indoors or behind garden walls to protect themselves from the filth and swelter of the streets. The garden of the Avegno home was perhaps its most impressive feature: big and secluded, with all signs of the bustle beyond magically obscured.

Combining a sizable bank account with good blood and excellent prospects, Anatole Avegno represented the best of young New Orleans. Soon after graduating from law school, he was one of the city's most promising attorneys. His striking physical ap-

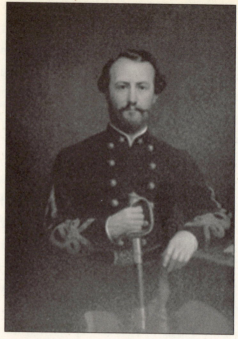

Anatole Avegno in uniform. The up-and-coming lawyer, who enthusiastically supported the Confederacy, was mortally wounded at the Battle of Shiloh. He and his daughter Amélie shared two distinctive features: their copper-colored hair and the prominent Avegno nose. *(Private collection)*

pearance was yet another asset: he had pale skin, unusual copper-colored hair, and the distinctive "Avegno nose," long, sharp, and vaguely Roman. The Avegno nose might have been considered ugly on someone else, but on Anatole, it was almost royal, giving an upward tilt to a face that already suggested aristocratic genes.

Marie Virginie Ternant, his bride, was, like Anatole, pure Creole. Her mother, Virginie Trahan, was born in 1818 and grew up to be a bewitching young woman. At age seventeen, she mar-

ried a forty-nine-year-old widower and landowner, Claude Vincent Ternant. The union of Virginie and Vincent raised eyebrows, because Virginie had been his ward. There were also whispers of a history of mental and emotional instability in the Trahan family. Whatever the gossip, Virginie was a fortunate bride; along with her wedding ring came the keys to the magnificent Ternant plantation.

She could have enjoyed a decorative life, embroidering, entertaining, and maintaining her appearance, as many wealthy women did at the time. But Virginie decided to take care of her husband's plantation herself. She had fallen in love with the estate, and despite her youth and inexperience, she was a born manager. Overlooking the False River, an extension of the Mississippi north of New Orleans, the Ternant plantation was stately, serene, and verdant. The large main house was surrounded by extensive grounds featuring lush, exotic gardens and enormous oak trees, whose branches dripped with Spanish moss. Cedars planted to evoke classic estates of France flanked the long road leading to the house, and two octagonal pigeonries ensured that the family would always have a supply of fresh squab. Sheep grazed on the grounds of the estate, while cattle, mules, and horses were kept in nearby fields. Tending to the animals and the crops were 147 slaves, watched by an overseer.

Inside the house, every room was filled with fine furniture and decorations. The Ternant dinnerware included 325 china plates, thirty-four wineglasses, eighty-seven champagne glasses, cabinetfuls of expensive linens, and a fortune in silverware. The basement held a wine cellar with at least two thousand bottles of wine and a medicine room stocked like a pharmacy.

Virginie managed every detail. She was described by an observer as "the Lady of False River, the figure about which would revolve, whether they liked it or not, the lives of most of those within her reach. All that had happened before on the plantation might be taken as preliminary to her coming."

Very young, very beautiful, and very determined, Virginie gave birth to three children in the first four years of her marriage: a son, Marius Claude Vincent; a daughter, Marie Virginie (who rarely used her first name); and another daughter, the lovely but troubled Julie Euriphile. While she loved False River, Virginie was too socially ambitious to confine the growing family to country living. The plantation was well over a hundred miles from the city, yet Virginie and Vincent remained connected to Creole high society by way of the Mississippi riverboats that passed their front lawn. New Orleans offered access to Paris, and the Ternants maintained an apartment there. They often set up housekeeping for years at a time, enjoying the luxurious expatriate life to the fullest. As with all established Creole families, French was the Ternants' first language, and they spoke it even when they were in Louisiana. When in Paris, they lived as Parisians, playing host to the French elite and emulating the fancy manners of Napoleon III's lavish court. Virginie and Vincent announced their comings and goings with calling cards and entertained extravagantly; they studied the *Almanach de Gotha,* the Who's Who of the European aristocracy, so they would know who should sit next to whom at their dinner table.

Vincent Ternant died in 1842, leaving the plantation to Virginie, still in her twenties. Two years later, she married a French

naval officer, Charles Parlange. He also resided in both Paris and New Orleans, and he had the distinction of possessing an extensive library at a time when literacy levels in the American South were extremely low and books were in small demand as well as supply.

Virginie renamed the Ternant plantation Parlange. In 1851 she bore another son, whom she diplomatically named Charles Vincent, in homage to both husbands. Family records are vague, but they suggest that Virginie and Charles may have had another son before Charles Vincent, one who did not survive childhood.

The Paris residence of the newly combined Ternant-Parlange family was at 45 Rue Luxembourg, near the church of the Madeleine, in one of the wealthier and more desirable neighborhoods in the city. Each member of the family was painted by Claude-Marie Dubufe, famed court artist to Emperor Napoleon III and Empress Eugénie; welcoming the opportunity to make herself look imperial, Virginie commissioned a portrait of herself measuring a grand eighty-six by sixty-one inches. The painting emphasized her delicate features and graceful form; her pale face was framed by dark ringlets, and her good figure offset by a stylish black gown. The image radiated personality, strength, and a flirtatious arrogance.

Dubufe's paintings dominated the second-floor parlor at Parlange, where Virginie tried to re-create the oval shape of fashionable Parisian salons by hanging her children's portraits in such a way that they obscured the corners of the room. The Parlanges believed in displaying their wealth; indeed, they covered almost every surface with their possessions.

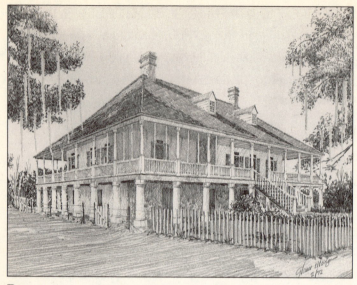

Parlange plantation as it looks today, classic example of an antebellum home. The Creole traditions practiced by young Amélie Avegno's mother and grandmother in their Louisiana residence prepared her for life in Paris. *(Drawing by Glenn C. Morgan)*

Virginie had high ambitions for all her children, at the least expecting them to marry well. Marius as a teenager was already a quintessential rake, who drank, gambled, and womanized enough to be known as *"le grand m'sieu,"* the big shot, on the river. Parents would warn their daughters to stay away from him, though as the southern chronicler Harnet Kane noted, "the girls of False River—and of other parts of Louisiana and of Paris, for that matter—liked Marius too well for their own good or his." Marius was a confirmed bachelor who had no interest in working, on the plantation or anywhere else. Spoiled and profligate, he squandered his money and repeatedly broke his mother's heart with

public displays of bad behavior. Neighbors were scandalized by the sight of him playing cards in his coach in broad daylight.

Julie, Virginie's younger daughter, was another source of pain and disappointment to her mother. From Virginie's family she had inherited the unfortunate legacy of madness. Her Acadian grandfather, Joseph Leufroy Trahan, was declared insane during the early years of his marriage, and Julie, along with other Trahan cousins, shared his illness. They all showed signs of melancholia that became more acute and disabling as they grew older. Their families kept these episodes as quiet as possible, fabricating—or at least not denying—tales that conveniently obscured the truth. One typically southern gothic story that circulated about Julie was that, on her wedding day, having been forced to abandon the man she loved to marry an older French aristocrat, she committed suicide by hurling herself against a giant oak tree on the plantation. The legend further claimed that Julie's wedding-gowned ghost haunted the property, mourning her lost love. With stories like this, Julie remained in the shadows of her family for so many years that most people believed she was dead.

But Virginie's other daughter did not disappoint her family in any way. In fact, when Marie Virginie Ternant married Anatole Avegno, she fulfilled all their expectations. The young couple took up housekeeping in the flourishing French Quarter, surrounded by Anatole's brothers and sisters and their families.

New Orleans was enjoying a period of prosperity and tranquility in these middle years of the nineteenth century. The city had never been more colorful and exotic. The acclaimed actor Edwin Booth performed onstage as Richelieu. The Spalding &

Rogers Circus was in town, advertising a "living skeleton violinist" among its featured acts. The fact that camels were promoted as the latest thing in farm animals testifies to the influence of far-off places.

On January 29, 1859, Marie Virginie and Anatole had their first child, Virginie Amélie. The baby had several names, as was the French custom, but she was called Amélie—a fashionable name then in New Orleans—probably to distinguish her from her mother and grandmother, other Virginies. There were various Amélies who might have inspired her name. Anatole's brother Jean-Bernard had a sister-in-law named Amélie Durel, and a statue of the Virgin Mary commemorating Marie-Amélie, the last queen of France, was on display in a New Orleans church.

Amélie inherited the graceful Ternant form visible in family portraits, but her face was pure Avegno. She was her father's daughter, with her copper-red hair, pale, creamy skin, and distinctive, compelling, Roman-coin nose.

In the summer of 1859, Marie Virginie and six-month-old Amélie—fondly called "Mimi" or "Mélie"—vacationed at Parlange, even with the enormous Avegno garden at their disposal in New Orleans. Marie Virginie wanted to escape the unbearable heat of the city and the health threats there. The only thing that improved during a New Orleans summer was the crime rate: it was simply too hot to break the law. Parlange may have been subject to extreme heat and mosquitoes, but the scenic False River fronting the plantation made the air fresh and consistently inviting.

In 1860, at forty-two, Virginie Parlange was worth $300,000

in land and $50,000 in personal property—in today's money, a fortune of tens of millions of dollars. No other Pointe Coupee Parish family came close to equaling the Parlange wealth; Virginie was the richest and most powerful landowner in the area. She worked hard for every dollar, though. The plantation was a demanding business, whether it was producing cotton, indigo, or sugar cane, crops that changed over time to meet the shifting demands of the market. Most of the responsibility fell to Virginie, as Charles traveled frequently to New Orleans.

While Virginie ruled her property with an iron glove, she could not control her wild and irresponsible firstborn. Marius Claude Vincent Ternant died on January 14, 1861, only twenty-four years old. No cause of death was recorded, but it is likely that he died recklessly, in a duel or an accident. His half brother Charles Vincent Parlange kept to a more promising path. Charles demonstrated a passion for the plantation and paid close attention to its workings in preparation for one day assuming control.

In 1861, Marie Virginie and Anatole Avegno celebrated the birth of a second daughter, Valentine Marie. They appeared the perfect family, attractive, privileged, sheltered, and secure. Though it maintained its usual festive atmosphere, however, their community was being shaken by talk of war. When the southern states finally chose to fight to protect their slaveholding rights, New Orleans sent its newly enlisted soldiers off to battle with marching bands, parades, and sweethearts blowing kisses. "Dixie," written in the North in 1859, became the South's unofficial anthem when it was performed as a rousing finale to a performance

at the Varieties theater in New Orleans in 1861. The audience went wild when local soldiers, Creoles dressed in colorful Zouave uniforms, marched onstage, keeping time to the music.

On May 26 of that year, the atmosphere in the city darkened. President Lincoln had sent the Union warship *Brooklyn* to blockade the port, and now New Orleans was effectively cut off from the rest of the world. Ships could neither enter nor leave, and the port, once busy with boats, sailors, passengers, and cargo, was silent. Trade was the lifeblood of New Orleans, and without it, the city came to a halt.

Anatole was eager to join in the fight to protect southern values, and on September 13 he left his law firm to enlist in the Thirteenth Louisiana Infantry. He and his brother Jean-Bernard were so enthusiastic about the Confederate army that they recruited an entire battalion, which was dubbed the "Avegno Zouaves." Nervous southerners tried to convince themselves that the war would end soon and their men return unharmed; they held regular parades and celebrations to bolster their spirits. Marie Virginie, too, believed that her capable, commanding husband would come back to her. She moved her two daughters back and forth between her home in the Vieux Carré and Parlange, where it was rumored that Amélie's still-beautiful grandmother Virginie could protect her precious home from destruction with an irresistible combination of fine food and superior conversation that would charm generals from both sides of the Mason–Dixon line. Virginie was also said to have hidden the family silver in deep transom casements above the doors and windows of the house. She buried money in the yard, only to forget later exactly where.

Some seven months after Anatole optimistically assumed command of Louisiana's Thirteenth Infantry, the course of his life, and that of his family, was tragically altered. The Battle of Shiloh, now a famous moment in history, but then just another skirmish for the weary soldiers headed into it, commenced early on the morning of April 6, 1862. In his dispatches, Confederate captain E. M. Dubroca, an eyewitness, described heavy losses for Major Avegno's "gallant little band" as they charged the enemy. Like so many on both the Confederate and the Union sides, these men were not trained soldiers. They were gentlemen, dedicated but ill equipped for the hardships and deprivations of war. Anatole had developed acute laryngitis, and because he could not call out orders he transferred his command to another officer.

When he resumed control of his men on April 7, Anatole was wounded in the leg after a last charge on the enemy. Infection set in and his leg had to be amputated. Eleven days later, he was on his way home to recuperate. On the military train he lost consciousness: a journalist reported that he "rallied for a moment, smiled and dropped to sleep as gentle as a child." In New Orleans, Marie Virginie waited for news. She knew that her husband had been wounded, but held out hope that he was recovering and returning to her. The train that arrived in New Orleans brought her Anatole's corpse, not the strong, confident soldier she had said good-bye to months earlier. In an emotional obituary, the *Daily Delta* observed that Anatole had fallen "where the brave love to die, at his post of duty."

Anatole's death abruptly transformed Marie Virginie from young wife to young widow. In this she was not unusual. New

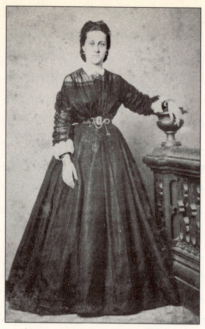

Marie Virginie Ternant Avegno at twenty-five, after she had lost her husband. She was a strong mother for her daughters Amélie and Valentine. *(Eshleman Collection, 2001-52-L, The Mettha Westfeldt Eshleman Bequest, The Williams Research Center of the Historic New Orleans Collection)*

Orleans counted a number of women whose married lives ended abruptly. Now alone responsible for her two daughters, Marie Virginie had to make important decisions about the future. Fortunately, there was money. Anatole had inherited considerable property from his father's estate and had left it to his daughters, appointing their mother and a former law partner, George Binder, as their guardians.

Anatole's death was not the only tragedy to befall Marie Vir-

ginie. Children in New Orleans were particularly fragile, subject to the diseases that devastated the city every few years. After the defeat of the Confederacy, they were even more vulnerable because medical supplies were limited. On March 11, 1866, five-year-old Valentine died suddenly, of a congestive fever. She was buried alongside her father in the family plot at Saint Louis Cemetery, blocks from the French Quarter homes she had shared with her mother in her short life, and from her grandparents' Toulouse Street garden, where she had played with her sister.

Marie Virginie was ready for a change of scene, a new start. She chose to return to Paris, which would be fresh and at the same time familiar. Postwar Louisiana offered nothing but depression and instability compared with the city that had been Marie Virginie's second home when she was growing up. Families whose fortunes were built on land values were now poor, the land worthless. The Parlanges, without the money they had enjoyed before the war, were forced to take out multiple loans to keep their plantation running. Marie Virginie must have felt that there was no future in New Orleans, only the sad and unbearable past.

In 1867 she and young Amélie sailed for France. They may have traveled with Jean-Bernard Avegno, Anatole's older brother, and his family. Jean-Bernard had been an important figure in the Confederate government; he had signed Louisiana's secession papers at the start of the war. Like other wealthy Creoles, he wanted to protect himself and what money he had left during the difficult period of reconstruction ahead. Paris was the perfect place to live while times were uncertain in New Orleans.

Marie Virginie had another family member as traveling com-

panion, her sister Julie. Marius's death had had a serious effect on Julie, who unsuccessfully sued her mother for control of his estate. Virginie, troubled by Julie's unpredictable behavior and the rumors it inspired, found it easier to send her away than to live with her.

Marie Virginie's move to Paris was more than just a change of setting. It was a brave first step toward a new life. The day she left New Orleans, she assumed a role that was unfamiliar and perhaps a little frightening: at age thirty, she became the matriarch of her own family. An ocean away from her domineering mother, she would be independent, free to make her own decisions and run her own household. It was time for Marie Virginie to concentrate on the future—and the future was Amélie.

# *City of Light*

Amélie Avegno saw Paris for the first time when she was eight years old. The city had never looked more beautiful: unlike New Orleans, devastated by war, her new home had the bright and shiny veneer of a renovated metropolis.

Only a few decades previously, Paris had been a filthy eyesore. There was no light in the "City of Light," which was more medieval than modern. Ancient, dilapidated buildings toppled one onto another, blocking all hints of the sky. Thousands of people poured the contents of their chamber pots into the streets every day. Visitors from other cities were appalled by the stench and the filth that Parisians took for granted.

Emperor Napoleon III wanted a city that was cleaner, better organized, and more aesthetically pleasing. In 1853, he placed Baron Georges Haussmann in charge of one of the most elaborate urban renewal plans in history. Napoleon wisely identified Haussmann, a career bureaucrat from the suburbs with impeccable connections and tremendous ambition, as a man who had the ability to imagine a better Paris and the tenacity to get the job done.

Haussmann more than satisfied the emperor's expectations. He and the men who worked in his department, the Prefecture of the Seine, carried out their herculean efforts with military precision, believing themselves "an army whose task was to go forth in the conquest of old Paris."

During the twenty years Haussmann was in office, he and his staff conquered the city. Haussmann razed 19,722 buildings, mostly slums, and erected 43,777 new ones. He revolutionized transportation by turning warrens of streets into a series of boulevards that made it possible to move fluidly from one location to another. He saw to it that each boulevard served a purpose, leading to an impressive monument or building, such as the newly constructed Opéra. Most amazing, Haussmann added 4,500 acres of parks to a city that before had offered scant light, air, or recreational space to its inhabitants.

To his credit, Haussmann was just as concerned about the Paris that was not visible. He built new sewers (tourist attractions today) and sophisticated water delivery systems, to substitute the decaying underground tunnels that had carried disease and vermin. Some citizens complained bitterly that Haussmann had carelessly destroyed the charming parts of old Paris along

with the rotten ones, yet even they had to appreciate the changes that improved the quality of their lives.

Haussmann had a dynamic effect on the private sector, supervising contractors who, following his strict guidelines, built modern apartment houses with multiple floors, spacious rooms, and separate sleeping quarters for servants. With his encouragement, developers updated the city's already famous commercial districts. Shopping had always been key to Paris's economic well-being. In the eighteenth century, Philippe d'Orléans, a down-and-out member of the French royal family, became a retailing visionary when he saw that he could make more money from one piece of property by building multiple floors of shops on the same site. He erected the first *grand passage,* a covered shopping arcade. Centrally located near the Palais Royal, it opened in 1781 and was an immediate success. Shoppers were drawn to its novel layout and its air of a Turkish bazaar.

Precursors to the shopping malls of the twentieth century, these arcades, or *passages,* offered modern shopping at its best—several stores under one roof, sheltered, comfortable, safe. The merchandise was diverse and abundant, since each *passage* housed a variety of boutiques, and the arcades even offered entertainment, in the form of guest appearances by popular writers of the day. Because these arcades extended from block to block, with brief interruptions for street crossings, shoppers could avoid the weather by strolling from one protected corridor to another. Beautifully appointed, some of them—the Galerie Vivienne, the Passage Jouffroy, and the Galerie Coulbert—featured such innovations as gas lighting and glass roofs.

In the first chapter of *Nana,* his scathing novel about the hopeless amorality of a self-absorbed courtesan, Émile Zola used the Passage des Panoramas, located next door to the theater where Nana performed, to expose her greed. When she walked through the corridor of colorful shops on her way to work, she was compelled to buy something, *anything,* to satisfy her desire for material goods. She was not alone. Parisian women were seduced by these jewel-box arcades, which introduced the concept of shopping as a leisure activity and became retail chapels for the idle rich, who had too much time and money on their hands.

The *passage* was a good idea, but the department store was an even better one. Instead of one building with many different stores owned by many different people, the *grand magasin,* as the French department store was called, would have one roof, one owner, and many different "departments." While Haussmann did not invent the department store, he gave developers both the inspiration and the opportunity for this retailing phenomenon. All over Paris, small and antiquated family businesses specializing in gloves, umbrellas, fabrics, and other merchandise were destroyed by Haussmann's wrecking ball to make way for new streets, buildings, and monuments. Aristide Boucicaut, an imaginative entrepreneur, took a small endangered drapery shop and turned it into a big idea. He opened the Bon Marché department store, which eventually occupied an entire city block and aspired to sell absolutely everything. Boucicaut modeled the interior of his store after Haussmann's boulevards, using wide aisles to lead shoppers from one department's "neighborhood" to another.

Zola immortalized Boucicaut and his invention in his best-

selling novel *Au Bonheur des Dames* (*The Ladies' Paradise*), where he revealed the inner workings of the Bon Marché as a self-contained city. The men and women who worked there also lived there—eating, sleeping, and playing out their own dramas within the store, during and after hours.

Zola analyzed the interaction between the store and its customers, intuiting that this new form of retailing was really a form of seduction. Owners would cleverly entice customers by creating a relatively private and comfortable setting where women could spend time as well as money. Inside the department store, ladies could sip wine cordials at a buffet, or write letters in a large room stocked with paper and pens, and furnished with lounge chairs. Their notes, including clandestine communications to lovers, were quickly delivered by messengers while the women stayed in the store to await a reply. There were attendants for their children, counters where they could sample perfumes, and dressing rooms where they could try on the latest fashions. At the Bon Marché, and Le Louvre and Au Printemps and the other department stores that soon followed, women felt protected from the unpleasant realities of everyday life. These stores were splendid, self-contained universes created specifically for women, where their only obligation was to live out fantasies and spend money.

Customers were attracted to the stores by eye-catching window displays and merchandise from all over the world, and by affordable items that served as bait. While some people remained outside, window-shopping—"licking the windows," as the French expression *leche-vitrines* would have it—those who ventured

inside found a dreamworld of vast assortments of clothing, accessories, and home furnishings, all under one roof.

Shoppers in these stores did not need cash. They charged their purchases to a personal account and had them delivered to their homes—a practice that could encourage even the most parsimonious woman to overspend. And the prices were set: because department stores purchased their goods in bulk, they could undersell boutiques, thereby making shoppers feel prudent just as they were being most profligate. Shoppers enjoyed two other popular features as well: sales and a revolutionary returns policy. The Bon Marché dazzled Paris with its first white sale, a January event that provoked shoppers into a buying frenzy. The store advertised discount prices on all white-colored merchandise, knowing that the customers who came to take advantage of the sale would also make full-price purchases (a retailing concept equally valid, and practiced, today). Department stores devised their own calendar of sales throughout the year to move stock at a faster rate. When seasons changed, merchandise would change with it. And if shoppers had second thoughts about any purchase, they could bring it back for a refund. This unprecedented policy had a tremendous psychological effect on consumers. It encouraged them to buy more, because they knew they could always change their minds. Women who shopped just for the thrill of shopping were liberated from their consciences; they could tell themselves they would return the merchandise, even if deep down they knew they never would.

The *grands magasins* made for a heady, near-libertine mindset and a new social malady: kleptomania, or "department store

thefts," as they were labeled in 1883 by a psychiatrist, Henri Legrand du Saulle. Respectable women who would never consider breaking the law elsewhere were caught stealing from stores. When questioned, they claimed to have been overcome by dizziness and an almost sexual feeling. Incapable of resisting the impulse to take what they wanted from an overwhelming array of merchandise, they surrendered, despite knowing it was wrong. Such behavior would have been impossible in the smaller, old-style shops, where merchandise was not on view and the relationship between customers and attentive shop owners was much more personal and protected.

This Paris of department stores, massive apartment buildings, and tree-lined boulevards as far as the eye could see was where Marie Virginie and Amélie Avegno settled in 1867. With its considerable changes since her previous visit, the city was at once recognizable and strange to Marie Virginie. It helped that, just as in New Orleans, she was surrounded by relatives, including her brother-in-law Jean-Bernard and his family and relatives by marriage, and by other Creoles who had come to France to enjoy a lifestyle not available to them in the South during Reconstruction.

Marie Virginie, Amélie, and Julie occupied a series of apartments, among them the Parlange residence on the fashionable Rue Cambon, the new name Haussmann had given to the Rue Luxembourg. They lived in a kind of cocoon, Marie Virginie cultivating her daughter with the intention of having her emerge a beautiful butterfly, to be collected by a wealthy man. In their native city, legends had circulated about the *filles à la cassette*,

French maidens who went to Louisiana in the 1720s under the supervision of Ursuline nuns to find husbands. Amélie had made the reverse journey. Her new world was the Old World, but her mission was the same: to find a husband and make an advantageous marriage.

Before the transplanted Avegnos could grow too cozy in their new surroundings, they found themselves in another war. In July 1870, after a series of territorial skirmishes, France declared war on Prussia. The French, utterly convinced of their military and moral superiority, discovered, however, that they were not invincible. They suffered one humiliating defeat after another, culminating in early September with the Prussian capture of Napoleon III and a hundred thousand of his men. Disenchanted with their emperor, the French replaced him with a provisional government headed by Léon Gambetta, a man of the people who was minister of the interior, together with General Louis Trochu, the military governor of Paris, and Jules Favre, a statesman and politician.

One colorful, though fanciful, story places the expatriate Avegnos near the center of this turbulence. Jean-Bernard had become very close to Gambetta, who, in contrast to the Second Empire's thin-blooded aristocrats, was an earthy man famous for his appetites and his practical approach to politics and government. After Prussian armies cut off Paris in September 1870, Gambetta chose a singular way to escape his enemies. On October 7, high over the heads (and weapons) of the invaders, Gambetta and companions made a dramatic flight to safety in a hot-air balloon, the *Armand Barbès*. The flight took four hours, ending in Épineuse, some sixty miles from Paris.

Gambetta's companions on the flight were never identified publicly. But the genealogist Robert de Berardinis believes that Jean-Bernard Avegno was one of them. There were rumors at the time that eleven-year-old Amélie was there as well.

The Prussian army surrounded Paris for more than four months, devastating the city and causing severe famine. The Franco-Prussian War ended abruptly, with the two sides signing an armistice in January 1871. The Prussians staged a victory march up the Champs-Élysées, angering Parisians so much that they gathered afterward to scrub the streets and remove all traces of the enemy. Beyond Paris, the rest of the country was shaken and insecure. Adolphe Thiers, a statesman who had opposed the war, was chosen to lead the government. Many citizens objected, claiming that he had negotiated a humiliating peace with the Germans. Mobs filled the streets, demanding a new leader.

Once again, Amélie and her family found themselves in a civil war, this one within Paris. The Commune was a brief but intense revolution. The Communards, as the dissidents were called, did more damage to Paris than had the Prussian invaders. In an attempt to wipe out the decadence of Napoleon III and his empire, they blocked Haussmann's glorious boulevards with primitive barricades and set fire to hundreds of buildings, including the Tuileries palace and the City Hall.

The Commune ended in May 1871, after an especially bloody week of fighting. With the civil war over, Parisians turned their attention to rebuilding the city. A new French government, the Third Republic, was launched, along with a new social order. The aristocracy could flaunt their titles, but their influence was

restricted to wedding announcements and guest lists in the society columns. Politicians and businessmen were the real cornerstones of the new economy.

Marie Virginie recognized that the social and political upheaval would work in her favor. Her American-born daughter had a better chance of a good match now that the rules governing society were more relaxed. Socially ambitious mothers had once scoured the aristocracy for the best husbands for their daughters, even though men with titles rarely married down. Now young women could hope for wealthy businessmen as potential suitors, with fortunes that could propel them into the best social circles. Businessmen were even more desirable than aristocrats, because they would not be as selective in choosing a wife. They had liabilities. Their bloodlines were not blue, their family histories were not distinguished, and they held no rank in the *Almanach de Gotha.*

Every aspect of Amélie's life was carefully controlled, according to the customs of the time. She attended a convent school, paid for by an uncle. It is doubtful that she was encouraged to learn much; young unmarried women were shielded from too much education in the hope of keeping their minds pure and uncorrupted. This may seem somewhat futile for the permissive Paris of the 1870s, but it should be pointed out that many newspapers and novels were forbidden to young women because they offered visions of life they should never see.

Chaperoned by her mother, Amélie was allowed to attend select parties, teas, and musical evenings, social gatherings that could expose her to the right sort of marriageable men. Jean-

Bernard Avegno's family and their cousins the del Castillos were excellent social contacts.

Marie Virginie, still attractive herself, assumed the role of the widow Avegno at these functions, investing her energy in the packaging and marketing of her daughter, who was becoming more and more beautiful, and therefore valuable. Amélie emerged from her cosseted adolescence not so much a butterfly as a swan. She was extremely curvaceous, with an ample upturned bosom and a narrow waist. Her upper body, with long, elegant neck and sculpted shoulders, suggested a Greek statue; her pure white skin looked more like marble than human flesh.

While her figure may have evoked a classical ideal of beauty, Amélie's face was an original. The Avegno nose, a gift from her father, was impossibly long and dominated her face. This feature gave her no choice but to look haughty: she always had to look down her nose at the world. Her dark eyes were framed by emphatic brows, and her hair, also a testimony to the strength of the Avegno genes, was a coppery red.

The moment Amélie entered society, still a teenager but displaying signs of womanhood, potential suitors realized that she would be a magnificent trophy for a husband to display. Marriageable men and their mothers scrutinized the Ternant-Avegno gene pool, already wary of the girl's American roots. Knowing that an emotionally unstable relative like Amélie's aunt Julie would be a handicap, Marie Virginie had her moved to Burgundy to live with relatives of their stepfather, Charles Parlange. Sometime around 1876, Julie returned to Pointe Coupee Parish, where her mother had petitioned to have her committed to an

asylum, subject as she was to "an habitual state of mental derangement, insanity, and madness."

Although Marie Virginie had her hopes pinned on a spectacular match for her daughter, when Prince Charming showed up, he appeared more like a frog. At forty, Pierre-Louis Gautreau was more than twice Amélie's age. He was somber, bearded, and unusually short: family members described him as resembling Toulouse-Lautrec, who was so small that he seemed to be sitting when he was standing. But Gautreau was a member of the Legion of Honor, a commander of the Order of Christ of Portugal, and a commanding captain of the Tenth Territorial Artillery Regiment of the French army. He had fought against the Prussians and later against the Communards. He had a solid reputation, plenty of money, and a handsome country house in Brittany.

One of the sources of his income was less than glamorous. The Gautreaus made their fortune in banking and shipping, but also in fertilizer, specifically bat guano, imported from Chile. Pierre and his brother Charles spent a great deal of time traveling to and from that distant part of the world. Pierre's self-appointed nickname, Pedro, was intended to emphasize his South American connections and, perhaps, to add exoticism to a bland image. This is the name he used in business, in real estate, and in politics.

It is unlikely that the nineteen-year-old Amélie considered her suitor an especially romantic package. Yet she would have been prepared to accept the compromises that went with a wealthy husband. Money, and everything it could buy, would compensate for any girlish notions of love or attraction. And odd

as it might sound, for Amélie a marriage to Pedro represented freedom. Once a young woman was safely married and protected by her husband's good name, she could start breaking the rules that dictated absolute decorum for the bride-to-be. A woman could go anywhere if her husband accompanied her. She could flirt. She could wear revealing clothes. She could go out into society without a chaperone. She could even have affairs, if she did so discreetly. With marriage, Amélie's years of preparation would be over and the fun would begin.

Marriage offered independence to Pedro as well, who at the time of his engagement to Amélie still lived in his family's apartment in Paris. He had waited until middle age to marry, possibly, in part, because of his formidable mother, Louise La Chambre Gautreau, who came from one of Brittany's most important and wealthy families. The La Chambres were from St.-Malo, a walled city on the Atlantic, seemingly at the edge of the world, in an area whose magnificent beaches and unusually temperate climate have earned it the name "Emerald Coast." A ripe location for attack from enemies because it was exposed to the sea, St.-Malo endured centuries of invasions by the English, and was almost completely destroyed by German bombers during World War II. On a more romantic note, St.-Malo has had a very colorful population, including corsairs, seafaring adventurers licensed by the king to "confiscate" booty from English ships. An ideal departure point for ships sailing west and south, the city was home to noted explorers, among them Jacques Cartier, the sailor who discovered Canada.

The ocean is a powerful presence in St.-Malo. When the tide is low—and it is low frequently within each twenty-four-hour period—boats sit askew in the harbor mud, looking as if they had been plucked from the water by a drunken giant and placed haphazardly on land. In nearby Cancale, low tide reveals vast expanses of oyster beds in unexpected geometric patterns.

When the tide rushes in, the view changes dramatically. The ocean is higher in the bay of St.-Malo than anywhere else on the European coast. The waves are enormous, sometimes as high as forty feet and more, and have been known to reach into the streets of the town and pull people to their deaths. Residents boast that the air in St.-Malo is unique too in that it contains high levels of ozone.

Ozone or no, visitors sense the city's intoxicating atmosphere instantly. St.-Malo has always been considered a wild place, its unpredictable beauty inspiring figures such as François-René de Chateaubriand, whose melancholy novels introduced nineteenth-century readers to the concept of Romanticism. Here, far from the stuffy and superficially correct Paris salons, anything could happen. St.-Malo was not uncivilized—the city's lively social season was reported extensively in the Parisian newspapers—but the air was definitely conducive to recreation, especially in the last quarter of the nineteenth century.

Everyone who had money, or who pretended to, would flee the heat of Paris in June, as soon as the races at Longchamps were over. St.-Malo was a favorite destination, even more so with

the new railroads, which shortened to mere hours trips that used to take days and weeks. Energetic travelers could take trips within trips: some owners of châteaus and country houses would keep those plush summer residences for a while, then abandon them to vacation at spas and hotels elsewhere, such as Nice and Deauville. With enough servants to pack their voluminous luggage, and baggage cars to transport it, anything was possible. Brittany, a comfortable train ride from Paris, was a very desirable place to have a summer home.

Pedro Gautreau was born in St.-Malo and grew up on an estate in nearby Paramé. The estate was known as Les Chênes (the oaks) because the spacious park surrounding its château was filled with oak trees. Pedro's mother, Madame Louise, had inherited the property from her father; a more magnificent estate, La Briantais, was occupied by her brother Charles-Émile. The differences in financial circumstances always irritated the money-conscious Gautreaus, and may well have been the source of an ongoing feud between the families.

Indeed, a constant awareness of sibling inequity may have lain behind Madame Louise's extreme money-consciousness. She was known to never forget where a penny—or more appropriately, a centime—came from, or where it went, and she recorded every detail of her family's financial activities in a large multicolumn ledger. Although it consists mainly of terse entries, the ledger is revealing, as between the lines is a great deal of attitude. Madame Louise kept her son on a short leash, conscientiously listing the cost of having his pants cleaned and the price

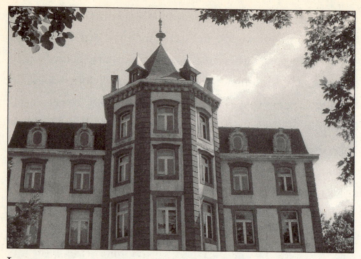

Les Chênes, the Gautreau estate at Paramé, Brittany. The family summered at the impressive château, which was surrounded by a walled park. Sargent stayed at Les Chênes in 1883 to work on his portrait of Amélie.

of a new chamber pot for his room. She entered every minute expense with the apparent satisfaction of one who thinks she is saving money even as she spends it.

According to her monthly calculations, Pedro worked his way through very little of the Gautreau fortune during his bachelor years—until the fateful day in June 1878, when, according to the ledger, he purchased the all-important book that indicated his readiness to marry and start a family of his own. Called the *livre mariage,* this served as the official record of a marriage, as well as of the births and deaths within a family.

When lovely nineteen-year-old Amélie Avegno entered his life, Pedro's expenses skyrocketed. In August 1878, the month of

his wedding, Madame Louise enthusiastically took on the role of judgmental mother-in-law, communicating intense disapproval with every slash of her pen as she totaled the escalating expenses. Carefully noted in her ledger: 80 francs for Amélie's wedding bouquet; 503 francs for her gown; 187 francs for a bracelet Pedro bought for his mother-in-law; and miscellaneous fees for the photographer and the notary. Louise's debit columns grew and grew. There is no hint of maternal pleasure, pride, or celebration in this mean-spirited accounting of the Avegno–Gautreau nuptials.

Amélie and Pedro's wedding required the preparation of extensive legal documents, including a long and specific marriage contract. Bride and groom elected to keep their respective property separate, in a *régime dotal,* by which each of them would continue to own anything they individually brought to the marriage. They would instead share anything that came to them as a result of "the profits and earnings made during the marriage." Pedro's holdings, principally real estate and business investments, were valued at 1,750,000 francs. Amélie's, consisting of New Orleans real estate inherited from her father and her sister, was evaluated at 166,000 francs; her clothing, jewelry, and piano—her most important possessions—were valued at an additional 15,500.

The marriage contract was signed on June 19 in Paris. Friends and family members, among them Amélie's and Pedro's mothers, attended the signing ceremony. Amélie's sixty-year-old grandmother, Virginie Parlange, had made the trans-Atlantic journey with her son Charles. The signatures of these three women were high up on the document, an indication of great respect.

Sandwiched between the signatures of the two Virginies—

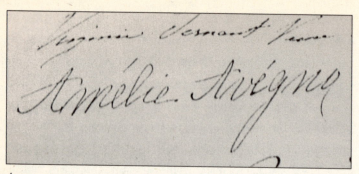

Amélie's signature, in a charmingly girlish hand, on her 1878 marriage contract. The lengthy legal document lists all the nineteen-year-old's possessions and carefully describes an elaborate financial arrangement with her forty-year-old husband-to-be.

Ternant Avegno and Parlange—is that of Amélie Avegno. Her letters are clear, even, and well formed, yet there is something girlish and romantic about their slant, as if she had practiced to give her signature a certain flourish. She added an accent over the third letter of her last name to match that over the third letter of her first name, perhaps for a symmetrical effect. Virginie, the first name she was given at birth and her most obvious connection to her mother and grandmother and her New Orleans heritage, had disappeared.

After the signing of the contract came the wedding itself. Records indicate that Amélie and Pedro were married on August 1, but no location is specified. The church in St.-Malo would have been a likely choice at that time of year, when the summer season in Brittany was at its height. Amélie's couture wedding gown was made of velvet. She wore expensive jewels, purchased by her fiancé for the occasion, and carried a large bouquet of flowers.

Her uncle Charles escorted her down the aisle. He had spent much of the summer in France and Italy studying beekeeping, a business he hoped to import to Parlange plantation.

The newlyweds traveled to Belgium for their honeymoon, then returned to Paris to enter society as a couple. They felt themselves most welcomed among the politicians and self-made businessmen who were the rising stars of the Third Republic. Established families—moth-eaten aristocrats who lived in the faubourgs, the old neighborhoods reserved for high society—tried to close ranks against parvenus like the Gautreaus. But in the new order, these older families were rapidly becoming social dinosaurs. Instead of looking back to ancestry and antique conventions, the members of the new society looked to the future, and to establishing their own rules.

Paris was expanding west, to the suburbs surrounding the Parc Monceau, where recently landscaped boulevards offered spacious and spanking-new maisonettes and apartments. The Gautreaus moved into a stately private four-story home on the fashionable Rue Jouffroy, perfect for introducing a respectable, married beauty and her husband into the glittering Parisian beau monde. Wide, lined with trees, and punctuated by graceful traffic circles, the Rue Jouffroy was an ideal residential location: close enough to be convenient to the center of Paris, but far enough to avoid the unsavory aspects of the old city. The air was cleaner, the views better, and Paris's unsightly poor safely distant.

Immediately after the wedding, a telling line appeared in the Gautreau ledger. The entry *"toilette de Madame"* informed of Amélie's 200-to-300-franc monthly allowance without mention-

In Paris, Amélie and her husband lived in a four-story mansion on the Rue Jouffroy, near the newly fashionable Parc Monceau. They decorated the house with furnishings from the Bon Marché, the city's first department store.

ing her name, her identity reduced to the title "Madame," as John Singer Sargent would use years later. Pedro's mother referred to the other members of the family by their given names.

With her allowance and the charge accounts she established at stylish stores in Paris, Amélie embarked on outfitting her new home. She purchased rugs of all sizes to cover her floors. She ordered a dining room table and chairs, bookcases, accessories such as bronze candelabra, paintings, and selected *japonaiserie,*

including crockery and a brass incense burner. Anything that evoked Japan was in vogue at the time, in part because of Edmond de Goncourt, whose passion for Japanese design inspired a fad embraced by retailers and customers seeking something foreign, different, in their ordinary lives.

In her home decor, Amélie combined smart contemporary details with touches of the past, creating a splendid stage on which to make her debut as a married woman. She had reached an exciting new period in her life. Though she was still a teenager, her marital status had brought her into adulthood. Her mother, who had guarded her until now, was reduced to a background presence instead of a force. Amélie had stepped into the limelight.

Pedro too was experiencing a taste of liberation. The new mansion was the first residence he did not share with his mother and some of his grown siblings, who all lived together in an apartment in Paris and on their estate in Brittany. After being the dutiful son for decades, he was finding it an adventure to have a young, beautiful wife and a home of his own.

The couple made their official social debut in the fall of 1878, when fashionable Parisians, back from their summer sojourns in the country, were ready to devote themselves to the next few months of dinners, operas, and balls. Armed with Pedro's income, the new title of Madame, and the Ternant-Avegno legacy of beauty and ambition, Amélie Gautreau set forth to conquer the City of Light.

# A Professional Beauty

The social and economic changes that had transformed Paris in the 1870s made the city a more welcoming place for a beautiful upstart like Amélie, who represented the new Frenchwoman, and more specifically the *parisienne*. Urbane, spirited, and independent, the modern Parisian woman enjoyed increased freedom of movement in a city that offered safe, pleasant destinations such as parks, stores, and tearooms. She was eager to try challenging new inventions, such as the bicycle. And she was ambitiously climbing the social ladder, capitalizing on the fact that republican society promoted upward mobility and encouraged the moneyed and upper classes to blend.

It was their preoccupation with beauty that made modern Frenchwomen famous around the world. Known for her "genius for grooming" and the "fragrance of sensuality that rises from her bosom and falls from her skirts," the *parisienne* was a model to be copied by other women. In New York, London, and New Orleans, women patronized French designers and slavishly adopted French beauty rituals, hoping to make themselves as alluring as their continental counterparts.

Parisian women grew so experienced at perfecting their sophisticated look that, paradoxically, they made it seem effortless. In truth, they had to spend long hours at their dressing tables to accomplish that air of easy elegance. Fashion magazines, the most timely how-to guides then available to women, were popular sources of advice and instruction. *La Mode Parisienne,* a favorite ladies' publication, offered head-to-toe suggestions for colors, fabrics, hemlines, bustles, corsets, and other sartorial concerns. The magazines presented fashion forecasts with detailed illustrations of models wearing the latest designs. These illustrations, often created by women, were printed from engraved plates, and thus the term "fashion plate" to describe a person with style.

"In Paris, half the female population lives off fashion, while the other half lives for fashion," wrote Emmeline Raymond, a social observer. Ladies with social aspirations were expected to be constantly careful about their appearance and their comportment, and to follow strict rules regarding dress. Morning outings called for a dark outfit and a heavy veil. Luncheon, unless it was a family occasion, required a change of dress, as did receiving

days at home, when gloves had to be worn. Dinner and the opera allowed, even dictated, a low-cut dress.

Books about beauty were immensely popular. Women were given step-by-step guidance to navigate the complicated toilette, including instruction about makeup, hairdressing, and hygiene. Doctors and journalists wrote advice books that provided scientific data and emphasized health. But the most popular beauty books were written by aristocrats, or women pretending to be aristocrats; it was thought that advice from a "royal" would carry more weight with socially ambitious readers. Despite the new Republican government, readers believed that women with titles were more experienced in the ways of beauty.

In one such book, translated as *My Lady's Dressing Room,* a Baroness Staffe dispensed practical advice to women for effective and up-to-the-minute beauty routines. The baroness encouraged women to employ artifice to hide their imperfections: "There is no falsehood in it," she wrote. "What is life, what is love, without illusion?" She counseled her readers to set up two dressing tables in a well-lighted room, one for washing, the other for styling hair and applying makeup. To combat wrinkles, women should spend one entire day a week in bed and apply various creams and treatments to every part of the body. Bathe and bathe and bathe again, the baroness admonished, ignoring the fact that in most households a hot bath was difficult to come by, that tubs of steaming water had to be ordered from door-to-door vendors. As laid out in the baroness's long and detailed directions, beauty was a full-time job.

With the pursuit of beauty a national pastime, nineteenth-century French writers and artists were fascinated by the subject and were constantly analyzing it in their works. One major question was whether beauty was enhanced or diminished by artifice of the type advocated by Baroness Staffe. Should women use cosmetics, or should they rely on what nature gave them? The prolific essayist Octave Uzanne wrote passionately about Frenchwomen and this issue. His literary style was a combination of philosophy, observation, and just plain dishing. Uzanne explained why modern women should want be beautiful and commented on the lengths they had to go to in order to get that way. He profiled a range of women, from aristocrats to prostitutes, but wrote most tellingly about the moneyed bourgeoisie, whom he saw as brilliant butterflies who believed their sole purpose in life was "to be seen and to shine."

Uzanne maintained that women should use cosmetics to enhance their looks, and improve on nature whenever possible. He liked the way rice powder "spiritualized" the flesh and the way carmine made the lips enticing, as epitomized in the paintings of Frans Hals, the seventeenth-century Dutch artist whose richly colored works were recently in vogue. Uzanne likened women painting their flesh to artists painting their canvases.

Nineteenth-century moralists condemned cosmetics, which they associated with the face paint of actresses and prostitutes. *Godey's Lady's Book,* an American magazine, stressed that proper young women should look clean and natural. But the poet Charles Baudelaire praised cosmetics, explaining that a woman "is even accomplishing a kind of duty when she devotes herself to appear-

ing magical and supernatural; she has to astonish and charm us; as an idol, she is obliged to adorn herself in order to be adored." Like Uzanne, he endorsed the use of rice powder, observing that it had been "anathematized" by misguided Arcadian philosophers who failed to see that nature, especially in the form of a blemish, can and should be improved by artful maquillage.

As the cult of beauty was celebrated by some for aesthetic reasons, others stressed more practical concerns when advocating self-enhancement: Uzanne, for one, saw the beauty industry as a cornerstone of the Parisian economy. He did the numbers, estimating what a great lady would spend on maintaining her appearance. For the dressmaker, the tailor, the milliner, and the hairdresser (the jeweler was omitted in this accounting), a woman in Amélie's class could expect to spend as much as 40,000 francs a year (more than $100,000 today), or perhaps a little less if she was famous and was extended a discount for the publicity she generated by wearing a designer's clothing. "The combined business done each year by dressmakers, bootmakers, glovemakers, hairdressers, jewelers, makers of underclothing, tailors, furriers, and perfumers," Uzanne reported, "is reckoned at more than a thousand million francs"—about $3 billion in today's terms. However frivolous all this attention to appearances might seem to some, the very economy of Paris would have been jeopardized if its nineteenth-century women had not cultivated their beauty with such dedication.

Among those who endorsed the use of cosmetics for women, opinions differed on specific procedures, such as skin lightening,

a common, but much-debated, practice throughout the century. Many how-to writers—though not Baroness Staffe, who feared that rice powder blocked the pores—offered recipes for "whitewashes" that would give skin a look of milky perfection. Women (and some beauty-conscious men) who desired a superior pearly countenance visited professionals who painted, even enameled, their skin. One problem with enamel was that it was highly unstable: a single crack could ruin the entire finish, reducing a face to an unattractive web of artificial lines and chips. A more serious problem was that enamel paint contained lead. Stories circulated about unfortunate women who suffered facial paralysis and blood poisoning as a result of enameling. Indeed, blood poisoning from excessive enameling sometimes led to painful death.

In a world of fluctuating opinions, where lines were drawn between nature and artifice, Amélie had to choose one camp or the other. She knew that her look, perhaps more than her money or her position, would be the key to her success in society. She therefore invested a great deal of intelligence into her launch. When she was on the market for a good match, Amélie had presented herself as quiet and virginal. Now she needed to make a splash. With her husband's good name to protect her reputation, she could be flamboyant—stand out, not blend in.

Amélie chose artifice over nature. Since white skin attracted attention, Amélie saw to it that her skin was the whitest. Her makeup was more daring and original than that of other women, who simply reddened their lips and cheeks. Not only did she use lipstick and rouge, she added a touch of red to the tips of her ears and outlined her eyebrows with a mahogany pencil. The effect

was an almost painterly study in contrasts, the occasional stroke of color that much more dramatic against her pale flesh.

Amélie's wardrobe choices were similarly contrived. She emphasized her shapely figure by wearing slight and simple neoclassical gowns rather than the often ungainly and upholstered creations of designers such as Charles Worth. She was inspired by fashions reserved for late afternoon, the "four-to-five," the widely accepted hour of infidelity. During this time, respectable men would connive to see their mistresses, and respectable women would steal moments with their lovers. Such rendezvous might begin with passion, but would frequently end in confusion, as an intricately coiffed and corseted woman tried to pull herself together post coitus. The process of dressing was complicated, with hoops, bustles, corsets, and petticoats, and some women insisted that their lovers provide on-site hairdressers and maids to repair the damage. A famous cartoon from the naughty contemporary newspaper *La Vie Parisienne* showed a husband staring in bafflement at his wife's corset, wondering how the bows he had tied that morning could look so different that night. One reason corset-makers switched from ribbons to hooks and eyes was, supposedly, to protect unfaithful wives from detection.

For women who could contrive to receive lovers in their own homes during the four-to-five, a special costume was available. The *robe d'intérieur,* a tea gown, was originally a bathrobe-like garment worn by married women. Loose and diaphanous, it was meant to offer a pleasant escape from the restrictive corsets women wore at other times. The tea gown, easy to put on and take off before one's husband came home from his own afternoon pec-

cadilloes, quickly became synonymous with seduction. It announced that the woman wearing it was sexually experienced.

Amélie realized that she looked adorable, enticing, downright sexy in her at-home dishabille. And she had no intention of reserving the undressed look for her husband or restricting it to her home: she incorporated it into her public apparel, calling attention to her soft white shoulders, swan neck, and womanly curves with gowns that outlined her body. The inventive strategy worked. At her debut as Madame Gautreau, Amélie made a stunning impression on Parisian society. During this time, wrote Gabriel Pringue, "women wore high coiffures with false curls. They also padded their breasts, wore balloon sleeves, ample dresses".; their endless trains were often caught in doorways, they upset armchairs and footstools. Then, into this "effervescence of silk, lace and velvet," a door opened "to let enter an antique statue, auburn hair with gold reflections, thrown back and tied in a Grecian knot, freeing a proud forehead, and admirable face of absolute regularity of feature, without the slightest defect, with the transparency of alabaster, set on a long neck, magnificently placed on perfectly rounded shoulders . . . dressed in a white Grecian cloth which molded her superb figure." Slender yet full-bosomed, and with her singular face, nineteen-year-old Amélie Avegno Gautreau was the bold new era's bold new ideal of female beauty.

She completed her look with a diamond crescent in her hair, like a tiara, to make her look royal. It also served as a memento of her overseas birthplace, the Crescent City.

In October 1878, exquisitely costumed and coiffed, Amélie began making the rounds of dinner parties, balls, and charity af-

fairs, captivating the men and women in her own set and winning the attention of the public as well. She accepted invitations to teas, dinners, and the Japanese-themed receptions popular at the time. Before long, she had become a celebrity. Her public appearances turned into spectacles: not only did her peers notice her at balls and the opera, but when she rode in a carriage in the park or on the boulevards, crowds would push and shove, stand on benches, and even cause traffic jams, to catch a glimpse of "La Belle Gautreau."

In the late fall of the year, Amélie became pregnant. She was able to conceal her condition for several months, and continued participating in the social season; she then retreated into the customary period of confinement once her pregnancy became more noticeable. She moved to Les Chênes, where she spent the quiet spring and summer months resting, playing the piano, and faithfully reading *Le Figaro* to keep up with the society news.

In August 1879, Amélie and Pedro's child, a daughter, was born. They named her Louise, after Pedro's mother, who had died earlier in the year.

For little Louise's baptism, the new parents hosted an elaborate fête, complete with ham, oysters, and champagne. They dressed Louise in a fashionable layette ordered from the Bon Marché. Her proud father was more generous with money than his mother had been. Amélie's allowance was raised substantially, to 1,000 to 3,200 francs a month; she also received a one-time payment of 40,000 francs, possibly for having given birth. Although she took pleasure in the celebrating and shopping entailed in having a child, Amélie was eager to resume her Parisian

Amélie's mother-in-law started a detailed ledger of family purchases, which included her daughter-in-law's rice powder (*"poudre riz"*), the secret behind her legendary white complexion. *(Courtesy Archives Municipales de Saint-Malo)*

society life. Pedro's secretary, who had taken over the ledger from Madame Louise, made note of "Madame's" purchases during and after her confinement, including white rice powder for her face and black satin for a gown.

The Gautreaus returned to Paris in October and climbed even higher in the social firmament. Amélie's schedule was quite demanding. In the fall and winter, she was expected to attend bazaars and balls celebrating Christmas and Carnival and first nights at the Comédie-Française and the Opéra. In the spring, it was essential that she appear at the Fête des Fleurs, costume balls, the art Salon, and the Grand Prix and other equestrian races at Longchamps. A single day might involve as many as eight changes of clothing, hairstyle, and accessories. A promenade in the Bois de Boulogne might be followed by five-o'clock tea, dinner, the opera, a ball, and then a midnight supper, each event requiring a different costume and a complicated toilette.

Amélie was always fashionable, with a distinctive wardrobe that received extensive coverage in the newspapers. *L'Événement* reported her appearance in a dress of salmon-colored velvet on one occasion, and on another in a magnificent Directoire gown of white satin with crystal drops, a shower of diamonds on her shoulders, an orange crepe de Chine scarf around her waist. *Le Figaro* raved about her dress of red velvet with a bodice of white satin, as did *La Gazette Rose* about her white satin dress with pearl netting.

Over the next three years, Amélie's fame spread from Europe to America. In 1880, a reporter for *The New York Herald* saw her in France and filed a flowery story describing her magnificence. "La Belle Américaine: A New Star of Occidental Loveliness Swims into the Sea of Parisian Society" was filled with the requisite allusions to classical mythology; the reporter noted that Amélie was the loveliest creature he had ever beheld. Other observers were astounded by her beauty, he wrote, and an admiring murmur greeted her everywhere she went; crowds "opened, as if awe-struck with her beauty, to let her pass."

King Ludwig II of Bavaria attended the Paris Opéra with the sole purpose of witnessing Amélie's entrance up the grand staircase. Her Imperial Highness Elisabeth of Austria asked to meet Amélie and was so taken by her that she invited her to pose among the statues in her garden in Corfu. Amélie's young daughter, well aware of her mother's celebrity, responded thus to her nurse's admonition to be better behaved: "And if I am, will the morning papers say that the little daughter of the beautiful Madame [Gautreau] has been good?"

Of course, not all of the talk about Amélie was complimen-

tary. Paris was rife with venomous tongues. Gossips called Amélie a professional beauty—an insulting suggestion that she worked at her appearance, when a woman of her class was not supposed to work at anything. The cause of her pallor was hotly debated. Some swore it was her true coloring; after all, it had not washed off when she'd been seen swimming in St.-Malo. "The mother-of-pearl coloring of her shoulders," it was reported, "had not been disturbed by the . . . water." Detractors noted that she had been swaddled in towels by an enormous African attendant before she emerged fully from the waves, and thus it was impossible for anyone to have seen what Amélie's skin really looked like after those few minutes in the ocean. The extreme whiteness of her skin, said the skeptics, was caused by her ingestion of arsenic. She swallowed a small amount every day, it was said, just enough to maintain her otherworldly shade of lavender-white without actually killing herself.

Although many people delighted in picking at Amélie's carefully constructed image, one group in Paris worshipped her unconventional appearance and notoriety. Artists were always on the lookout for a new model to inspire them. For decades, French painters had favored female models with dark hair and olive skin, and advertised for "Italian types" to pose for them. The late 1870s brought a dramatic shift in style. The chic and alluring *parisienne* began to dominate the art scene, just as she had taken over society. Her white skin signified urbanity, and her smooth shoulders, usually framed by sumptuous evening dresses, suggested luxury and indulgence. Her sophisticated image captured the essence of cosmopolitan Paris.

Amélie, the ultimate *parisienne,* inspired artists from successful portraitists to struggling students. She was the most original woman around, the most sophisticated, the most fascinating. The gossip columnist Perdican planted a blind item about an artist who was known to spy on Amélie while she bathed at the shore. "In Saint-Malo–Paramé," Perdican wrote, "I know of a painter, enamored of Greek splendors, who has taken opera glasses to see better and a canvas in order to paint from a distance the shoulders of the lovely [Madame Gautreau]." Young artists developed crushes on Amélie, who was close to them in age but who moved in a different social orbit. Edward Simmons, an American art student living in Paris, proclaimed her a goddess and confessed that he "could not help stalking her as one does a deer." Painters and would-be painters studied her face and form, and wrote about her bewitching beauty in their journals, trying to determine what made her so special.

Artists were eager to paint or sculpt Amélie. They bombarded her with requests, which she refused time and again. She understood that she must choose the creator of her first major portrait with great care, for it would be examined closely by admirers and detractors. Selecting a painter for a portrait was an important personal decision, as important as wearing flattering clothes or arriving with the proper escort. Paris's wealthy and bourgeois commonly commissioned portraits of themselves, and patronized a select group of artists. Among the many candidates to consider, Amélie would not entrust her image to anyone until she was sure he was capable of creating a masterpiece.

# The Pupil

In the 1870s, Paris was one big campus for art students. Museums offered the opportunity to learn from classic paintings and sculptures. Parks and stately boulevards presented an unending choice of picture-perfect subject matter. The city was also home to the best teachers, whose classrooms attracted a polyglot community of creative types hoping to make their mark on the art world.

These students, young men and women from France and beyond—British, European, American—flocked to the Left Bank and Montmartre, then a less fashionable, and therefore less expensive, neighborhood. The streets in this area were older and

more intimate. The buildings, mostly residential, shared a particular feature: they had enormous windows, especially on the top floors, to permit as much natural lighting as possible. Artists coveted the cavernous top-floor apartments for use as studios. Although these spaces were freezing in winter—even with a stove— and stifling in summer, the idealistic tenants cared more about light, preferably northern, than comfort and convenience. Driven by their desire to experience *"la vie de bohème,"* wealthier students rented their own live-in studios, while their less affluent colleagues divided space with roommates or settled for the small rooms and shacks in forgotten corners of the city.

Art students in Paris had at their disposal a variety of educational choices. There were government-sponsored schools such as the École des Beaux-Arts, which offered tuition-free instruction by prominent artists of the day—once students passed the rigorous entrance exams. The faculty of these institutions was often conventional, teaching art according to rigid, old-fashioned ideas. Teachers would conduct their classes in almost military fashion, insisting that pupils follow their directions to the letter. Little if any room was left for personal expression. Jules Bastien-Lepage, a successful painter in the 1880s, admitted that "I learnt my trade at the École and I do not wish to forget it, but in reality, I did not learn my art there." Jean-Léon Gérôme, one of the chief opponents of Impressionism, was an influential teacher at the Beaux-Arts for almost forty years.

Like it or not, any artist who aspired to rise to the top of his profession had to win the patronage of the École des Beaux-Arts and its governing bodies, the Institut National des Sciences et

des Arts and the Académie des Beaux-Arts. The artists who served on the boards of the Institut and the Académie determined which younger artists would be successful, as they were responsible for awarding prizes and medals and, more important, for deciding, through their own old-boy network, which lucky new talent would join their ranks. The winners could expect fame, prime commissions, and generous compensation. Artists who were excluded from this network would, naturally, have a harder time making a living.

In the government schools, impatient young artists had to curb their creativity while following a strict program of lessons that progressed from copying plaster casts to painting flesh-and-blood models in life-study classes. Their schedule was demanding. Classes began early in the morning, so students who had spent the night carousing or working had to force themselves awake.

Aspiring artists who didn't pass the exam to attend a government school could choose a less structured form of training. Paris was home to dozens of independent ateliers, private studios hosted by individual artists. Each atelier had a personality to reflect the style and temperament of its artist founder. He would teach his particular technique and encourage students to imitate the masters he admired. The independent ateliers served two important purposes. They were often used as feeder programs, polishing students who needed more experience before they could meet the standards of the École des Beaux-Arts. And they provided bolder and more confident young artists the chance to work closely with professionals who were more accessible and

flexible than the teachers at the more regimented academic schools.

The ateliers may have been part of the refined art world, but the attitude there was fraternity house. Very often, the artist in charge was too busy with commissions, appointments, lunches, and other engagements to attend to the everyday matters of running the school. He might delegate to a student the responsibility of collecting fees and keeping order. Many students of college age possessed an age-appropriate appetite for pranks. New arrivals were subject to hazing and burdened with cleaning and other menial chores. Once they proved their worth, however, these newcomers became part of a brotherhood. Students who attended the same atelier would spend hours together in cafés, restaurants, and elsewhere, sharing ideas and one another's company.

A promising atelier was that run by the artist Carolus-Duran, who was for a period Paris's most in-demand portrait painter. Born Charles-Auguste-Émile Durand, he was flamboyant and cosmopolitan, and a rising star in Third Republic society. He was an overnight sensation in the art world in 1869, when he presented his painting *The Woman with the Glove* at the Salon, an annual art show that had the power to make or break an artist's reputation. In Carolus-Duran's case, fortune was kind. Critics raved about his simple yet dramatic portrait and proclaimed him the painter of the moment.

Subsequently, admirers would compete for invitations to his studio, desiring to be in the company of a celebrity. Carolus-Duran was so confident of his lasting popularity that he created

his own rules: his fees for paintings were not negotiable, and his studio was open to the public only in the early morning, when most of society was still asleep. Albert Wolff, a journalist, observed that "a Parisian woman never rises before midday except on Thursdays to visit Carolus-Duran."

The artist had opened his atelier after two students asked him to oversee their work. If they rented a studio in Montparnasse, another neighborhood popular with artists, and recruited other students to share the operating costs, Carolus-Duran agreed, he would come twice a week to offer advice, criticism, and lessons in technique. As his specialty was portraiture, among the most profitable genres at the time, his studio easily drew a following. Carolus-Duran was sought after as a portraitist because he knew how to make his subjects look attractive and important but not at all boring or conventional. His appealing style guaranteed him a long and lucrative career.

As a teacher, Carolus-Duran was inventive and inspiring, especially compared with the dogmatic professors at the École. He was not interested in academic painting, a widely accepted, and conformist, method that relied on neat sketches and polished surfaces. He instead encouraged his students to capture the big picture: to work rapidly and even passionately, to paint what they saw directly onto their canvases, *au premier coup,* at first touch. He impressed them with his characteristic habit of backing away from the canvas to check perspective, then racing forward with his brush to render exactly what he saw at that moment.

Carolus-Duran expected his students to have excellent drawing skills, which they had to demonstrate before being admitted

to his atelier. But he did not believe that drawing was the foundation of art. He was more concerned about the use of *valeurs,* or values, the juxtaposition of light and dark to create an image. One of his primary influences was the seventeenth-century Spaniard Diego Velázquez, whose paintings taught him the power of simplicity. He would dramatically chant the artist's name to his students while they worked, so they would get the point. His maxim was consistent with Velázquez's lesson: *"En art, tout ce qui n'est pas indispensable est nuisable"*—"In art, everything that is not indispensable is harmful."

Carolus-Duran's classes were usually limited to twenty-four students, most of them English and American, although he neither spoke nor understood English and he had his pupils speak French at all times. He may have opened his door to foreigners because he knew that French students might be unwilling to study with someone who challenged the very establishment they wanted to join. But foreigners would not be afraid to test his radical teaching methods. They appreciated his expressive, freewheeling style and were less invested in the restrictive French system; they could always return to their native countries to paint if they did not succeed here.

Among Carolus-Duran's American students was a tall, reserved young man named John Singer Sargent. He had come to the atelier at age eighteen, accompanied by his father. Sargent's fellow students found him mature for his age and oddly cosmopolitan, speaking flawless French with no discernible accent.

While Sargent called himself an American and had an American passport, he had been born in Italy and had never even vis-

ited the United States. His expatriate parents had been in per-
petual motion for more than twenty years, moving from one Eu-
ropean city to another in pursuit of milder weather, better health,
cheaper accommodations. Sargent's lack of an accent was due to
his frequent relocations as a child: he had lived in so many Euro-
pean cities while he was growing up that he never had time to ac-
quire one.

His father, Fitzwilliam Sargent, was a successful doctor who
came from a large and established Philadelphia family. In 1850
he married Mary Newbold Singer, who had goals that could be
accomplished only in Europe: she dreamed of living in an envi-
ronment that would be more hospitable to her artistic talents:
she sketched, painted, and played the piano. When her first child
and namesake was born in 1851, Mary was forced to concentrate
on more practical matters. The Sargents adapted to a life of re-
spectable domesticity, until little Mary's death at age two. Her
mother suffered a physical breakdown and convinced her hus-
band that Europe was the only place where she could recover.

With the $10,000 that she had inherited from her father in
1854, the Sargents began Mary's long-desired journey. She loved
traveling. She wanted to see and experience everything Europe
had to offer, and she had no interest in assuming the monotonous
life she had left behind in America. So she convinced her hus-
band that they should spend the summer in Geneva and the win-
ter in Rome, visiting spas regularly to tend to her delicate health.
Soon she was so addicted to travel that as soon as she arrived
in one place, she was already thinking about the next destina-
tion. Dr. Sargent seems to have never guessed that she might

be exaggerating her symptoms of illness to avoid returning to America.

The Sargents traveled from Florence to Nice to Rome, and back. Unlike typical Americans on a grand tour, they were drifters, mindful of their fixed income, forever trading one temporary address for another. They economized by visiting fashionable places in the off-season, hiring second-rate servants, and moving to cheaper locations whenever life became too expensive.

The Sargent's second child, John Singer, was born in Florence on January 12, 1856, a strong and healthy boy. The next year, another daughter, Emily, was born in Rome. Traveling was more difficult with the larger household, but Mary could not be persuaded to stop.

The peripatetic lifestyle left Dr. Sargent feeling restless and lonely. He missed his Philadelphia medical practice. John and Emily had to learn to be best friends, playing and studying together since their unpredictable itinerary made regular friendships and formal schooling impossible. They were tutored by their parents: Dr. Sargent gave his children natural history books and Bible stories, and Mary taught her specialties, art and music. Both children were bright, and quick, open to the new languages, cultures, and histories of their ever-changing environment. At its best, the Sargents' lifestyle was rich in experience.

In 1860, when she was not yet four, Emily suffered a serious accident that damaged her spine. The Sargents never discussed the incident, keeping the details of her condition to themselves; family members believed that Emily had been dropped by a nurse. Her parents consulted doctors, who recommend a drastic

course of treatment that included long periods of complete immobility. Emily stayed in bed for years, and when she finally got up, her body was misshapen and she had to relearn the fundamentals of movement, such as how to walk.

In 1861 a fourth child was born, Mary Winthrop, called "Minnie." The Sargents continued to travel, moving four or five times a year, setting up house in, say, Nice only to dismantle it a few months later to go to London. On gay evenings when money was good, Mary entertained the new acquaintances she had collected. John befriended the children of other expatriate families, including Ben del Castillo, who was distantly related to the Avegnos, and Violet Paget, who would later call herself Vernon Lee. When money was tight, the family's accommodations and lifestyle declined accordingly.

Fitzwilliam Sargent thought about America constantly and wrote to his relatives with great longing, wishing for a reunion. But whenever he broached the subject of a return to the United States, Mary dismissed him with one excuse or another, usually claiming that she and the children were not healthy enough to make the trip.

Health, not surprisingly, became Dr. Sargent's obsession. His letters described in detail each family member's physical condition at the time of writing, as if his wife and children had become the patients who were denied him when he gave up his practice. He wrote that Mary was "improved," Emily was "weak," and the family in general suffered from "rather delicate health." His diligent observations could not forestall tragedy. In 1865, only four years old, Minnie Sargent died.

John was the only healthy child in his family. His size and robust constitution made him a good athlete: he enjoyed sports and physical activity and, like his mother, hated to sit still. Dr. Sargent, a patriot who wrote a pamphlet entitled "England, the United States and the Southern Confederacy" to show his support for President Lincoln and the Union army, fondly imagined his strapping son growing up to be an officer in the U.S. Navy.

But John had other plans. His interests were those of an artist, not a soldier. By the age of thirteen, he was spending hours in museums studying the works of the old masters. He took a notebook with him everywhere, and filled its pages with images from life done in pencil and watercolor. Mary's friends in the art world were impressed by the boy's talent and urged the Sargents to arrange for him to have professional training.

As the family moved through Spain, Italy, Germany, and Switzerland, Mary had two more children; Fitzwilliam Jr., who was born in 1867 and died two years later, and Violet, born in 1870. The death of one child seems to have brought the birth of another. The Sargents' financial resources were increasingly strained, and so they moved to the affordable destination of Brittany, an area Violet later called "the land of rocks and cheeses" because of its stony terrain and omnipresent dairy products. The Sargents rented a small house in St.-Énogat, a suburb of the busy resort town of St.-Malo.

While the move may have eased the family's financial stress, they weren't quite happy. Mary's social ambition had never abated, and even the successful salon she organized in St.-Énogat did not satisfy it. Dr. Sargent, though pleased at having settled

somewhere, was unhappy with the continued nomadism. He wanted his family to establish permanent roots.

While neither Mary nor Fitzwilliam Sargent had achieved the adult life they had wanted, they were sensitive to their talented son's needs. In 1874, acting on their friends' advice, and knowing that the capital would offer the best instruction, they moved to Paris to find an art school for him. John had admired Carolus-Duran's work, and after one meeting with the artist he made up his mind to study at his atelier. Carolus-Duran judged John's portfolio accomplished and promising; he accepted him as a pupil on the spot and straightforwardly told him that although he had to unlearn some things, he showed great potential.

Sargent was enthusiastic about his acceptance into the studio. Yet he must have felt apprehensive too. His mother had instilled in him a rigorous work ethic, and he knew he didn't fit in with the high-spirited and self-consciously bohemian students, who would stage sponge fights in the studio and tease each other with pranks. Sargent was shy and taciturn. He dressed formally and was very serious about his work.

His classmates could easily have ostracized him for being different, but instead they treated him with great respect. His painting astonished them. Sargent's work, his classmate James Beckwith wrote in his diary, "makes me shake myself." Another student described Sargent as "one of the most talented fellows I have ever come across; his drawings are like the old masters'."

Sargent was always the first to arrive at the atelier on Monday mornings, beating the other students to the best spot to position his easel. When Carolus-Duran's class was finished and the

model dismissed for the day, Sargent would talk other students into posing for him so he could keep painting. In the evenings, he would study drawing at the École des Beaux-Arts, then, after a hasty dinner, attend a night class with the artist Léon Bonnat.

When he wasn't in school, Sargent would join Beckwith and other new friends to visit museums and galleries, and to hear concerts. He still lived with his family, who had an apartment on the Right Bank, and he often brought fellow students home for family dinners and entertainments. Mary was delighted: she finally had the salon she had always wanted.

Sargent gradually grew accustomed to the company of rowdy young artists. In a letter to his childhood friend Ben del Castillo, he described a lively evening of celebration and camaraderie at Carolus-Duran's atelier. "We cleared the studio of easels and canvasses, illuminated it with Venetian or colored paper lanterns, hired a piano and had what is called a 'devil of a spree.'" After years of occupying a narrow and hushed world consisting only of his immediate family, Sargent was awakening socially.

His social life never interfered with his work, however. He remained the most dedicated artist in his class, practicing long hours to master his technique. Although the other students in Carolus-Duran's group tried to follow their teacher's precepts, Sargent was the one who fully absorbed them and made them his own. When he took the École des Beaux-Arts' rigorous month-long entrance exams, he passed them on his first try. He placed thirty-seventh in a group of 162 aspirants, an extraordinary accomplishment for an American.

Sargent traveled to Brittany to summer with his parents and his two sisters when the atelier closed for the season in 1875. But when his parents decided to stay in St.-Énogat for the winter to save money, he returned to Paris alone. His experiences as an art student had given him the confidence to live independently. He was on the right track professionally, with Carolus-Duran guiding him toward a lucrative career in portraiture. Sargent felt stirrings of ambition, and he was ready to face every young artist's greatest challenge: his first Salon.

# A Smashing Start

As a fledgling artist, Sargent had to make decisions about what he would paint, and how he would paint it. The year 1876 was important in terms of making these decisions, because the Parisian art world was offering alternatives to traditional academic, color-within-the-lines painting. The nineteenth century, an age defined by revolutionary spirit, saw art movements that challenged conventional aesthetics. Realism, pioneered in France by the rebellious Gustave Courbet in the 1850s, called for a dramatic shift in painting. Realists wanted to replace the academy's sanitized historical, mythological, and genre scenes with penetrating depictions of everyday life, including peasants and laborers at

work. They did so in a direct way, without idealizing or glorifying the common man's condition, and thus prompted detractors to call their work offensive and ugly. In time, Courbet inspired another generation of artists to start their own controversial movement: Impressionism.

At the second Impressionist exhibition, at the Durand-Ruel gallery, Sargent had the chance to meet in person Claude Monet—one of the crop of "Impressionist" painters who were revolutionizing art with their ideas about light, form, and perspective. Although many artists and art lovers were enthusiastic about the new movement, these rebels, including Monet, Camille Pissarro, Pierre-Auguste Renoir, Alfred Sisley, Edgar Degas, Berthe Morisot, and Édouard Manet, had more opponents than supporters.

Conservative artists, upholding the standards of the academy, considered the Impressionists to be amateurish and vulgar, and their work anarchist rubbish. But these ground-breaking painters held firm, united against the repressive academy that condemned their spontaneous approach to painting. While the Impressionists were (and are) categorized as a group, they were in fact a non-movement movement. They shared a common revolutionary spirit, but they each had an individual style. They were linked by their desire to paint life as they saw it (albeit each from a distinct viewpoint), rather than as something idealized. They also took painting out of the studio, favoring *plein air,* or outdoor, scenes that did not rely on arranged props, backgrounds, and lighting.

Sargent had heard of the controversial artists: the advantage to studying in Carolus-Duran's relatively progressive atelier was that new approaches to painting were explored along with

the old ways. Sargent was encouraged to experiment, and since Carolus-Duran was friendly with Monet, it is no wonder that some of his experiments show elements of Impressionism.

At the same time that Sargent was absorbing new ideas about color and movement, he was learning that art was big business. Talent alone rarely catapulted a living artist to success. A working artist in Third Republic Paris required keen commercial instincts and a sound business plan. Carolus-Duran set an excellent example for his protégé, who knew that his teacher's career had advanced in no small part because of his ability to maneuver through society as a well-paid portraitist.

Sargent needed to make money. His family depended more and more on him financially. His mother and father were getting older. Emily, his childhood playmate and companion, would never leave home; her ill health had turned her into a spinster. Violet was still a child. As the only son and the only healthy and productive member of the family, Sargent understood that it would be his responsibility to support all of them, emotionally as well as economically. He would have to command sizable fees. He decided on a career painting portraits.

Portraiture, an established genre for hundreds of years, evolved to fulfill a basic human need, providing people with likenesses of their loved ones. This was especially important after a death, when mourners wanted a way to remember the deceased. A generalized depiction of a face—a vague rendering of features and coloring—would never do. Even early portraits, however primitively rendered, had to emphasize a subject's individuality. *The Grove Dictionary of Art* defines a portrait as an image in

which "the artist is engaged with the personality of his sitter and is preoccupied with his or her characterization as an individual." The challenge for portraitists has always been to find their own way of conveying that individuality.

In the eighteenth century, artists elevated portraiture by making it grand and heroic. Commissioned by the royal or the very rich to create artistic testimonials to power, wealth, beauty, and status, painters made their subjects took larger than life. But patrons discovered that a portrait did not have to be physically big to be effective. Miniature portraits, called limnings or "paintings in little," also became popular. The word *miniature,* in this case, had nothing to do with the diminutive size of the portrait. In the past, illuminated manuscripts with their small illustrations—often a depiction of the patron who had commissioned the work—were created with a red lead pigment called minium. When these illustrations evolved into freestanding portraits, the term *minium* turned into "miniature."

Executed with fine brushes in watercolor on vellum, or in oil on enamel and ivory, miniatures were practical forms of portraiture because, mere inches long, encased in delicate frames, they could be held in the palm or worn as jewelry. They were also easy to transport, and proved especially useful in negotiating marriages: they could be sent to prospective brides and bridegrooms, and their parents, to show what the betrothed might look like.

The silhouette, a profile traced onto and cut from black paper, was a simple alternative for people who could not afford other forms of portraiture, which, in the eighteenth century, was still an expensive proposition. They were named after Étienne de Silhouette, a French government official who in 1759 imposed

such harsh economic demands that his name became synonymous with anything done very cheaply. The quick outlines, created at virtually no cost, came to be known as *portraits à la Silhouette*. A clever artist could create likeness even with such rudimentary tools as paper and scissors. Parts of these silhouettes, for instance the lips, were sometimes colored to add life to the image.

A more technologically advanced method of obtaining an image of a loved one was announced in France in 1839 by Louis Daguerre. With the arrival of photography, portrait miniatures fell out of favor; this new process captured images quickly and accurately. Posing for a photograph was far less tedious—and less expensive—than sitting for a portrait.

With wider prosperity in the nineteenth century, however, and the rise of the bourgeois, more and more people wanted to announce that they were wealthy enough to have their portraits painted. A portrait was a sign that one had arrived, socially. What people wanted above all was a portrait that was flattering. While serious artists were advised not to idealize their subjects on canvas into looking completely different from their real-life counterparts, they were expected to create portraits that enhanced the subjects' best features.

In the past, that enhancement might involve depicting subjects in classical or mythological settings, clothing them in fanciful but emblematic costumes, or seating them before garden backgrounds. But a new movement in portraiture in the late nineteenth century presented subjects more realistically. Painters like Léon Bonnat, Henri Fantin-Latour, and Carolus-Duran showed people in real settings, with an "increased sense of life and personality."

With his penetrating eye and quick hand, Sargent was especially qualified for a career as a portraitist. At this early stage in his career, he was already demonstrating his versatility, his talent at working in the style of the old masters, like Velázquez, and the new renegades, like Manet.

In the late spring of 1876, Sargent traveled to the United States. An American by birth, the twenty-year-old was required by law to visit the United States to maintain his citizenship. He left Liverpool in May with his mother and Emily. Dr. Sargent stayed behind to take care of six-year-old Violet, who was thought too young for such a long trip. Mary Sargent, who had resisted making the trip west for at least the past twenty years, was now going home, while her husband, who had always yearned to be reunited with his family in America, was remaining in Europe. He had to comfort himself knowing that his son and daughter would finally meet their American relatives.

In her typical fashion, Mary never sat still while they were in America. The Sargents docked in Jersey City in May, proceeded to Philadelphia, went on to Newport, then Montreal and Niagara Falls. The weather was unbearably hot that summer, too hot for so much traveling. Though tempers among his relatives might have been short during the four months the Sargents moved from place to place, everywhere he went, John Sargent charmed and impressed with his formal, but quaintly endearing, ways. He struck his relatives as being far more European than American.

The biographer Stanley Olson suggests that Sargent's trip was liberating for him artistically. While at sea, he became fascinated with the idea of distorted perspective and examined dif-

ferent ways of representing it. He treated the ocean as new subject matter—though he had lived near the water in St.-Énogat, he never painted it until he went on this voyage—presumably inspired by a dramatic storm during the crossing. Sargent believed that his trip to America represented a new beginning for him, even a rebirth. The next time his name appeared in an art catalogue—to which he had supplied the accompanying biographical information himself—he was identified as "Sargent (John S.) né Philadelphia," born in Philadelphia. In his mind, his birthplace was America.

Sargent returned to Paris in the fall. He applied his newly acquired sense of perspective in a painting of a popular Paris musical group, *Rehearsal of the Pasdeloup Orchestra at the Cirque d'Hiver.* Emily told Vernon Lee that her brother worked "like a dog from morning till night." He was consumed with creating the perfect painting for his first Salon submission.

The French were passionate about art, and they approached paintings with the same enthusiasm they would demonstrate for movies in the next century. The annual Salon, like the Cannes Film Festival today, was a monumental event, with all the attendant publicity and press coverage. It was a place to sell paintings and launch reputations. Art dealers, critics, and buyers could take the artistic pulse of Paris simply by noting which paintings commanded the most attention and who was looking at them. The Salon was a giant entertainment, however, not an academic experience, and so it was popular with nonprofessional audiences as well. During the show's six-to-eight-week run, hundreds of thousands of people would crowd into the exhibition hall, the

Palais de l'Industrie, on the Right Bank. Attendance would spike dramatically on Sundays, when admission was free, reaching numbers as high as fifty thousand.

The Palais de l'Industrie was enormous, with walls that rose to meet impossibly high ceilings. It could hold up to seven thousand works of art, including paintings and sculptures, which were wedged into every available space. The Salon was so big that even the most ambitious and energetic visitor could not see everything in one day.

Every year, a few artists would emerge as Salon favorites among the thousands who exhibited. Their works instantly became dominant images in popular culture: reproduced on the covers of newspapers and journals, copied onto posters, cards, and candy boxes, even reenacted onstage in dramatic tableaux vivants. Most important, these lucky artists would be bombarded with commissions, so they could actually make a living in art. Although the chance of being plucked out of obscurity in this manner was extremely rare, young artists held out hopes that they might achieve instant success. These aspirants as well as established artists would subject themselves annually to the arduous process of submitting a painting to the jury.

On Submission Day, anxious artists would transport their works to the Palais de l'Industrie, struggling to keep their top hats on while wrestling with often oversized masterpieces. They would have been a funny and familiar sight to Parisians, who knew they were placing their art, and their egos, in the hands of the forty-member Salon jury.

The procedure for creating the jury should have been demo-

cratic, since the judges were elected by artists who were veterans of the Salon. But as with most elections, it was frequently a popularity contest. The veteran artists would vote for their own patrons and teachers, hoping to gain from them a good word on the final selection day. Each painting submitted would be reviewed by all forty judges, who determined whether an entry would be accepted. The fortunate artists whose works had won a medal or an Honorable Mention at previous Salons bypassed this process: their paintings were accepted automatically. The judges also determined where in the Salon each accepted painting would hang, as placement was everything. The paintings that excited the jury were guaranteed visibility. The less impressive ones were "skyed," or hung close to the ceiling. Many artists were condemned to anonymity simply because their works were difficult or impossible to see at the Salon.

The Salon opening, always on May 1, was tense and exhausting for artists. But it was one of the most important and anticipated days on every fashionable Parisian's social calendar. It was *the* place to see and be seen. The festivities began with the exclusive vernissage on Varnishing Day, the morning before the official opening. Ostensibly a private preview for artists, critics, journalists, and other members of the art world, this intensely social event attracted celebrities of all kinds. Artists stood on ladders and attempted to apply varnish to their paintings so the glossy finish would be perfect at the next day's opening, while trend-setting Parisians crowded around them, vying to identify the next rising star.

Edward Simmons, the American artist who was so captivated by Amélie Gautreau, described Varnishing Day as "the next excitement. Everyone of importance and all fashion turned out.

New York society cannot conceive of what a place the fine arts have in France. . . . Inside, great masses of people go through the galleries together, with some such person as Sarah Bernhardt at the head and the lesser following." Newspapers reported on the famous people who climbed the Salon steps. Great beauties always attracted attention. At one Salon opening, a *New York Herald* reporter witnessed the arrival of Amélie Gautreau: "Later on came Mme. [Gautreau], who does things in the way of art, but always distracts the artistic eye when she appears. She strolled slowly through the rooms, finding more interest in admiring the throngs than in the pictures." Amélie was not the only Parisian who came to the Salon to be seen. Gyp, a satirist who typically lampooned socialites, wrote a short play that featured two characters exchanging dialogue about the Salon: "Then which paintings are you looking for?" asked one. "None!" answered the other. "[The] paintings are all the same to us!"

After spending a few hours at the Salon, spectators would walk the short distance to Ledoyen, a restaurant located in a park setting at the end of the Champs-Élysées. One of the oldest and most elegant dining establishments in Paris, it was rumored to have been where Napoleon met Josephine. Every year, the restaurant staged a special luncheon on Varnishing Day, setting up a tent to accommodate the hordes of artists and admirers who crowded into the gardens surrounding the dining rooms. A constant line of people waited for tables, and waiters were in such short supply that it was not unusual for impatient artists to serve themselves bread. Ledoyen was famous for its food, but most of the people who came on Varnishing Day were more interested in

celebrity-spotting than eating. If they waited long enough, the artist of the moment was sure to make an appearance.

Seeking to make his mark at the 1877 Salon, Sargent settled on his first submission. He had started a portrait of a young woman, Frances (Fanny) Watts, and it seemed to offer possibilities. Fanny was a childhood friend who traveled the expatriate circuit, like Sargent's friends Ben del Castillo and Vernon Lee. Sargent may have had a crush on Fanny, and this may have motivated him to paint her in the first place. But if he had these feelings, he did not pursue them. Fanny's relatives believed that Mary Sargent discouraged a romance between the two because she had higher marital aspirations for her son.

Sargent finished the portrait in March of the year. A proud Dr. Sargent wrote about what he called his son's "opus magnum" in a letter to his sister in America: "To my uneducated eye it is— particularly if one considers that it is his first attempt at a serious, finished work—a very creditable and promising one." The portrait was especially ambitious in capturing motion and repose at the same time: Fanny is caught in the moment between sitting and standing, her body subtly poised to move.

The educated eyes agreed with Dr. Sargent. The Salon judges accepted the painting for the upcoming Salon, and expressed their enthusiasm for this work by an unknown twenty-one-year-old by hanging it where the crowds could see it. Critics responded favorably: Henri Houssaye, in the *Revue des Deux Mondes,* for example, called it *"un charmant portrait"*—exactly the kind of notice a young artist wanted.

With this Salon victory barely behind him, Sargent was al-

ready planning his next submission. Having shown a portrait, for the next exhibition he would submit a landscape to demonstrate his versatility. He spent the next several months on vacation with his parents in Brittany, painting the unusual oyster beds in the fishing village of Cancale. He was fascinated by the beaches, whose strange, shimmering light was intensified by the contrasting blues of ocean and sky. In adding a group of local women and children to the landscape, Sargent brought classic Breton imagery as well as color to the canvas.

When Sargent returned to Paris in October, Carolus-Duran, perhaps wanting to profit from his protégé's budding reputation, invited him to collaborate on a ceiling decoration for the Palais du Luxembourg. Carolus-Duran liked to have his most talented student by his side, and he treated Sargent more like an assistant than a pupil. *Gloria Mariae Medicis* was to be a historically themed painting with dozens of faces in it. On close inspection, two of these faces are familiar. They are Carolus-Duran and Sargent. The teacher painted his pupil's face on one of his figures, and Sargent painted Carolus-Duran's head leaning over a balcony.

Sargent continued working on his Breton painting, which he called *Oyster Gatherers at Cancale.* He completed two versions, and sent one to New York for the Society of American Artists' first exhibition and the other to the Salon jury. The painting was accepted in Paris. When the 1878 Salon opened, the critics confirmed what they had suspected the year before: John Sargent was a talent to watch.

Soon after the Salon, Sargent asked Carolus-Duran to sit for him. The decision to paint his teacher was audacious and compli-

John Singer Sargent, *Portrait of Carolus-Duran,* 1879

Sargent's teacher, a celebrity in Belle Époque Paris, was the subject of one of his early Salon portraits. *(Oil on canvas. 1955.14. © Sterling and Francine Clark Art Institute, Williamstown, Massachusetts)*

cated on Sargent's part. It seemed to indicate that he wanted to pay homage to his mentor—painting the maestro would be the best way to demonstrate the lessons he had learned at the atelier. But Sargent had another, more practical agenda. Carolus-Duran was a celebrity who was always in the news, and his image, especially as painted by his prize student, would draw attention and publicity.

Sargent's instincts were correct. His *Portrait of Carolus-Duran* was a hit at the 1879 Salon, counted among the exhibition's most popular and acclaimed paintings. Critics hailed it as "one of the best portraits of the Salon," and a journalist said of Sargent, "No American has ever painted with such quiet mastery." The jury awarded it an Honorable Mention, a prize that carried the added benefit of guaranteed acceptance for Sargent's next entry to the 1880 Salon.

Critics were quick to spot an interesting angle in the story. With his portrait of his teacher, Sargent proved that he was a better painter, or at least a more innovative one, than his *"cher maître,"* as he called Carolus-Duran in the dedication painted at the top of the canvas. Carolus-Duran had won the most important prize at the 1879 Salon for his *Portrait of the Vicomtesse de V.* Critics who found Sargent's work more exciting were very happy to say so, because they hoped to provoke a rivalry between the two men. Carolus-Duran had made enemies over the course of his career by thumbing his nose at the establishment. *The New York Times* described him as someone who was "cordially liked or cordially detested by each member of the art colony in Paris."

The attention Sargent received carried him to a much higher position in the art world. Lured to the portrait by the irresistible bait of its subject, the press recognized his talent and spread the word. The painting appeared on the front page of the popular newspaper *L'Illustration*—a great honor for a new artist—and inspired whimsical caricatures in such publications as *Le Journal Amusant.*

Sargent's career was off to a smashing start. Everyone from

art lover to aristocrat was talking about the dynamic newcomer. Moreover, people were willing to pay for his work. Dr. Sargent boasted that his son received no fewer than six commissions as a result of the 1879 Salon. Édouard Pailleron, a French poet and playwright, engaged Sargent to paint separate portraits of himself, his wife, and their children. The Paillerons were excellent social contacts, members of the Parisian intellectual elite.

Sargent's portrait of Madame Pailleron turned out well enough for him to exhibit it at the next year's Salon, along with *Fumée d'Ambre Gris,* a painting inspired by a recent trip to Morocco. *Ambre gris,* or ambergris, a resinlike substance derived from whale sperm, is said to act as an aphrodisiac when inhaled or ingested. Sargent's painting shows a magnificently dressed Arab woman holding her veil over an incense burner. She is perfuming herself with, and presumably inhaling, the burning ambergris, surrendering with every breath to the intoxicating power of the fumes. Henry James called the painting "exquisite" and "radiant," and other Salon critics predicted that this "perfect piece of painting" might win a medal. Sargent demonstrated a remarkable technical achievement with the work, which is executed almost entirely in subtle shades of white. But *Fumée d'Ambre Gris* also presents an intriguing metaphor for Sargent's state of mind. Like the mysterious figure in the painting, he was opening his eyes to the idea of intoxication, surrender, possibly even seduction.

Ramón Subercaseaux, a Chilean diplomat who was himself a painter, saw *Madame Édouard Pailleron* and *Fumée d'Ambre Gris* and immediately sought out Sargent to paint his wife, a beautiful socialite. The resulting portrait won Sargent a second-place

John Singer Sargent, *Fumée d'Ambre Gris,* 1880

The striking depiction of a mysterious woman inhaling the fumes from an incense burner points to Sargent's fascination with the exotic, in art and in his life. *(Oil on canvas. 1955.15. © Sterling and Francine Clark Art Institute, Williamstown, Massachusetts)*

medal at the 1881 Salon. He was delighted, for this award elevated him to the permanent status of *hors concours.* He could now bypass the Salon jury every year.

Sargent's new status won him new social connections. The casual art-student dinners he had been accustomed to gave way to formal receptions. He was invited to salons and country estates by wealthy clients who wanted to be painted in their own

Sargent in Paris. Handsome, confident, and optimistic, he set out to make a name for himself in the highest artistic and intellectual circles. *(Private collection)*

homes. He not only understood their tastes but also came to share them: he appreciated the good life and aspired to live in the same world as the privileged people he painted.

This is not to say that Sargent felt perfectly comfortable in high society. There were moments during the early years of his social ascent when he felt like an outsider, and he expressed that in his art from time to time. One of the works he displayed in his studio was a copy he had made of *Don Antonio el Inglés,* Velázquez's portrait of a dwarf courtier with a dog. According to a tradition in art and literature, the dwarf represented the artistic outsider, his physical form matching his inner torment. Sargent must have experienced some feelings of exclusion as he ventured into society.

Aspiring artists now looked to Sargent as their idol; they dreamed of achieving his success, dissecting his techniques, and trading stories about him just as they once discussed Carolus-Duran. Everyone knew about Sargent's idiosyncrasies in the studio. He talked constantly while he painted. He chain-smoked cigarettes and cigars, although, as his friends teased him, he didn't inhale properly, "denying himself the true purpose of 'Princess Nicotine.'" Unlike many artists, he never wore a smock to protect himself from his paints. And as one model recalled, he kept his pockets filled with pieces of bread when he sketched, and would roll the soft part into little balls to use as erasers.

Sargent began each portrait with the same ritual, placing his canvas next to his sitter so they could share the same light. He would prepare his palette, then step back, fix an image in his mind, and run forward to the canvas to paint it. He would be in constant motion throughout a session, walking what he estimated was four miles a day to and from his easel.

When he was very excited, Sargent would rush at his canvas with his brush poised for attack, yelling, "Demons, demons, demons!" When he was particularly angry or frustrated, he expressed these feelings with "Damn," the only curse he allowed himself. He once had the expletive inscribed on a rubber stamp so he could have the satisfaction of pounding it on a piece of paper. Far from being offended, his subjects were amused by his outbursts, Sargent seemed so buttoned-up and formal in every other way.

His artistic gifts were not restricted to his canvas. Several experts believed he would have been a first-rate pianist had he pursued music instead of art. The composer Charles Martin Loeffler

marveled at his quick mind and his ability to play by ear. Sargent loved listening to his favorite composers, from the celebrated Richard Wagner to the lesser-known Gabriel Fauré, and when he performed music himself, he had such an intuitive understanding that he could bring any piece to life the first time he played it. "If he didn't play all the right notes," Loeffler observed, "he played the right *wrong* notes . . . a sign of true musicianship."

Sargent had a great appreciation for literature as well as for music. His friend Eliza Wedgwood noted that he loved reading in a "wedge," as he called it, devouring numerous books by the same author, one after another. He enjoyed historical works, such as Edward Gibbon's *Decline and Fall of the Roman Empire,* and the exotic and fantastic as well. He thoroughly relished William Beckford's novel *Vathek,* part *Arabian Nights* and part gothic drama, which had developed a cult following among aesthetes in Paris and London.

Sargent's prodigious appetite for literature and the arts was matched by his enthusiasm for food. His meals were usually the multicourse affairs common at the time, including soup, fish, beef, chicken, vegetables, cheese, and dessert. On days when his schedule was full, Sargent was known to race into a restaurant or club at lunchtime, place his pocket watch on the table to keep track of the minutes, and work his way rapidly and efficiently through each and every dish. Even as a student, he loved dining out and rarely ate any meals at home; he maintained the practice for the rest of his life.

Collecting was another favorite activity. Sargent was a pack rat and tended to fill any given space with possessions—antiques, paintings, carpets, and fabrics. He captured butterflies, and killed

them by gently blowing cigar smoke on them so their beauty would be preserved, then mounted them for his collection.

Sargent was famously generous, especially to fellow artists. Paul Helleu, one of his closest friends, was a ladies' man who was more successful as a lover than as an artist. One day, depressed and questioning his vocation, Helleu was visited by Sargent, who insisted on buying a drawing of Helleu's. He paid a thousand francs on the spot, cleverly helping Helleu in a way that allowed him to maintain his pride.

Whether people were talking about his character or his technique, his background or his prospects, John Singer Sargent was the subject of discussion in Parisian drawing rooms and artists' studios. His name began to appear in the society columns. In June 1881, the gossip columnist Perdican used Sargent as an example to warn that the French were far too liberal in welcoming ambitious Americans into their midst: "Beware this people that grow ever larger. . . . Uncle Sam threatens with his gnarled, industrious hands our commerce, our agriculture, and our stables. . . . Their painters, like Mr. Sergeant [*sic*], take away our medals. Their pretty women, like Madame Gauthereau [*sic*] outshine our own—and their horses thrash our steeds, as Foxhall ridden by Fordham did on Sunday."

Perdican's point was that his countrymen should be wary of the Americans in their midst because they were encroaching on French territory. This was a sensitive matter at the time, for the United States had passed restrictive laws regarding French imports and imposed high tariffs on French art that was brought into the country. Since American artists were welcomed into

Parisian art schools and benefited greatly from the fact that these schools were subsidized by the state, the French considered the U.S. government's position extremely hostile. Newspapers demanded retaliation, one of them urging that "we will have to respond . . . by closing the doors of our art shows to the artists of a country that does the same to our artists."

But with his statement, Perdican also made the point that John Singer Sargent and Amélie Gautreau were two of the most visible imports of the day. And Sargent, for one, was delighted by the fact that his name appeared alongside Amélie's. She was famous, the subject of countless newspaper items. If Perdican referred to him in the same breath, he must be a star as well. Together, they were a perfect confluence of good looks and talent: Amélie Paris's greatest American beauty and Sargent the city's brilliant young American painter.

Amélie's celebrity status made her more desirable to her adoring public, and now that he'd experienced the first indications of success, Sargent discovered he was suddenly desirable too, an excellent catch for a marriageable young lady. No one was more aware of his potential as a son-in-law than Mary Elizabeth Burckhardt, the mother of two daughters in need of husbands. She licked her chops when she realized that Sargent, a family friend, could be a candidate for marriage for either of her daughters, whether it be Charlotte Louise or her older sister, Valerie. Mrs. Burckhardt's desire to have a successful artist as her son-in-law is significant. In the latter part of the nineteenth century, artists, especially portrait painters, were working professionals with solid financial futures. When Mrs. Burckhardt imagined a

daughter of hers married to Sargent, she did not envision the couple living *la vie de bohème* in a chilly garret on the Left Bank. Rather, she foresaw recognition, considerable fees, and a comfortable future, just as if Sargent were a banker or a lawyer. Flourishing artists of the time could expect a level of economic security.

With this as her goal, Mrs. Burckhardt single-mindedly pursued Sargent, focusing on him as a mate for Louise after Valerie decided to marry a gentleman named Harold Hadden. People who knew Louise described her as a pleasant but unremarkable young woman. Some acquaintances even suggested she was a little stupid. Above all, she was a docile and obedient daughter, dedicated to fulfilling her mother's ambitions for her.

Mrs. Burckhardt plotted several romantic excursions during the summer of 1881, contriving to bring the two young people together. She invited Sargent and his friend James Beckwith to Fontainebleau and other nearby destinations that would remove them from the distractions of Paris. Normally, Sargent seemed to have no time for romance. He painted constantly during the academic season, and when he took vacations, he usually traveled with his family. But this summer was different. Mary and Emily Sargent went off to America while, once again, Dr. Sargent stayed in Nice with Violet. Sargent was on his own, possibly missing the female companionship of his mother and sisters. He appeared to warm to Louise and actually welcomed opportunities to be alone with her. Beckwith caught them unaccompanied several times—something that would never have happened during those days of constant chaperones if Mrs. Burckhardt had not counted on a wedding in Louise's immediate future.

Inexplicably, however, Sargent's interest waned and evaporated completely by the end of the summer. At the very moment when Mrs. Burckhardt felt closest to attaining the prize of a marriage proposal for Louise, the artist baffled her by reverting to his friendly, yet decidedly platonic, relationship with her daughter. Louise confronted him at his studio, hoping for an explanation. Sargent had the difficult task of convincing her that their flirtation, if it could be called that, was over. Their unpleasant conversation was interrupted by Beckwith, who walked in on them and saw that there was "evidence of trouble." Sargent confessed to him that although he valued her friendship, he didn't care for Louise in a romantic way.

One of the reasons they had spent so much time together during the latter part of their "courtship" was that Sargent had started an enormous portrait of Louise. Titled *Lady with the Rose,* it depicted Louise in a black gown with a rose in one hand, recalling Carolus-Duran's portrait *The Woman with the Glove.* Sargent's interpretation of Louise was most striking for what it lacked: any sign of passion or sexuality. *Lady with the Rose* was more than competent, but it was utterly conventional. It was as bland as the young woman who posed for it. The painting revealed Sargent's true feelings: this was not the work of a man, or an artist, in love. At best, Sargent liked Louise and enjoyed her company. But she occupied her own portrait tentatively—she was little more than a place saver for someone who might exercise a real romantic hold on Sargent in the future.

Sargent had higher ambitions than a bourgeois marriage, and he did not need the distractions of eager mothers and their hope-

John Singer Sargent,
*Lady with the Rose (Charlotte Louise Burckhardt),* 1882

Charlotte Louise Burckhardt hoped to marry Sargent, and her matchmaking mother considered the artist an excellent catch. Sargent spent time with Louise, but as his portrait of her might suggest, their relationship remained platonic. *(Oil on canvas, 84 x 44¼ inches, 213.4 x 113.7 cm. The Metropolitan Museum of Art, Bequest of Mrs. Valerie B. Hadden, 1932 [32.154]. All rights reserved, The Metropolitan Museum of Art)*

ful daughters. He wanted to penetrate the inner circles of Paris's social, intellectual, and artistic elite, not only because he knew he would find wealthier clients, but also because he was drawn to the "beautiful people." He directed his attention to his canvas, which would be his passport to that elusive world.

# Brilliant Creatures

In a lull between commissions during the summer of 1881, Sargent busied himself with portraits of friends, all the while surveying the horizon for his next splashy assignment. He spotted an opportunity when he was asked by Carolus-Duran to attend a party at an apartment on the Place Vendôme, one of the most fashionable addresses in Paris. The host was Samuel-Jean Pozzi, a respected gynecologist, surgeon, and man of the arts who was even better known for his breathtaking looks, charismatic personality, and insatiable appetite for sex. Pozzi traveled with the most exclusive—and the most decadent—international set, consorting with the beau monde's brightest luminaries.

In his prime, he embodied the Belle Époque romantic ideal. He was tall and well built, and his dark hair contrasted dramatically with his white skin. He wore every kind of clothing well, from close-fitting business suits to the sheik costumes he playfully donned for the photographer Nadar. Intelligent, artistic, and irresistible, Pozzi brazenly used his profession for entry to the best bedrooms in Paris.

Pozzi began his life as the son of a Protestant minister. He was born in 1846 in Bergerac, a town in the Dordogne, to Inès and Benjamin Pozzy. At some time, his father changed the spelling of the family name, ignoring his ancestors' apparent preference for the dramatic flourish allowed by the *y* at the end of the signature.

Pozzi's mother had inspired his interest in medicine, specifically women's health. She was twenty-three when she married her husband, and over the next thirteen years, she bore five children. She was always pregnant or recovering from a pregnancy, and she died at age thirty-six. Her son was only ten, but he had vivid memories of her constant confinements.

A brilliant student, Pozzi could have entered any profession. He chose to follow in the footsteps of an older cousin, a successful physician in Paris who had treated members of the Bonaparte family. Pozzi may have imagined a similar physician-to-the-stars career trajectory for himself.

He entered medical school and was assigned to Dr. Gallard, one of the few physicians in Paris who specialized in the study and treatment of women's health. Through Gallard, Pozzi was introduced to the intriguing new medical field of gynecology. He

was enthusiastic about his work and applied himself to his studies with dedication. But his classes were interrupted by the start of the Franco-Prussian War.

Joining with other young men in Paris, Pozzi enlisted in the army in July 1870. For the first months of service, he was stationed in Paris, where he spent most of his time participating in parades and ambulance marches. When he arrived at the front, he demonstrated remarkable courage and dedication. He suffered a fractured leg in the line of duty, and was discharged and sent home to his family to recover. After the war and the bloody Paris Commune, he resumed his studies, and won a coveted position under the esteemed Dr. Paul Broca. Pozzi was awarded a gold medal for his outstanding internship and received his medical degree in 1873.

During the Third Republic, French doctors were encouraged for the first time to study the female body and address health problems that related specifically to women. Curiously, it was the Franco-Prussian War that promoted interest in women's health and reproduction. The French believed that their defeat had been caused, in part, by the rampant physical and moral degeneration of their people. They had spent decades shamelessly indulging their baser instincts under the leadership of Napoleon Bonaparte and his descendants. Contaminated bloodlines and bad behavior were to blame for their degeneracy. Curing moral decay was a complicated proposition for which there was no simple solution. But, the French believed, the physical side of the problem could be addressed in a very practical way. Doctors, nurses, housewives, and mothers could promote better personal

hygiene to combat alcoholism, venereal disease, and tuberculosis, among the conditions that had undermined the populace.

The French were also extremely concerned about their country's plummeting birth rate. After the war, and through the early 1890s, years passed in which more people died in France than were born. Medical practitioners were encouraged to find ways to improve prenatal care, internal examinations, and deliveries, in an effort to make childbirth safer for mothers and babies. Even the reinstitution of the divorce law in 1884 was seen as a way of promoting births: childless marriages could be dissolved, to make way for unions that could produce offspring.

Doctors were interested in the challenging field of gynecology. Some of them wrote handbooks and endorsed beauty products, just as some physicians promote their own product lines today. The handbooks were not always specific, informative, or even accurate, yet they indicated a growing comprehension of women's physical concerns. Pozzi, who was also studying to be a surgeon, pursued his interests in this area.

Pozzi was a conscientious medical student who demonstrated a great aptitude for his work. But his interests extended beyond the world of science. He was passionate about literature, art, and the theater, and was drawn to artists of all kinds. In 1869, Pozzi fell under the spell of Sarah Bernhardt. After seeing her in a production of *Le Passant* at the Odéon, he became one of the actress's most devoted fans.

Two years older than Pozzi, Bernhardt was a fascinating bundle of contradictions. Although she was of Jewish descent, she was raised in a Catholic convent and baptized at the age of

twelve. With her skinny body and curly hair, she was not a conventionally beautiful woman, but she had what some described as a *"voix d'or,"* a voice of gold. She was vivacious and full of life, yet she traveled everywhere with a satin-and-velvet-lined coffin, a prop guaranteed to generate publicity. She mounted extensive tours of England and America that kept her away from France for months at a time. No matter how long she was gone, however, she always returned to adoring Parisian audiences.

At first, Pozzi and Bernhardt restricted themselves to friendship. But they were two passionate people: a love affair was inevitable. The adoring young doctor and his diva often dined together at her home. Bernhardt usually dressed provocatively in black lace, with dramatic touches like accordion-pleated gloves that stretched to her shoulders. One night, after her son, Maurice, and his tutor had gone to bed, Bernhardt led Pozzi to her sumptuous coffin for their first amorous encounter.

Bernhardt was astonished by her lover: she called him "Dr. Dieu," Dr. God. Once, when Pozzi had to cancel a date because he faced an important medical exam, a distraught Bernhardt raced to his apartment and kept him entertained in the bedroom for sixteen hours. Pozzi's punishment for missing his exam was the odious assignment of translating a long scientific treatise by Darwin. Bernhardt wittily commemorated the evening by naming her new pet, a chimpanzee, Darwin.

Despite his handsomeness and his amorous reputation, Pozzi was not a frivolous man. Dedicated to his work, he was renowned in international circles for his achievements in medicine and science. Pozzi was a perfectionist: he always wore white cover-

alls when he operated, to demonstrate to his students that it was possible to perform surgery without incurring the stain of even a drop of blood. He invented the bimanual manipulation, the method of performing an internal examination still used by gynecologists today. He maintained an active private practice as both gynecologist and general surgeon, did charity work at Paris hospitals, and found the time to write, among other books, *A Treatise on Gynaecology, Clinical and Operative,* the nineteenth century's definitive textbook about women's health.

Pozzi was considered an excellent catch when, in 1879, he married Thérèse Loth, a railroad heiress with a considerable fortune, but far plainer looks than her husband's. The Pozzis moved into a spacious apartment at 10 Place Vendôme, a few doors from where Chopin had once lived. They were attended by a fleet of servants, including a chef and a footman. Their luxurious apartment was filled with objets d'art, valuable books, rare coins, and the beginnings of a significant art collection. They traveled often to resort towns such as St.-Malo. The only discord in their lives was the doctor's complaint that his wife was far too devoted to her mother, a possessive and opinionated widow who was a constant presence, and to their children, Catherine and, later, Jean.

As time passed, the discord between the doctor and his wife grew more serious. When pressed to choose between her husband and her mother, Thérèse would always side with her mother. Pozzi was unaccustomed to rejection, especially from a woman, and his unhappy marriage was his first experience with failure. He consoled himself with the fact that Thérèse's preoc-

cupation with family matters gave him considerable freedom to move in intellectual and artistic circles—and to spend time with women who were not his wife. Bernhardt was not the only one who responded to Pozzi's charms: famous and infamous women alike welcomed this intensely desirable man into their arms, and as he was their doctor, they did so without arousing the curiosity or the wrath of their husbands and lovers.

By 1881, Pozzi could have any mistress he wanted; he became drawn to the stunning new face in town, "La Belle Gautreau." With her husband and child on hand to maintain an aura of respectability, Amélie traveled in the fast group of wealthy politicians and businessmen who owned the new Paris. She was their favorite ornament, and they provided her with a welcome distraction from her moneyed but unexciting marriage.

Amélie's name was frequently linked to that of Léon Gambetta, a political force in Paris in the 1880s. It is likely that he had met Amélie when she was a child, during the dramatic days of the Franco-Prussian War. They had many opportunities to be in each other's company at the home of Amélie's uncle Jean-Bernard Avegno. Gambetta exuded the kind of raw magnetism that often accompanies political power, and his wartime heroism would have impressed a girl Amélie's age. When an older Amélie entered society as a married woman, she attended political dinners where Gambetta was a guest, held his arm at public events, and, according to rumor, met him for private tête-à-têtes. Gossips speculated that she was the "Madame X" the newspapers referred to as Gambetta's secret mistress. But Amélie's reputation

was protected by his long association with her relatives—he could feign familial interest in his beautiful young companion even as he was secretly making love to her.

Amélie was seen also in the company of Ferdinand de Lesseps, the diplomat who masterminded the Suez Canal. Often portrayed as the secret admirer of Napoleon III's wife, the Empress Eugénie (who was his cousin), Lesseps was a flashy and important figure in the Second Empire and the Third Republic. His comings and goings were reported in the newspapers, and the woman on his arm always attracted interest. Despite the tremendous difference in age (he was in his seventies, while Amélie was not long out of her teens), Lesseps was a distinguished escort, and would have been an impressive choice for a lover as well.

Of all Amélie's reputed paramours, the most discussed was her gynecologist. According to one tale that spread rapidly throughout Paris after her wedding, Amélie's husband was so obsessed with the virginal young Amélie that he had agreed to a *mariage blanc*—a sexless marriage—to persuade her to be his wife. Pedro Gautreau upheld his end of the bargain by not forcing her to fulfill her wifely duties. Mysteriously, only a few months into their marriage, Amélie began to show unmistakable signs of pregnancy. She was shocked by her condition and insisted that she was still a virgin. Her gynecologist examined her and confirmed her innocence. The doctor assured the irate Monsieur Gautreau that his young wife was not pregnant. He explained that she was carrying her own vestigial twin; the condition, he said, was easily remedied with modern medicine. He quickly

came up with a surgical solution to the potentially scandalous situation, and all was well in the Gautreau household.

The first part of the story is wonderfully implausible. There wasn't much time for a *mariage blanc,* given the apparent rapidity with which Louise was conceived after Pedro and Amélie's wedding. Implausibility notwithstanding, Amélie did in fact have a gynecologist, none other than Samuel-Jean Pozzi. But he was not content to be Amélie's doctor.

One day, he invited Amélie to afternoon tea at his Place Vendôme apartment. When she accepted, Pozzi dashed off a few words on a calling card to his friend and confidant Count Robert de Montesquiou-Fezensac. There was a definite tone of victory in his note: "Dear and extremely rare friend . . . Madame Gautreau of the swan's neck will be taking tea at my house the day after tomorrow, Tuesday the 5th. If you want to see her again, come."

Pozzi's tea with Amélie would lead inevitably to private assignations. Whenever he became enchanted with a woman, Pozzi would mount an elaborate campaign, wooing her with passionate letters, expressing his deepest emotions and most profound thoughts. "I like to be loved," he wrote in one such letter, and confessed that he enjoyed exploring the "alchemy of the heart." It is believed that he saved his mistresses' replies, but these revealing souvenirs of his love affairs seem to have been suppressed out of respect for his family.

Sargent was familiar with the Pozzi folklore—everyone in Paris was—and had heard that the doctor was, understandably, vain about his looks. During a visit to Place Vendôme in the

For more than a century, rumors have linked Amélie to Samuel-Jean Pozzi, one of the most desirable men in Belle Époque Paris. This note from Pozzi to Robert de Montesquiou substantiates the connection. (*Bibliothèque Nationale de France*)

company of Carolus-Duran, Sargent admired a charming painting of Thérèse Pozzi, and pointedly expressed regret that there was no portrait of her handsome husband in their salon. It was an ingenious move on Sargent's part. Appealing to Pozzi's vanity, he planted the idea that there should be a portrait of him and that he, Sargent, should be the one to paint it.

Sargent's audacity—right under the nose of Carolus-Duran, no less—won him the job. Pozzi responded enthusiastically to the suggestion and agreed to sit for Sargent. With this important commission from the doctor, whom Sargent later called "a very brilliant creature," the artist had secured his entry to the coveted inner circle.

# *Heat and Light*

Buttoned up and businesslike in his customary suit, in the late summer of 1881, Sargent set up his easel in Pozzi's apartment, ready to find a pose for his subject. His admiration of Thérèse Pozzi's portrait—a sweet depiction of a young woman holding a basket of flowers, by an artist named Blanchard—led his hostess to expect an equally conservative rendering of her husband. But as Sargent observed Pozzi in the flesh, he abandoned any ideas of a conventional portrait of the successful doctor. He wanted to show Pozzi as he really was, a man so flamboyant and dazzling that Sargent, like the most interesting people in Paris, was drawn to him like a moth to a flame.

Searching for the image that would best convey his subject, Sargent turned his eye on the seductive world the doctor ruled like a high priest. The painter discovered that while Pozzi and his socially prominent friends were relentlessly creative—writing, painting, debating aesthetic issues—their greatest preoccupation was sex. If they weren't doing it, they were talking about it with an abandon that was unfamiliar to Sargent, a man who seems to have had little sexual experience.

Sargent, who encouraged his sitters to receive visitors while they posed, because they were likely to be more relaxed in the company of friends, had many occasions to witness Pozzi in action. At the time, the doctor and Amélie were at the height of their affair. Pozzi's portrait sessions afforded the pair the chance to flirt while ostensibly chaperoned. Given the intensity of the rumors about their relationship, they must have generated a palpable undercurrent of passion when they were together. But Thérèse, busy with her mother and her own social engagements, continued to overlook her husband's extramarital activities.

While working on the portrait, Sargent also saw a lot of Robert de Montesquiou-Fezensac, Pozzi's friend and frequent dining companion, and a nineteenth-century version of a cool hunter. Called the "Prince of the Aesthetes," the outrageous Montesquiou started new fads every time he did something daring. When, for example, he painted the walls of his drawing room gray and displayed flowers that matched, the rest of Paris followed suit. He pinned a nosegay of violets at his neck to serve as a tie, and wore a ring that contained a single human teardrop. Having decided that his pet tortoise looked too drab on his car-

pet, he had the animal's shell embellished with gold and jewels. He wrote a little, painted a little, and spent the rest of his time seeking pleasure. Montesquiou's self-indulgence inspired Joris-Karl Huysmans, the author of *À Rebours* (*Against Nature*), to create des Esseintes, among the more decadent characters in literature.

There was talk about Montesquiou's sexuality: supposedly, he was homosexual and had been confirmed as such by a wild moment with Sarah Bernhardt—he found it so distasteful that he vomited for twenty-four hours afterward. He loved women as idea and even as ideal, but not as flesh-and-blood reality. His affection for Pozzi, though, was tinged with unbridled lust. Their notes to each other—Montesquiou's written in lavender ink—were playfully erotic, with Pozzi indulging his friend's tendency to turn the most mundane communication into an impassioned declaration of love. They addressed each other as "my dear, sick soul," and signed their letters "I am all yours, very yours."

Judith Gautier, also a visible figure of the period, was another intimate of Pozzi's whom Sargent came to know at this time. A respected writer and critic, she was fascinated by Oriental culture and habitually incorporated elements from this exotic world into her life. She wrote about Asia in her stories and plays, and she regularly wore kimonos. Gautier traveled in lofty artistic circles, where she developed a reputation for being something like a groupie, a woman who gave herself body and soul to the artists she admired.

Gautier had entered the creative world at birth through her father, the writer Théophile Gautier. She grew up in the com-

pany of intellectuals such as Baudelaire and embraced their bohemian lifestyles with a vengeance. As a girl, Gautier was extremely precocious and was given much more freedom than other children her age. Her father, who asserted his own independence by never marrying Gautier's mother, encouraged his daughter to read progressive writers and to make unconventional life choices. Gautier demonstrated what a freethinker she was when she married Catulle Mendès, a devilishly attractive avant-garde writer.

Mendès was a member of Paris's new generation of poets, self-absorbed young men who wore their hair long and played at being romantic heroes. It was rumored that he had made up his name, selecting those of the Roman author of libidinous verse, and the Egyptian god with the head of an ox, but his family name really was Mendès. Women found his edgy looks irresistible; he was "as beautiful as a bad angel." His poetry—laced with pornographic references—was judged obscene, and he served time in prison for offending public morals with it. He made no secret of the fact that he was a philanderer who enjoyed Paris's demimonde of prostitutes and criminals. He was said to have contracted a vicious venereal disease from one of his many mistresses.

During the early years of their marriage, Gautier ignored Mendès's behavior and concentrated on their pursuit of the artistic elite. The couple befriended important writers, including Victor Hugo and Gustave Flaubert, and cultivated a friendship with Richard Wagner, whom they both worshipped. But after eight years of tolerating her husband's escapades, Gautier could no

longer ignore his raging infidelity. Even her liberal-minded father was relieved when the marriage fell apart in 1874.

Flirtatious before her divorce, afterward Gautier developed close relationships with many of the men she and Mendès had admired together. Hugo doted on her, and to help her maintain the lifestyle she had had as a married woman, he tried to arrange a government pension for her. When a government official hesitated to do so—Gautier was not such a distinguished artist in her own right that she warranted such a gift—Hugo told him in no uncertain terms that "it is enough that this is so, and that I tell you, for the pension to be given." He had that kind of power, and was happy to exercise it for his alluring friend.

Wagner and his wife, Cosima, also welcomed Gautier into their realm. Gautier had a way of making herself indispensable to artistic people. She flattered them. She convinced them that she alone understood their art and its importance. She did such a good job of being a fan that, sometimes, her heroes became her admirers. There was a serious flirtation between Gautier and Wagner, leading the eagle-eyed Cosima to ban her from the composer's presence. Whether or not Wagner and Gautier had a sexual relationship, she was his intellectual and emotional intimate, and this was enough to make her the high priestess in Wagnerian circles.

In the 1880s, Richard Wagner was a god in Paris—and a particular favorite of Sargent's—because he was the quintessential romantic artist. His life and his music were built around his epic vision of the world, a universe of legend, passion, myth, loss, redemption, and the eternal battle between good and evil. His *Ring*

*of the Nibelung* was the most spectacular, the most imaginative, and certainly the most provocative entertainment anyone had seen. Wagner spent twenty-eight years creating the masterpiece, expanding his *Death of Siegfried* into a saga that incorporated the tragic hero's entire life, and more. Wagner was so concerned about the staging of his monumental tale of gods, giants, and other mythological creatures that he persuaded patrons to spare no expense in building the Festspielhaus at Bayreuth, a special theater where the *Ring* cycle could be performed according to his specifications.

A largely self-taught musician, Wagner spent years bringing his complex compositions to life. He had an enormous ego and insisted on being the dominating force in his household. His first wife was an actress, Christine Wilhelmine (Minna) Planer. Their tempestuous marriage lasted from 1836 to 1860, while Wagner traveled through Europe, composing his operas and creating controversy in the musical world.

In 1861, Wagner met the great love of his life, and his emotional and artistic match, Cosima von Bülow, the daughter of Franz Liszt and the wife of the pianist and conductor Hans von Bülow. They moved in together and started a family, and married after Minna died in 1866. Wagner and Cosima managed to stay afloat financially with the patronage of Ludwig II, the "Mad King" of Bavaria. Ludwig, who had succumbed to the spell of Wagner's music as a teenager, was an eccentric who spent fabulous sums of money making his most decadent dreams come true. He built elaborate fairy-tale castles, such as Neuschwanstein, in his homeland, freely borrowing the swans from Wagner's *Lohengrin*

as his insignia. In one of his outrageously outfitted castles, Ludwig would act out bizarre *Arabian Nights* fantasies in a man-made lagoon. The very castles that sent Bavaria into a financial tailspin and sparked a successful plot to remove the king from his throne would become lucrative tourist attractions in the next century, and Neuschwanstein would inspire the design for Cinderella's Castle at Disneyland.

People either loved Wagner, as Ludwig did, or hated him. His supporters believed he was one of the greatest artistic forces of the century, and made the pilgrimage to Bayreuth to see the *Ring* performed exactly as Wagner decreed. But after the Franco-Prussian War, many French people found his music an offensive reminder of their terrible defeat. When they heard the stirring chords and the overt celebrations of German history and folklore, they thought of nothing but the humiliating Prussian victory. Opera houses had to hire guards and print disclaimers in their programs when they produced works by Wagner, warning, "The public is requested neither to hiss nor to shout encore during the Wagnerian performances!"

As Sargent observed Pozzi and the fascinating figures around him, he saw that their behavior had a marked influence on how he painted. Pozzi presented him with a new challenge. While Sargent was a master at capturing forms and features through the juxtaposition of light and shadow, Pozzi's most distinctive feature, his potent sexuality, could not be rendered with art school technique alone. Sargent would have to learn to paint emotionally as well as intellectually, using his brush to capture that potency as well as his own reaction to it.

Sargent conceived a daring image that both demonstrated his talents and expressed the feelings he had for his subject. He persuaded Pozzi to wear his scarlet dressing gown for the portrait, the male equivalent of a lady's *robe d'intérieur*. A garment reserved for intimate moments at home would suggest that Pozzi was in his bedroom. Sargent then posed the doctor with one hand at his heart while the other played suggestively with the cord of his tasseled belt, as if preparing to undo it. His long fingers, tools in his profession, were graceful, immaculate, and sensual in the painting. He looked like a man poised to commit an indiscretion.

With every artistic choice—the robe, the pose, the use of the color red—Sargent eroticized the already erotic Pozzi, turning him into a symbol of male sexuality. And the portrait said as much about Sargent as it did about the libidinous doctor: clearly the painter of this portrait was captivated by his subject. Any artist could have painted Pozzi in a conventional way, but only an artist who was smitten could have captured the man's power to seduce.

Sargent sent the finished portrait to an exhibition at London's Royal Academy of Art in 1882, where it drew the attention of Oscar Wilde, a writer familiar with "the love that dare not speak its name." Wilde recognized Sargent's deep feelings for his subject, and he later immortalized Sargent's relationship with Pozzi in *The Picture of Dorian Gray*. In the novel, the artist Basil Hallward makes a startling declaration to his subject, Dorian Gray, confessing, "I have worshipped you with far more romance of feeling than a man usually gives to a friend. . . . Your personality had the most extraordinary influence over me. I quite admit that I adored you madly, extravagantly, absurdly." Wilde felt no

compunction about using the details of a real artist's life in his fiction: Hallward is said to paint energetically, with "the sweep and dash of the brush on the canvas," just like Sargent. Hallward shows his paintings at the same Paris and London galleries where Sargent exhibited, and favors colors Sargent sometimes used, lilac and purple.

Though Sargent may have been enamored of Pozzi, the doctor would have been an unattainable object of desire. Pozzi flirted with men, but was without question a womanizer, so the relationship between the two—as that between Pozzi and Montesquiou—would have been confined to friendship. Sargent seems to have been comfortable with this platonic bond, and he further secured it by becoming close with several of Pozzi's intimates, including Judith Gautier. He also started to form his own circle, pursuing friendships with artists he met in various Left Bank cafés and restaurants. At Sargent's favorite place, L'Avenue, the cashier kept an album for artists to use for drawing if they didn't bring their own. Sargent would monopolize it, sketching everything from arms and legs to small portraits, and it was commonly referred to as *"l'album Sargent."*

Albert de Belleroche, a student at Carolus-Duran's atelier, happened into the restaurant one night in 1882 when Sargent was holding court. A beautiful young man with fine bones and an aristocratic bearing, Belleroche was at age eighteen new to the Parisian art world. He had met Sargent once before, at the annual studio dinner honoring Carolus-Duran, but they did not know each other well. When Belleroche looked through the album at the restaurant, he was surprised to see a drawing of

himself. Sargent had sketched him without his knowing it. Belleroche, enchanted, tore the page out of the album and took it home.

Sargent was fascinated by the younger man, initially by his appearance, and later by his personality. They started spending time together and became fast friends. Sargent teasingly called Belleroche "Baby Milbank" (Belleroche used Milbank, his step-father's last name, until he was thirty), and the nickname stuck.

Belleroche came from one of France's oldest and noblest families, Huguenots who moved to England in the seventeenth century in pursuit of religious freedom. Belleroche's father, Edward Charles, the Marquis de Belleroche, died when his son was a baby. The marquis's widow, Alice, was a great beauty. Still a young woman, she married the notorious Harry Vane Milbank, who was reputed to have shot twenty men in duels, and they maintained residences in Paris and London. Years into their marriage, the Milbanks became cocaine addicts. They lost everything to their addiction and ended up impoverished. But when Belleroche was an art student, they were a wealthy and fashionable Parisian couple.

Belleroche introduced his new friend to his mother and step-father at an opportune time: Alice's husband wanted to have her portrait painted. Belleroche suggested Sargent, who posed her in a daring black gown with an extremely revealing décolletage. Sargent was testing new ideas of perspective and palette when he started the painting, and he was never satisfied with the results. He abandoned the portrait before it was finished, and eventually gave it to Belleroche.

The two artists kept up a long friendship. They shared studio space in Paris, and later in London, and frequently painted and sketched each other. Belleroche drew Sargent, casually dressed and uncharacteristically relaxed, working in front of his easel. Sargent painted Belleroche in various poses and costumes—as a proper modern gentleman, for instance, or in medieval dress, holding a giant sword. A photograph taken at Sargent's studio shows the artist pausing from his work while Belleroche poses in what appears to be a seventeenth-century courtier outfit. One day Belleroche placed a fur hat on his head and Sargent painted him as a Spanish aristocrat.

The brooding and romantic quality in Sargent's portraits of Belleroche suggest a relationship that went beyond that of artist and model, or mentor and student. The early months of their friendship were an ongoing flirtation, much like that with Pozzi. The art historian Dorothy Moss writes that "Sargent's portraits of Belleroche, in their sensuality and intensity of emotion, push the boundaries of what was considered appropriate interaction between men at this period." In the throes of this second romantic crush, whenever Sargent painted Belleroche, he did so with the same heat that he used in painting Pozzi.

Sargent's emotionally charged relations with these two men electrified his art, and nowhere is this more apparent than in *El Jaleo,* his 1882 Salon entry. The painting, enormous in size and dramatic in mood, showed a Spanish dancer, transported by the sensual movement of her body as she surrenders to the power of the music. Sargent demonstrated a new level of emotional in-

John Singer Sargent, *El Jaleo,* 1882

More than eleven feet wide, Sargent's dramatic rendering of a Spanish dancer is charged with energy and emotion. *(Isabella Stewart Gardner Museum, Boston)*

volvement with his subject: *Le Figaro* proclaimed *El Jaleo* "one of the most original and strongest works of the present Salon."

But he was still an American, and therefore an outsider to the influential Parisians whose commissions he needed. In their eyes, there was an abundance of home-grown French portraitists, like Carolus-Duran, who were more deserving of their money. Sargent's good reviews at Salons and his highly visible portraits of figures such as Dr. Pozzi had helped establish his reputation. But his nationality would remain an issue unless he became truly famous.

## His Masterpiece

Since his Salon debut in 1877, Sargent had demonstrated great range, versatility, and technique. He had been praised by clients and hailed by the press as a rising star. But at this stage of his career, in order to affirm himself as one of Paris's leading portraitists, he had to show more than talent. He needed a big idea.

The end of one Salon always meant another on the way, with a new submission to prepare. In early 1883, as Sargent sought an image that would launch him once and for all, there was one that burned clearly in his mind. Sargent had been thinking about Amélie Gautreau ever since he'd met her while painting Pozzi.

As a fellow upstart American who shared her goal of fame in Paris, Sargent identified with Amélie. He also found her personally bewitching. He was enthralled by her face, her form, her ineffable elegance. Like a teenager, Sargent was subject to crushes on intriguing celebrities of both sexes, and Amélie was the most captivating of all.

Sargent knew that a portrait of a beautiful woman would be most likely to cause a sensation at the upcoming Salon. Carolus-Duran, after all, had established his reputation by showing *The Woman with the Glove,* a depiction of his lovely wife. Sargent speculated that once his portrait of Amélie Gautreau won him recognition, fashionable Parisians would follow in her footsteps, lining up to have their portraits painted by him.

He was also familiar with the *affaire de scandale* that ensued when Édouard Manet's *Olympia,* a portrait of a beautiful woman, was exhibited at the 1865 Salon. This controversial painting depicted a reclining nude with extremely white skin, attended by a black maid carrying a bouquet of flowers. Salon-goers were accustomed to nudes in art, of course; paintings of classical and historical scenes often featured naked bodies. But Olympia was not a figure from the past. She was a modern-day courtesan, a woman nineteenth-century Parisians would recognize as a contemporary.

The public went wild when *Olympia* was unveiled. Courtesans were a fact of life, but the French balked at seeing one displayed in a painting at the Salon. Critics were so hostile that Manet complained, "They are raining insults on me." Salon audiences were so angry and offended that guards had to be posted

to control them. For better or worse, *Olympia* was the one paint-
ing people spoke of that year.

At this pivotal point in his career, Sargent saw a risky yet po-
tentially rewarding course of action. Manet's reputation not only
had survived *Olympia,* but seemingly was enhanced by the con-
troversy as time passed. And unlike Olympia, Amélie Gautreau
was not a courtesan. She was a respectable, if somewhat adven-
turous, married woman whom Sargent would use to draw atten-
tion to his work; he would open viewers' eyes to a new kind of
beauty, depicted in a new and challenging way. He would give his
viewers a taste of what Henry James described in *Harper's New
Monthly Magazine* as "uncanny spectacle," extreme reality served
up with extreme style.

It was a clever idea, and Sargent mounted a campaign to win
Amélie's permission to paint her portrait. Pozzi could be counted
on for a recommendation. He was highly pleased with Sargent's
portrait of him, and his opinion would mean something to
Amélie. Sargent's friend Ben del Castillo was also close to Amélie,
having known her since childhood. Sargent pleaded for Ben's
help, in playful words that conveyed his nonetheless serious re-
quest: "I have a great desire to paint her portrait and have reason
to think she would allow it and is waiting for someone to propose
this homage to her beauty. If you are 'bien avec elle' and will
see her in Paris you might tell her I am a man of prodigious
talent." Sargent's choice of words is revealing: he says "man,"
not "artist," and "desire," rather than the less suggestive "wish"
or "hope."

Sargent even asked his friend Madame Allouard-Jouan, who

owned a house in Brittany not far from the Gautreau estate and who was friendly with the Gautreaus, to put in a good word for him. Madame Allouard-Jouan, a translator and novelist, was probably a friend of Judith Gautier's as well. She had posed for Sargent earlier in 1882; her portrait shows a stylish woman in a black dress and a fetching feathered hat. Madame Allouard-Jouan and Sargent maintained a lively correspondence for years, and in one of his letters the artist alluded to his persistent attempts to win Amélie's favor.

Miraculously, Sargent's campaign worked. Amélie said yes, and in February 1883 agreed to sit for her portrait. Sargent, feeling confident, prosperous, and optimistic about his future, moved to a larger, more expensive studio on the Boulevard Berthier, a short distance from Amélie's home on the Rue Jouffroy. A number of artists had traded their cramped quarters on the Left Bank for more comfortable spaces in buildings that offered bigger windows and unobstructed light. Sargent's new studio was also close to the Parc Monceau, in a neighborhood preferred by people with new money, the very people he hoped would soon be commissioning portraits from him. The painter Jacques-Émile Blanche, a contemporary of Sargent's, made fun of his new status, saying, "Whether he liked it or not, Sargent was an artist of the Plaine Monceau"—meaning that he had become a member of the establishment.

Sargent's excitement carried him through the planning stages of Amélie's portrait. He wrote to Vernon Lee, asking, "Do you object to people who are 'fardées' to the extent of being a uniform lavender or blotting-paper colour all over? If so you would not

care for my sitter; but she has the most beautiful lines, and if the lavender or chlorate of potash-lozenge colour be pretty in itself I should be more than pleased." Calling a woman a "fardée" implied that she was no stranger to makeup; here, Sargent made it clear that he was not put off by Amélie's famous artificial skin tone. In fact, he was looking forward to exploring it with his paints.

After studying Amélie's lovely form and going through her wardrobe, he decided she should wear her sleekest and most revealing gown, a black dress. Black, to Sargent, was a way of setting off his subjects' features. He always exercised control over the wardrobe in his paintings, and would carry trunks of costumes and accessories whenever and wherever he traveled, so he would have the perfect garments and props at hand for his subjects. In Amélie's case, Sargent had access to dozens of her dresses. He picked the gown that stood apart from the rest, the one he believed would capture Amélie's essence and demonstrate his own virtuosity. It was the epitome of chic, with more style than the bird-cage designs of the period.

The dress's designer was Félix Poussineau, who went by one name only, Félix, and who had begun his career as a hairdresser. He opened his own *maison* on the exclusive Rue de Faubourg Saint-Honoré and became one of the grand couturiers of the day. His sleek and elegant label displayed his name in yellow letters on a black satin background. Charles Worth may have been more well known, but while his designs were fussy and sometimes upholstered concoctions, Félix's fit closer to the body and were less showy, and thus more appealing to some women. His simple, often neoclassical, style was perfect for a flawless figure like Amélie's.

Black was an unusual color for Amélie. Contemporary news-papers regularly described her various gowns and always spoke of white or pastels. Yet black was an interesting choice at the time. On the one hand, it was worn by domestics, shopgirls, and businessmen to signal their decency. On the other, anyone who wanted to look theatrical, distinguished, romantic in the Byronic sense, or even erotic, donned black in the evening.

James Whistler had recently painted Lady Meux, formerly the barmaid Valerie Susie Langdon, who married Harry Meux, scion of a wealthy and exceedingly snobbish English brewing family. The marriage caused a scandal, with Lady Meux cast in the role of calculating seducer. In Whistler's portrait *Arrangement in Black No. 5: Lady Meux,* exhibited at the Paris Salon of 1882, she wears a revealing black evening gown. According to the art historian Anne Hollander, at the end of the nineteenth century, black was coming to be seen as a sign of dangerous sex-uality, and Whistler's painting underscored that point.

In dressing Amélie in black, Sargent may have been moti-vated in part by the idea that a black dress would make for an ar-resting image, as in the portrait of Louise Burckhardt. But Louise's unsophisticated frock, which eradicated her sexuality, contrasted entirely with Amélie's alluring gown. Louise appeared sober and respectable, like a clerk or even a nun, while Amélie radiated sex-uality, her dress emphasizing the more provocative parts of her body. It's possible that Sargent wanted to create a deliberate ambiguity—to make Amélie look decent and indecent at the same time.

With his sitter outfitted, Sargent could start his preliminary sketches. Amélie, however, was impatient and easily distracted by her innumerable social obligations. Young, willful, and spoiled, she liked to win and hold the spotlight, and she did not like anything that could be construed as work. She simply couldn't sit still. The responsibilities of the winter social season—dinner parties, concerts, balls—were too exacting for her to set aside time for sittings, and so after breaking innumerable appointments with Sargent, she suggested he come to the Gautreau estate in Brittany, during the quieter summer months. The invitation was a graceful way of postponing her portrait.

Sargent accepted; he did not want a minor setback to cloud his enthusiasm. Time was not an issue, as he had decided that *The Daughters of Edward Darley Boit,* an intensely psychological group portrait of four girls he had painted for an expatriate Boston family, would be his 1883 Salon entry.

After the June races at Longchamps and the official end of the social season, Sargent took the train to St.-Malo—a trip he had made many times in the past. Set among green hills of the Breton coast, Les Chênes seemed ideal for an artist's summer retreat. The majestic walled estate was famous for its magnificent grounds, with garden, graceful brook, and row upon row of oak trees. Numerous windows and glassed doors invited light and air into every room of the four-story château. Sargent had his choice of several locations for his studio, including the airy *grand* and *petit salons,* perfumed with the Spanish jasmine of the garden.

He was somewhat nervous about the weeks ahead because

Amélie was so unpredictable. But, as he wrote to Madame Allouard-Jouan, he was finding his time at the château much more enjoyable than he had imagined. Amélie appeared to be cooperating with his requests. The days were pleasantly hot, and the nights, when the Gautreaus' guests, including Marie Virginie, would spend hours in the Delft-blue tapestried dining room, were balmy.

In his initial pencil and oil sketches and watercolors of Amélie, Sargent seems consumed by her form, her face, and especially her profile. He drew her some thirty times, sitting, standing, and even with her back to him. In one sketch she pretends to read a book that sits so precariously on her lap it might be falling. In another, she slumps on a couch, looking like a bored and impatient teenager wearing her mother's clothes, without any pretense of maturity or hauteur. In yet another, she stands with her back to Sargent, the folds of her gown falling gracefully from her waist. Sargent considered positions that made no sense at all, including one that obscured Amélie's face, as he tried to find the perfect pose for his canvas. Perhaps he was taking an unusually long time preparing for Amélie's portrait because he didn't want his sessions with her to end.

Even as he was struggling, Sargent was clearly captivated by Amélie's image. In all his preparatory works, he used soft pastel colors that made his subject appear dreamy and romantic. One night, as if to escape the pressure of determining the elusive Salon pose, he dashed off a small oil painting of Amélie at dinner. *Madame Gautreau Drinking a Toast* shows a beautiful and sensual woman reaching out teasingly to toast an unseen dinner

John Singer Sargent, *Madame Gautreau (Madame X)*, 1883

Exhausted by the hours she spent posing for Sargent, Amélie collapsed on a couch, looking younger than her twenty-four years. Restless, impatient, and easily bored, she proved a difficult and often exasperating subject. *(Courtesy Fogg Art Museum, Harvard University Art Museums, Bequest of Grenville L. Winthrop. Photograph by Photographic Services. Image copyright © President and Fellows of Harvard College)*

partner, perhaps Sargent himself. The artist who painted this picture saw an uncomplicated inner beauty in Amélie and had no trouble fixing it on his canvas.

Here, Amélie's flesh is warm and soft. She wears her low-cut black gown under a frothy pink shawl, and her décolletage is charming and seductive, as is the Avegno profile. Sargent was in-

toxicated by the splendor of the setting and the allure of his host-
ess. He generously inscribed the painting for Amélie's ever-present
mother: *"Témoignage d'amitié,"* a testimony to friendship.

As soon as the novelty of posing in a bucolic setting wore off,
Sargent learned his subject was just as much of a handful in the
country as she had been in the city. Amélie was impatient with
the interminable, boring process, the frequent sessions of en-
forced stillness. She had difficulty paying attention to Sargent's
directions, and the household was chaotic, overrun by four-year-
old Louise, by Marie Virginie Avegno, by assorted houseguests,
not to mention the full staff of servants, coachmen, and gardeners.
Then there was the rigorous social calendar—parties at the local
casino; reunions with friends from Paris; horse races, theatrical
productions, and other entertainments; and of course, visits to
the beach and boardwalk.

In addition, Pedro was running for local office that summer
and was spending more time at home because of a falling-out
with his rich and powerful uncle, Charles La Chambre. Pedro
and his brother had been employed by La Chambre as agents in
his guano-importing business. The older man unexpectedly sold
the company, and he may have divided the profits unequally and
thus propelled the families into a full-fledged feud. Pedro shifted
his attention to local government and to domestic matters at the
château.

His efforts to insinuate himself into the government of
Châteauneuf-du-Faou, a neighboring municipality, in the sum-
mer of 1883 were not successful. The Breton newspaper *Le*

*Salut* ran a heated editorial outlining residents' complaints against him. Pedro Gautreau didn't know their township and had no understanding of how to represent it, they said; he was using money and influence to force himself into a community that did not want him. Ultimately, Gautreau was rejected in favor of a native politician.

Sargent continued struggling with what he termed "the unpaintable beauty and hopeless laziness of Madame Gautreau." He realized that there would be no routine for—and possibly no results from—the difficult job ahead. He was able to turn out gemlike sketches and studies of Amélie, but he became paralyzed whenever he tried to work on her formal portrait. He was blocked. The most basic decision, even the size of the canvas, eluded him. He waited for inspiration, but it just didn't come.

Sargent tried to maintain his sense of humor, at least when communicating with Albert de Belleroche. "Dear Baby," he wrote, "Despite the ridiculousness of conversing with a child, here I am answering your letter. But please don't write me anymore! Oh no. I am still at Paramé, basking in the sunshine of my beautiful model's countenance. Mme. Gautreau is at the piano and driving all my ideas away." Sargent illustrated the letter with an impish pen-and-ink drawing of Amélie's head peeking over the top of a piano, presumably playing the annoying tune.

Sargent, frustrated and discouraged, needed a change of scenery. Nothing had happened the way he had anticipated when he agreed to paint Amélie at the château. After weeks of false starts, he had run out of ideas for the portrait. Amélie, whom he

hoped would be his muse, was not particularly interested in him or his painting. Her looks, which at first had been inspiring, if challenging, were proving downright difficult. Hoping to clear his head, Sargent returned to Paris in mid-July.

The city was crowded with people who had come for the Bastille Day festivities. Sargent persuaded Belleroche and another artist friend, Paul Helleu, to accompany him to Haarlem to see paintings by Frans Hals; there was a night train from Paris. Sargent had made the trip before and had found it enlightening. Artists often traveled such distances to see works they had read about; these trips were an important part of their education. In Sargent's case, travel was a natural and necessary part of his life, just as it had been in his childhood. His letters repeatedly refer to trips he had taken or trips he was planning.

Night trains, with their fully appointed dining rooms and sleeping cars, offered a romantic form of transportation. Belleroche sketched Sargent while he was sleeping in his berth, producing an intensely personal vision of the artist at his most vulnerable and exposed.

Although Sargent had been consumed by Amélie's image and personality for the past few months, Belleroche had never really left his mind. There is a small Sargent pen and ink drawing of a head that for years had been thought a sketch for *Madame Gautreau Drinking a Toast*. The head is turned at the same angle as Amélie's in the painting. One image fits perfectly over the other. But a recent theory holds that the head in the sketch belongs to Albert de Belleroche. Sargent had started to draw Amélie, as faint marks on the paper indicate, but he transformed her into

John Singer Sargent, *Madame Gautreau Drinking a Toast*, 1883

Sargent's drawing at right has been thought a preparatory sketch for *Madame Gautreau Drinking a Toast*. But Richard Ormond and Elaine Kilmurray propose that Sargent turned Amélie into Albert de Belle-roche, merging both objects of desire, woman and man, into a single image. While Sargent was sketching and painting Amélie, he was also thinking of Belle-roche. (Madame Gautreau: [P2w41]. © *Isabella Stewart Gardner Mu-seum, Boston.* Head in Profile: *Yale University Art Gallery, New Haven, Connecticut, Gift of Miss Emily Sargent and Mrs. Francis Ormond [through Thomas A. Fox], February 18, 1931)*

John Singer Sargent,
*Head in Profile of a Young Man,* c. 1883

Belleroche, shortening the ears and nose and adding more masculine touches.

Sargent was in fact thinking about Belleroche when he was painting Amélie. With a few quick pencil marks, he merged one obsession with another. True, there was a distinct physical resemblance between Amélie and Belleroche, at least in the way Sargent sketched and painted them. Both subjects had fine, albeit exaggerated features, and looked dreamy and enigmatic in their poses. This provocative theory suggests Sargent's emotional confusion in the summer of 1883. His blending of the two images was not just a drawing exercise. As the art historian Dorothy Moss puts it, Sargent saw a "woman in a man and a man in a woman." He drew Amélie and Belleroche over and over, using his art to express his obsession with the two people he desired most.

If Sargent was torn between desires, the excursion to Haarlem pushed him in Belleroche's direction. By the time he left his friend in Paris and returned to Amélie in Les Chênes, Sargent's feelings for her had changed. His romantic haze lifted and his artistic block disappeared. Sargent was back in control: he knew exactly how to paint her portrait, and he was ready to begin.

# The
# Flying Dutchman

S argent would now make up for lost time. He decided on a full-length portrait of Amélie, 82⅛ by 43¼ inches, since a smaller painting would get lost in the thousands of entries that decorated the Salon walls. An oversized work had a better chance of being seen, and accordingly, some of Sargent's recent Salon works had been enormous. *The Daughters of Edward Darley Boit* was 87⅜ by 87⅝ inches, and *El Jaleo* 94½ by 137—impossible to miss. Sargent wanted the same visibility for his latest work.

Amélie's position in the painting would be dramatically different from that in any of the preliminary sketches, where she had sat prettily on a couch or stood decorously at a window. In-

stead, he condemned Amélie, who hated remaining motionless, to one of the most tortuous poses in art history. He had her stand with her right arm leaning tensely on a table that was just a little too short to be a comfortable source of support. Her face turned sideways to draw attention to her remarkable profile, while her body pointed to the front. The muscles of her neck strained to keep her head at its awkward angle.

Sargent's plain-weave canvas was primed probably with gray oil-based paint, as were most of his portraits at the time. This particular shade of gray was made by mixing ivory black and lead white in linseed oil; the combination gave a coolness to the painting even after colors were applied over it. Sargent was generous with his paint, and he kept his palette heavy with pigments he combined with various mediums. Whites and other pale colors were mixed with poppy-seed oil because it did not yellow as quickly as linseed oil, which was reserved for darker colors.

Sargent planned to surround Amélie's figure with a dark, simple background, as he had done in *Mrs. Harry Vane Milbank* and *Madame Gautreau Drinking a Toast*. It was difficult, however, to find a background color that complimented Amélie's pale skin. Sargent settled on a mixture of ivory black, Mars brown, and a generous quantity of medium. He knew that this combination would produce a background resembling the brown in the works of Van Dyck and other masters.

Amélie's unusual pallor presented other technical challenges; his work would be judged in large part on how well he rendered her skin. Sargent wanted to paint Amélie's white flesh realistically, but in some lights it was mother-of-pearl while in others it

was a sickly lavender. Candlelight, though it softened the effect of her makeup, was too dim. Sargent needed strong light, yet he feared it might be unflattering. He tried his usual approach to flesh tones, using lead white, vermilion, bone black, rose madder, and even viridian green. Against the dark background of the painting, Amélie's skin looked macabre, corpselike, and her red-tipped ears inflamed.

Sargent fussed and fussed with his paints for a solution, as Amélie struggled to maintain her pose during endless sessions. One day, the jeweled strap of her dress slid off her tense shoulder. She may have tried to shrug it back into place. But Sargent, a genius at identifying the gesture or signal that revealed his subject's essence, assured Amélie that it was exactly what the portrait needed to distinguish it from other paintings of beautiful women in evening dress. Pozzi's fingers at his belt exposed the eager womanizer within, while his hand at his heart said he worshipped beauty. Similarly, Amélie's fallen strap, which called attention to the exquisite shoulder above, was enticing. Her profile, and her eyes averted into the distance, said she was unattainable. What did she think of Sargent's daring idea? Was she worried that people would find the painting risqué? After all, she must have known of the *Olympia* scandal. Even though Amélie wanted to be outrageous, there was a fine line between fame and notoriety, and no one, not even she, would have wanted to cross it.

From Amélie's own words, though, it is apparent that she felt nothing but admiration for her portrait. In a note she asked Sargent to include with a letter to their friend Madame Allouard-Jouan, Amélie wrote: "*Mr. Sargent a fait un chef d'oeuvre du*

*portrait, je tiens à vous l'écrire car je suis sûre qu'il ne vous le dira pas."* Sargent, she believed, had created a masterpiece. She was anxious to tell her friend this, as she was sure Sargent himself would not tell her. Even in its unfinished state, Amélie loved her portrait. Sargent's approach was bold, even risky, she knew. But her own calculated risks had served her well in the past.

Sargent now had a firm grasp of the overall look of the portrait, though he was still working on certain problems, such as the color of Amélie's skin. He found a pleasant distraction in the arrival of Judith Gautier, who was vacationing in nearby St.-Énogat. Gautier was also an acquaintance of Amélie's: the two women would have had many social occasions to meet, in Paris and in Brittany. One connection between them was through Pozzi. Sargent sketched the two women at Les Chênes, standing very close together with their arms around each other's shoulders while they communicated some secret message—perhaps about Pozzi. Sargent titled the drawing *Whispers.*

When Sargent visited Gautier at her beach house, Le Pré des Oiseaux (the field of birds), he encountered an environment quite different from the propriety of Les Chênes. Gautier's house, a compact villa separated from the beach by a balustraded stone staircase, exploded with her personality. Every corner was packed with souvenirs from Gautier's travels and memorabilia of her many friendships.

Dominating one wall in her living room was a stained-glass window designed for her illustrious father. The front rooms, including the living room, overlooked the beach, while a sun porch at the back of the house offered a lovely view of the gardens. At the

John Singer Sargent, *Whispers*, 1883–1884

The distinctive nose of the woman on the left and the hairline of the woman on the right suggest that they are, respectively, Amélie Gautreau and Judith Gautier. The drawing shows them sharing a private moment, perhaps at Les Chênes when Amélie was posing for *Madame X*. *(Charcoal and graphite on off-white laid paper, 13 9/16 x 9 11/16 inches, 34.4 x 24.7 cm. The Metropolitan Museum of Art, Gift of Mrs. Francis Ormond, 1950 [50.130.117]. All rights reserved, The Metropolitan Museum of Art)*

edge of the property was a small wooden pavilion that enchanted and amused many of Gautier's visitors. Robert de Montesquiou called it a "cigar box." Yamamoto, an artist visiting from Japan, had covered the interior walls of the pavilion with delicate painted blossoms. Le Pré des Oiseaux was a place where fancy ran free.

Even the story of how Gautier got the house was filled with fancy. Her publisher, Albert Lacroix, apparently had committed the unforgivable sin of losing one of her manuscripts. By way of apology, he invited her to stay at his house in St.-Énogat. Gautier had such a good time there that she impulsively signed her name to a list of people interested in buying property in the area. She never gave the matter another thought until, sometime later, she was informed that the foundation of a house had been laid on the property and that she was expected to foot the bill. Le Pré des Oiseaux became her home for a good part of her life, and she never regretted the expenditure.

In 1883, Gautier was thirty-eight to Sargent's twenty-seven, and he found the age difference alluring. She had an exotic presence, with a round, full figure and darkly expressive eyes. She wore her hair in a loose bun and dressed in Oriental robes made of sensuous fabrics. She was a worldly and experienced "woman of a certain age," described by one critic as a "nun of art," a woman who lived for art and artists. As she had done many times previously when in the company of an artistic man, Gautier focused her attention on Sargent and made him believe that he was every bit as interesting as those who had come before him.

An ardent Wagnerite, Sargent was elated to be in the company of a woman who had been so close to his idol. An inescapable suggestion of transference was at work here: for Sargent, Gautier was an almost physical connection to Wagner, as the woman who was one of Wagner's major obsessions became *his* woman when they were alone together.

To judge from the number of times Sargent sketched and

painted Gautier during her stay in St.-Énogat, they were alone together frequently. Charles Mount, a lively if not entirely dependable Sargent biographer, has suggested a convincing, but unprovable, reason for Sargent's visits: namely, that Sargent and Gautier had a love affair that summer. Mount describes Sargent's trips to Le Pré des Oiseaux like scenes from a farce, the artist running out the back door of the château at Les Chênes whenever he had a free moment and racing over the hill to Gautier's house for a few moments alone with her.

This could hardly have been the case. St.-Énogat is several miles from the walled city of St.-Malo (which is itself a distance from Paramé and Les Chênes), and would have been a time-consuming trip by horse or by boat in 1883. Whenever Sargent arrived at Le Pré des Oiseaux, he expected to stay for a visit. Now that he was working more decisively on Amélie's portrait, he had the time to do so. He was known to paint rapidly when inspiration struck, and he made efficient use of the moments Amélie stole from her busy August calendar.

Sargent had, according to Mount, approached Gautier about posing for him, using the same line that had worked so well with Amélie: he was an "ardent admirer of her beauty." Like Amélie, Gautier had refused other painters and also hated to sit still. Yet she made an exception for Sargent: his unusual talent, his combination of classicism and originality, would make her look distinctive.

Sargent's most romanticized rendering of Gautier is *A Gust of Wind,* likely his first painting of her. In signature kimono, she stands at the top of the stairs leading from her house to the beach. She looks young, slender, and beautiful, a fresh flower on

the bright landscape. But Gautier was not young, she was far from slender, and her beauty was definitely in the eye of the beholder. As in *Madame Gautreau Drinking a Toast,* Sargent, a man infatuated, captured the essence of Gautier's appeal in his painting: her power to seduce. Whatever fascinated Pozzi, Wagner, Victor Hugo, and other admirers was depicted on Sargent's canvas. It was Judith Gautier idealized.

Gautier was for Sargent a fascinating alternative to Amélie. While Amélie was slim, Gautier was overweight. Amélie was a young woman with more attitude than experience, while Gautier had years of both. Gautier's mature exoticism contrasted with Amélie's petulant sexuality. Amélie, the "professional beauty," was her own self-packaged work of art, while Gautier's beauty was rooted in her character.

Sargent enjoyed the time he spent with Gautier, playing chess, discussing music and art, and painting and drawing her. Legend has it that one day, when he did not have a canvas large enough to accommodate the full-length portrait of her that he insisted on starting that very minute, Sargent tore up a kitchen table. He is not usually perceived as the kind of man who would chop up the furniture rather than delay the creative process. But this was his "summer of love," perhaps the first and last time in his life when he allowed passion and impulse to rule his actions.

As had happened with Amélie, Sargent's ardor for Gautier cooled. He replaced his idealistic visions of her with more realistic representations. A later painting shows a full-figured Gautier at her piano, no longer girlish and alluring, but bearing the weight of maturity. He began to think of his visits to St.-Énogat as tire-

some obligations: in a letter to Madame Allouard-Jouan, Sargent complained of having to stay there when he would rather be on his way to Florence, but acknowledged that he would be thought a "brute" if he left.

As autumn approached, Sargent sought to free himself from romantic entanglements, real and imagined, and return to a more focused and structured life. "The summer is definitely over and with it, I admit it, is my pleasure at being at Les Chênes," he confessed to Madame Allouard-Jouan. He had spent too many weeks there, drifting from one romantic obsession to another. It was as if he were on a quest, casting himself quite consciously in the role of Wagner's Flying Dutchman, the mythic seaman who sailed from port to port on an eternal search for the one true love who might release him from his curse of loneliness.

Like the Dutchman, Sargent was nomadic, rootless, and alone. But he was beginning to think he might be better off that way. The past months had shown him that his infatuations came and went quickly, often ending in frustration. A more successful artist than lover, he could capture his subjects on canvas much more readily than in life.

Sargent turned his attention to more practical concerns. He had completed enough of Amélie's portrait to be able to work without a model. Sargent didn't need her anymore. It was time for him to roll up his canvas—his usual method for transporting unfinished paintings—pack up his paints, and return to his studio in Paris.

# *Finishing Touches*

In October 1883, with Les Chênes closed for the year, Amélie embarked on the new social season in Paris, and Sargent came home to utter chaos. After sharing lofts with other artists, he was unaccustomed to overseeing a studio the size of his establishment on the Boulevard Berthier. It was an expensive proposition for an artist with an uncertain income: in addition to rent and bills for art supplies, Sargent had to pay his servants, a cook and an Italian "majordomo," whom he had hired in the spring, when he felt optimistic about his future. His staff proved troublesome—the manservant drank and made the cook cry. Their antics were distracting, and the new expenses amounted to more

money than his income, which was not coming in as rapidly as he had hoped.

Sargent's first task, after firing the manservant and straightening out other affairs, was to complete the portrait of Madame Gautreau for its March deadline. He had painted and scraped the canvas so many times that the painting's surface was now cracked and uneven. Amélie's right arm, the one leaning awkwardly on the table, had required a great deal of work before it satisfied him. Worried that the mistakes would make the canvas look too rough, he decided to paint a copy. With a clean canvas beside the original, Sargent tried to produce a perfect replica.

Even as he copied the portrait, Sargent did not lose sight of the future he hoped to create for himself. He had taken a commission to paint Mrs. Henry White, the wife of an American diplomat. Margaret White, "Daisy" to her friends, was a handsome woman, and would appear regal and imposing on Sargent's canvas. She frequented diplomatic circles and was well connected in Paris and in London. The commission had arrived in the standard way, the husband coming to Sargent and arranging a proper fee—none of this campaigning to paint people, as with Pozzi and Amélie, or painting people for the Salon, as with Carolus-Duran and Louise Burckhardt.

Sargent's portraits of Amélie and Mrs. White both featured socially prominent women, but there the similarity ended. Amélie's revealing dress and fallen shoulder strap, the costume of a femme fatale, seduced and provoked. Mrs. White's luminous white silk gown, by contrast, was almost bridal in its innocence. She radiated respectability and affluence. Presenting her as an

emblem of the Gilded Age, Sargent aimed to demonstrate his skill and versatility to potential clients, to prove that he could paint the wealthy matron as artfully as he could the siren. If both paintings attracted as much attention as he hoped, he would have more commissions than he could handle.

Sargent completed his painting of Mrs. White and sent it to her in London. In the early months of 1884, he raced through the final stages of the copy of Amélie's portrait. Before he could finish the bottom of her gown, paint in the table, and add the fallen strap, he suffered an attack of insecurity. Was it eye-catching? Was it as bewitching as its subject? Would it succeed as his "big idea" Salon entry?

Sargent wondered whether he should further refine the copy or return to the original. He invited Carolus-Duran to give a candid assessment of his work-in-progress. His former teacher, Sargent believed, would be an informative, impartial, and trustworthy judge. He knew Sargent's capabilities, strengths, and weaknesses better than anyone, and he was an expert in portraiture. As well, Carolus-Duran had strong relationships with the artists who controlled the Salon. He knew the intricacies of its politics and was keenly aware of the judges' likes and dislikes.

Upon viewing the painting, Carolus-Duran quickly dispelled Sargent's fears. He advised him to send his finished portrait of Madame Gautreau to the Salon with confidence, assuring him that it would be well received.

Sargent was happy about this encouragement, and he never questioned Carolus-Duran's honesty or wondered whether he had his own motives for being so encouraging. As one of Paris's

most successful artists, teachers, and arbiters of public taste, Carolus-Duran must have sensed that Sargent's unusual painting would be controversial. If he didn't say as much, it may have been that he was conveniently struck dumb by his own ambition. He and Sargent had worked together for almost ten years, yet it would not have been in his best interests to foster his former pupil's success. Sargent was shaping up to be the older artist's competitor for publicity and commissions; with every stroke of his brush, pupil threatened to overtake teacher. Perhaps if Sargent experienced a professional setback, he would be a less formidable rival.

By February, Sargent had resolved to abandon the copy of the portrait; after Carolus-Duran's praise, he felt confident about submitting the original. He left the copy unfinished: the shoulder that might have had a fallen strap was bare. While he was readying the original and contemplating his still-uncertain future, Sargent met Henry James. The forty-year-old American novelist and journalist, who lived in London and was in Paris on a visit, was well known for his travel pieces and coverage of the international art world.

James was also well known for being a terrible snob. His clique was especially small and select—he had high intellectual standards and ignored those who failed to meet them. Although he rarely responded enthusiastically to a stranger, he was very impressed by the twenty-eight-year-old Sargent. "The only Franco-American product of importance here strikes me as young John Sargent the painter, who has high talent, a charming nature, artistic and personal, and is civilized to his finger-tips," James wrote

to a friend. "I like him so much that (a rare thing for me) I don't attempt too much to judge him." Though James had lukewarm feelings about Amélie's portrait when he saw it in Sargent's studio—he only "half-liked it," he confided to a friend—he was convinced that Sargent was enormously talented, and wanted to add him to his exclusive list of friends. James saw Sargent as one of his characters come to life, the quintessential American expatriate, a young man blessed with the spirit and energy of the New World and the polish and refinement of the Old.

Inspired by Sargent, James wrote a story entitled "The Pupil." It suggested dark realities at play in the artist's early life. The central character, a precocious boy with an artistic nature, was at the mercy of his selfish, shallow, and chronically irresponsible parents, whose inattention ultimately led to his death. James implied that young Sargent (and probably James himself, who had experienced a similarly nomadic childhood) suffered from the chaos, unpredictability, and insecurity that his family had imposed upon him for nearly twenty years.

Several critics have suggested that Sargent painted the way that James wrote, portraying the same gilded world with penetrating vision. Both men were intensely observant, but just as guarded. They used their art to express their emotions, while keeping the details of their personal lives, and especially their sexual orientation, extremely private. They left no clues regarding the true nature of their relationship with each other: was it physical, or merely a common infatuation between artists and intellectuals of the same sex?

Regardless of their geographic separation, James pursued

Sargent relentlessly. He insisted on being host, guide, and constant companion for Sargent on his upcoming trip to London to see his sister Emily. For the first time in his life, Sargent, unused to being the object of obsession rather than the obsessor, was cast in the role of the "brilliant creature." Stanley Olson described James as having been mesmerized by Sargent, "as one is mesmerized by an exotic flower." James's feelings for Sargent seem to have echoed Sargent's infatuations with Pozzi, Amélie, Judith Gautier, and Albert de Belleroche.

Before Sargent could think about his trip to London, he had to attend to the details of Amélie's portrait. Even as he was about to send the picture to the framer, he was making adjustments, as he reported to Ben del Castillo: "One day I was dissatisfied with it and dashed a tone of light rose over the former gloomy background. I turned the picture upside down, retired to the other end of the studio and looked at it under my arm. Vast improvement."

A Salon entry had to look important in its presentation, and Sargent selected an ornate French frame for the portrait. Its multileveled gold surface featured a busy design of overlapping leaves and cross-straps, all complementing the painting without overwhelming it. Back in his studio, Sargent applied a coat of varnish to the framed painting, as was his custom. *Portrait de Mme \*\*\**, as *Madame X* was called at the time (a polite gesture to keep a respectable woman's name out of the notices and reviews), was ready for the Salon.

A year had passed since he had commenced his sketches of Amélie. He had lived with her image for so long that he must

John Singer Sargent,
*Self-Portrait,* 1886

John Singer Sargent may have seemed an uncomplicated man, but, as with his paintings, a composed surface masked great complexity. In this self-portrait, painted when he was thirty, he suggested his ambiguities by showing half his face in light, the other half in shadow.

Amélie (left) and Valentine Avegno, c. 1864

This photograph of Amélie and her younger sister was taken in New Orleans during the Civil War. Valentine died of a fever not long afterward.

John Singer Sargent, *Dr. Pozzi at Home,* 1881

In his portrait of Belle Époque Paris's celebrated gynecologist and seducer of women, Sargent envisioned a Renaissance prince. The women in Pozzi's life—and there were a good many, including Sarah Bernhardt—called him "Dr. God" and "Dr. Love."

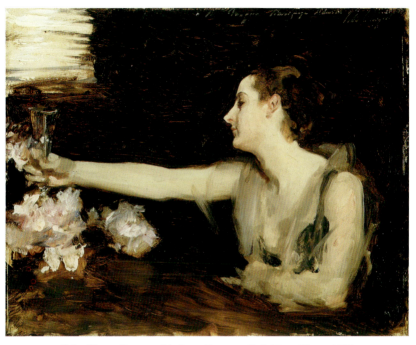

John Singer Sargent, *Madame Gautreau Drinking a Toast,* 1883

The first time Sargent painted Amélie Gautreau, he expressed his infatuation with his beautiful subject in every brushstroke. He romanticized her features in a candlelit setting, to make her appear soft, lovely, and alluring.

John Singer Sargent, *Madame Gautreau (Madame X),* c. 1883

In this watercolor study, Amélie wears the same chic black gown as in the finished portrait, but her pose, seated on a couch with a book, is not the one Sargent ultimately painted. He experimented for months before deciding to place Amélie standing beside a table.

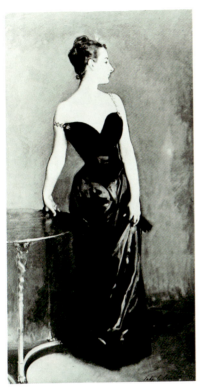

Photograph of
*Madame Gautreau,* 1884

THE METROPOLITAN MUSEUM OF ART,
NEW YORK

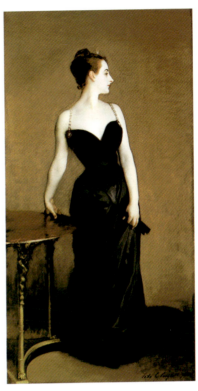

John Singer Sargent, *Madame X
(Madame Pierre Gautreau),* 1883–1884

THE METROPOLITAN MUSEUM OF ART,
NEW YORK

Sargent's painting as it appeared at the 1884 Paris Salon. The sight of Amélie Gautreau's fallen strap created a scandal that left the artist stunned and his subject "bathed in tears."

Once the Salon ended, Sargent repainted *Madame X,* placing the fallen shoulder strap in its proper position. He kept the portrait in his studio for the next three decades, then sold it to the Metropolitan soon after Amélie's death.

John Singer Sargent, *A Gust of Wind,* c. 1883–1885

PRIVATE COLLECTION

Judith Gautier was a bohemian writer and artist who attached herself to some of the most famous men of the day, including Victor Hugo and Richard Wagner. Sargent painted her, and became enamored of her, while he was in Brittany working on *Madame X.*

John Singer Sargent,
*Albert de Belleroche,* c. 1883

Albert de Belleroche was Sargent's
friend, fellow artist, and possible
love interest. Sargent, who affection-
ately called him "Baby Milbank,"
sketched or painted Belleroche in
more than thirty works.

John Singer Sargent, study for
*Carnation, Lily, Lily, Rose,* 1885

After the *Madame X* scandal,
Sargent was uncertain of his future.
*Carnation, Lily, Lily, Rose*—a pastoral
scene that evokes the innocence of
childhood—restored his reputation
and his faith in himself.

Gustave Courtois, *Madame Gautreau,* 1891

Seven years after the *Madame X* scandal, Gustave Courtois paid sly homage to Sargent's controversial portrait by painting Amélie in a white gown with a fallen shoulder strap. This time, the gesture failed to raise so much as an eyebrow.

have felt a combination of reluctance and relief when he sent her painting to the Salon in March. Sargent's previous awards guaranteed that the portrait would be accepted. Yet there was a difference between acceptance and accolade.

Sargent left for London, where he found James to be the perfect host, orchestrating a schedule that kept the two men in constant and furious motion for a week. In an attempt to persuade Sargent to move closer to his home, James introduced him to some of England's most successful artists. He dazzled him with his connections, arranging, for one day, visits to the studios of nine prominent British painters, including Edward Burne-Jones, and the American illustrator Edwin Austin Abbey.

Sargent was particularly fascinated by the members of the Pre-Raphaelite Brotherhood, an art movement founded by Dante Gabriel Rossetti and others. Rossetti was best known for his exotic and imaginative portraits of women, which were of special interest to Sargent. Not only was this trip artistically inspirational, it was economically advantageous. Sargent obtained several commissions for the summer, including a portrait of the three daughters of Colonel Thomas Vickers, an industrialist who made his money in munitions. This was a different sort of client for Sargent, who in Paris had made his name in the world of the rich, beautiful, and brilliant. But there was nothing brilliant or beautiful about the Vickers girls, whom Sargent described as "three ugly young women" who lived in "a dingy hole." Though he was glad for the income this work would provide, it was a step backward from the goal of fame and fortune in Paris, which remained the center of his world.

Sargent returned to Paris in time to attend a reception at the home of Frederic Spitzer, a wealthy Austrian expatriate who was amassing a large art collection and who owned an extraordinary assortment of antique armor. Spitzer, the son of a cemetery caretaker, had built his fortune on a discovery he made at the age of sixteen, when he found a painting by Rembrandt. Aristocrats considered him an unsavory parvenu, his new-money smell strong. More liberal-minded socialites flocked to his parties and enjoyed his generous hospitality.

According to a report in *L'Illustration,* Sargent and Amélie were both in attendance at a party Spitzer staged amid the swords and helmets in his armor gallery. Amélie drew her usual compliments from the press, but the most interesting gossip afterward came from Perdican, who this time connected the two Americans in his weekly column by leaking the news that Sargent's latest Salon submission would be a portrait of La Belle Gautreau. Amélie, he wrote, "would be even more admired at the Salon." There was a buzz around artist and subject: *Madame X,* it appeared, was a hot item even before anyone saw it.

# Dancing
# on a Volcano

At the end of March, Sargent traveled again to London, and again he saw Henry James. While there, he solidified some of the relationships he had established the previous month, spending time with Edwin Austin Abbey and other new friends. He visited artists' studios and attended exhibitions, among them the Grosvenor Gallery show of paintings by Sir Joshua Reynolds, whose portraits of eighteenth-century notables Sargent admired for their strong lighting effects. Still nervous about his own portrait of Amélie Gautreau, Sargent was preoccupied with thoughts of the rapidly approaching Salon.

He returned to Paris on April 29, just as insiders would get

their first look at the exhibition. Sargent went to his club that night, hoping to find a friend to ease his jitters. He ran into Ralph Curtis, his dashing distant cousin who, like him, led the expatriate life in Europe, traveling and studying art.

Sargent and Curtis dined together at Sargent's studio. Even though the portrait of Amélie no longer dominated the room, she still directed their conversation, as Sargent imagined various scenarios for the following morning. The apprehensions he and others in his position might have felt were expressed perfectly in the diary of Marie Bashkirtseff, a young Russian painter who was also exhibiting at the Salon. She spoke for all the nervous artists when she fretted: "To-morrow is varnishing day. . . . What will they say of me? Will it be good, will it be bad, or will they say nothing at all?" Some paintings would be dismissed as unimportant, or worse still, ignored completely.

In all the years Sargent had been exhibiting at the Salon, he had never had a bad experience. His entries had always been singled out for praise and awards. But the thousands of people who in the coming days would be passing judgment on his creation would be mostly Parisians, known for their unpredictable behavior. In 1884, they were especially contradictory.

After the Franco-Prussian War, the French had examined themselves under a magnifying glass and were horrified to find signs of weakness everywhere. The death rate in France was higher than the birth rate. The average height of Frenchmen was decreasing rather than increasing. Farms were underproducing. There were signs of social and cultural deterioration as well. Censorship of the printed word had relaxed, permitting writers

such as Zola and Huysmans to profile the most depraved members of French society, including alcoholics, prostitutes, and hedonists. There was nudity onstage, a brisk market for pornography, and widespread alcoholism, all symptoms of a pervasive decadence. Great thinkers saw parallels between France and the Roman Empire on the eve of its decline, and predicted a similar fall for France.

Religious leaders, concerned about rampant immorality in Paris, conceived a church that would be visible from everywhere in the city. It would remind citizens that God was watching the capital and everyone in it, thus inspiring them to behave. In 1875 work began on Sacré-Coeur, an impressive white basilica located on the hill of Montmartre, overlooking the rest of Paris.

The highly adaptable French didn't stop their wicked ways, however. They merely figured out how to conceal and refine them. The French perfected two kinds of morality: public and private. Married men supported their households financially while maintaining separate residences for their mistresses. Married women fiercely protected their daughters' virtue, chaperoning them at all times, but enjoyed private dalliances with lovers. Restaurants even opened private dining rooms, *restaurants particulières,* for illicit rendezvous, capitalizing on a legal loophole that deemed liaisons not adulterous if they were pursued in a public place.

In 1884, to accompany the city's decaying morals, a stench was permeating the streets of Paris; to some it smelled like burning, while others thought it was more like rot. For months, the source was untraceable. Zola might have invented it as a metaphor, but it was a fact, discussed at length in the newspapers. One

theory, that a volcano was buried beneath the streets, gained credence when a regional newspaper reported that underground workers had discovered evidence of an active, sulfur-spewing volcano near the neighborhood of St.-Denis. But Parisians were indifferent to the news. If there was a volcano under their feet, a Vesuvius that could erupt and bury this modern-day Pompeii at any moment, the best thing to do was dance on it.

Pleasure, decadent or otherwise, was actually a new concept for many in Paris. Life for the lower classes had always been grim and difficult, a constant struggle for survival in a city that was apathetic and even hostile to its poor. The population was stratified into distinct social groups: Day laborers, including domestics and unskilled workers, lived hand-to-mouth, while artisans, clerks, and salespeople enjoyed small but steady incomes. The rich, of course, lived for pleasure and had the money to do so.

The 1880s brought sweeping changes and new prosperity for every economic group. Between 1852 and 1882, men's wages rose about eighty-four percent on the average, and the cost of living fell. In postwar Paris, there was a bit more money for everyone, and a lot more for people who were already wealthy. The elite of the Third Republic were successful businessmen and politicians who celebrated capitalism and upward mobility, and worshipped at the Paris Bourse. The little people too had a better chance of succeeding in the new Paris. They could aspire to becoming middle-class by prudently managing their money and attending to hygiene, nutrition, and education.

Parisians with even limited disposable income could now enjoy public entertainments, the biggest growth industry in the city.

Curiously, when they looked for ways to escape from reality, they often turned to reality-based entertainments. Tabloid newspapers offered *faits divers,* stories about ordinary people in extraordinary situations. Some were victims of crimes, others were criminals. In either case, the newspapers emphasized the juicy details of their stories with sensational copy and bold illustrations, anything to turn banal, everyday life into marketable news. The discovery of an unidentified baby's body in a river would keep a story running for days, as readers clamored for more information—or misinformation—about the incident. In 1869, the crimes of Jean-Baptiste Troppmann, a young mechanic who killed a man, his pregnant wife, and their six children, were reported in *Le Petit Parisien,* which sold as many as 500,000 copies each day the story was covered.

When Parisians wanted to experience the most up-to-date reality-based entertainment, they visited the Musée Grévin, the city's first successful wax museum. The moment the Grévin opened, it was patronized by people from every class. It was located directly across the street from the popular Variétés theater—which also welcomed a socially diverse audience, from customers who purchased private boxes to those who took the cheap seats of the fourth balcony—and was adjacent to the fashionable Passage Jouffroy. The museum building was handsomely designed and appointed, featuring a marble staircase, an ornate chandelier, and velvet curtains. The wax renderings of famous people from past and present were extremely realistic: they had lifelike skin, which was carefully articulated with oil paint, and piercing eyes molded from medical-grade glass. The Grévin was

likewise faithful in its depiction of historical details. The wax figure of the French revolutionary Jean-Paul Marat, for example, was displayed in the actual hip bath where he was assassinated. Visitors had seen nothing like it before.

Called a "true spectacle" by the press, the Grévin packaged and promoted itself as a "living newspaper" and promised to reproduce scenes from the headlines so spectators could experience them firsthand. Tableaux were regularly changed and updated, according to developments in the news, and visitors would return repeatedly for new figures and up-to-the-minute scenes. One of the Grévin's most popular early tableaux was "History of a Crime," which mimicked popular contemporary serial novels with its depiction of a crime from start to finish, complete with the perpetrator's execution.

Yet it wasn't just the subject matter of the tableaux that drew large crowds day after day. It was the way in which they were displayed. They were usually full-scale dioramas, and they took advantage of spectators' basic voyeuristic urges by creating the sensation of spying on real people. The Grévin boasted "reproduction loyal to nature and respect for the truth in the smallest details," essentially offering peepholes into Parisian life. Some of the displays, such as that of a papal procession at the center the main room of the museum, took the experience one step further by inviting spectators to pretend that they were part of the scene.

"Realistic" as the Musée Grévin seemed to the thousands who passed through its doors, its showy and cleverly packaged verisimilitude could not compare with that of the spectacles unfolding daily at the Paris morgue, the other hot ticket in town.

The morgue offered something the Grévin could only simulate: real bodies of victims of real crimes. The morgue's popularity was the most extreme manifestation of the obsession with actuality entertainment.

The concept of looking was even explicit in the name given to the building that temporarily housed the dead. The word *morgue* derives from the Old French, *morguer,* which means "to look at fixedly." The original purpose of having a public place to display corpses was to facilitate identification.

At some time the morgue evolved from a purely functional municipal building to one of the busiest theaters in Paris. Haussmann had razed the old morgue and built a new one on a site more accessible to the public, centrally located behind Notre Dame. Admission was free and the "show" changed daily, depending on the deaths from the night before. On the surrounding streets, vendors hawking fruit and pastries added to the carnival atmosphere. As many as a million visitors would walk through the viewing rooms each year, horrified or thrilled—or both—by what they saw.

The most popular corpses were those of children and the victims of unsolved crimes. Celebrities such as Sarah Bernhardt might visit when a body generated considerable publicity, as did that of the four-year-old "Enfant de la Rue Vert Bois," whose body had been found in a stairwell. Crowds gathered at the morgue, intrigued by the mystery of the dead child, but she was forgotten as soon as the next corpse with a sensational story came along, extensively reported and graphically depicted in the papers.

While Parisians welcomed reality in their everyday entertain-

ments, they were not as enthusiastic about realistic art. One of the leading objections to Impressionism was that its practitioners simply painted what they saw in life, when they should follow academic principles, embellishing on nature and developing classical themes. Serious art was never to be confused with photography. A painting, be it a portrait, landscape, or historical scene, was to enhance, ennoble, and illuminate its subject. It was not meant to mirror, or in some way expose, reality.

The Paris Salon supported this aesthetic. The jury selected paintings that upheld the conservative traditions and standards of the academy and that gave French viewers what they supposedly wanted to see. The jury's choices always included rousing scenes from history, pretty pastorals, classical nudes, and flattering portraits. Portraiture, notably, was not held in high esteem at the academy: it was not taught in the classroom and therefore not taken seriously. Artists were expected to learn how to paint a portrait on their own, or in a private atelier.

The jury would have preferred to ignore portraits at the Salon, but the paintings were so popular with the public that the judges had to accept them. Salon-goers were opinionated about portraits because they were commonly displayed or reproduced, in drawing rooms, in museums, and in the newspapers, which ran full-page engravings of the most popular, and the most controversial, Salon portraits every year.

On this particular Varnishing Day, the weather was clear and beautiful. "It would be difficult to dream of a temperature more spring-like or a sky more filled with sun," *L'Événement* reported. "The trees themselves appeared to celebrate with their spring

verdure." The chestnut trees that lined the streets leading to the Palais de l'Industrie were in bloom, their pastel colors providing a soft canopy for the socialites outside the immense building. Horse-drawn carriages jammed the streets as one beautiful woman after another arrived. Attendees wore their finest, their outfits commissioned from couturiers months in advance because, it was known, reporters would be recording every detail.

Ralph Curtis, Sargent's companion the previous night, was one of the early arrivals. He was in good spirits: *Le Gaulois* had published a favorable review of Sargent's painting in its Varnishing Day supplement. The critic Louis de Fourcaud called *Madame X* "remarkable" and said that it was "of rare distinction and interest." Hoping that Sargent's late-night insecurities had been unfounded, Curtis mingled with the crowd on the street. Celebrities, society women, art critics, and flâneurs—boulevardiers alert to the ever-changing spectacle of Paris—ascended the grand staircase.

Amélie was there, as she was every year. That morning, she had dressed mindful of her reputation as reigning beauty and certain that this year she would get even more attention than ever. Unlike Sargent, she was confident about her portrait. She anticipated that it would draw the envious congratulations of her friends and the praise of columnists and critics. Sargent's success would be her success; this would be their shared moment of triumph, when Paris would formally acknowledge his talent and her beauty.

Inside the Palais, socialites and tourists, art dealers and potential buyers breathed the bitterness of varnish and turpentine

as they sidestepped ladders and supplies. Artists meanwhile sought to finish their varnishing in the midst of the crowds.

Dust was everywhere, and despite the pleasant temperature outside, the rooms in the Palais quickly overheated. A few tightly corseted women might faint from the heat. Necks would be stretching in every direction as viewers moved from one room to another, craning to see pictures hung at every level from floor to ceiling.

The most visible works either were very large, or were hung "on the line," at eye level, the position reserved for the best entries. Veteran Salon-goers knew that it was impossible to see everything on exhibit—there were thousands of works—and critics and buyers would consult their Salon catalogues for the most promising submissions, and note their reactions to them. Like other attendees, they would be on the lookout for the significant paintings, those that would be praised, discussed, debated, or vilified in impassioned conversations for weeks. The Salon would run its course, but it was in the first hour, or even half-hour, of Varnishing Day that reputations would be established or destroyed.

Thirty-one *salles,* or rooms, were dedicated to painting at the 1884 Salon, and more were designated for pastels, prints, sculpture, and architecture. Works were grouped alphabetically by artist, although an oversized painting might end up in a room reserved for larger works. As viewers moved from room to room, they stopped before the latest works by their favorite artists, the successful men who held powerful positions at the Académie des Beaux-Arts. In Salle 4, they found two paintings by Jean-Léon Gérôme. The more spectacular one, *Slave Market in Rome,* was a

historical scene depicting an ancient slave market. At the center was a beautiful nude woman who covered her face in a gesture of modesty. In his annotations to the Salon catalogue, an American visitor described the nude as "unpleasant." He was even less impressed by Gérôme's other entry, *Night in the Desert,* which he criticized for its "strange, disagreeable light."

Salle 8 featured two works by Jean-Jacques Henner, famous for his captivating red-haired, cream-skinned nudes. *Crying Nymph* showed a female figure who, like the slave in Gérôme's painting, hid her face in her hands. Henner's other entry, *Christ in the Tomb,* dramatically depicted Christ's semi-naked body.

Portraits were the big draw in Salle 11. Carolus-Duran's *Portrait of His Excellency M.Z.* attracted attention because of the painter's former successes, but this was not one of his best works. The real sensations in the room were by the French artist Charles Chaplin. His two portraits of society women were quite similar. Both women wore white low-cut gowns trimmed with feathers. One had the added touch of a silk bow around her neck. Their vacant expressions and familiar poses made the women appear bland and uninteresting, like airbrushed centerfolds. Critics were nonetheless charmed, and they crowned Chaplin as "the foremost painter of feminine elegance of his time." These were "works of a great artist [who] understands the highest doctrines of art."

In Salle 12, another rousing work, Fernand Cormon's *Return from a Bear Hunt,* thrilled spectators with its colorful re-creation of a prehistoric bear hunt. In Cormon's version, the participants were fully clothed, as Victorian-era cavemen were wont to be. In

the same room was an enormous painting by the Salon favorite William-Adolphe Bouguereau. *The Youth of Bacchus* was a classical scene celebrating youthful worshippers of the god of wine. Most of the young men and women in the painting were nude.

In Salle 14, visitors could view Jean-Louis-Ernest Meissonier's *Traveling Musicians.* They would have been familiar with Meissonier's work, for he was the most celebrated and successful artist in Paris in the second half of the nineteenth century.

In the next room, Salle 15, Benjamin-Constant's *Les Chérifas* indulged the crowd's insatiable appetite for exotic scenes with a representation of a nude woman and a robed sheik lounging in a luxuriant *Arabian Nights* setting. And in Salle 17, a few people may have paused to notice *The Meeting,* a distinctive little work by Marie Bashkirtseff, the artist who had confided her fears about Varnishing Day to her diary. During the early days of the Salon, Bashkirtseff and a companion positioned themselves on a couch near the painting in order to overhear comments from passersby, none of whom suspected the young woman seated nearby as one of the Salon artists.

Although women were allowed to show their work at the Salon, they were not permitted to study at the École des Beaux-Arts. If they wanted instruction, they had to attend private ateliers with liberal admission policies, such as that run by Rodolphe Julian. An entrepreneurial teacher who operated a number of ateliers in Paris, Julian offered special classes for young women, and he attracted students from the United States, Britain, and in the case of Bashkirtseff, Russia. Carolus-Duran, also known for his progressive ways, taught women one afternoon a week.

Salle 21, a larger room reserved for oversize works, was dominated by a mural-like painting by Pierre Puvis de Chavannes. Like Meissonier, Puvis was a household name in France, and one of the country's most beloved artists. People bought scaled-down replicas of his large murals, copies that he obligingly painted himself. Today, however, as with Meissonier, few know his name.

Puvis was both popular with the masses and highly regarded by his fellow artists, and Sargent admired his elegant compositions and classical attitude. Puvis's 1884 Salon submission, *The Sacred Grove,* depicted the nine muses in a pastoral setting, some with their breasts exposed. Even though the mythological theme would have been familiar, even predictable, the work was not without a fresh appeal: in it, Puvis experimented with space and depth, deliberately creating a flatness that was at once primitive and modern. Georges Seurat, who saw *The Sacred Grove* before he started working on his masterpiece *A Sunday on La Grande Jatte—1884,* may have been inspired by it.

Unlike Seurat, one American visitor was disappointed with Puvis's latest work. Beside the entry for *The Sacred Grove* in his catalogue, this visitor made a notation that began with praise for the "immense canvas that excites my wonder." But he went on to point out its flaws: "[It is] extremely disagreeable to me in color—absolutely without texture and looking and feeling like faded tapestry."

Spectators who had made it to Salle 31, where Sargent's painting was hung, would have seen enough of the Salon offerings to reach two conclusions: This was not the best year for paintings, and the 1884 exhibition counted a very high incidence

of nudes. Marie Bashkirtseff dismissed the Salon as a failure, writing: "There is nothing to see. This mass of painting without thought, without soul, is horrible."

As for the preponderance of nudes, Salon attendees were used to seeing artistic renderings of naked women. In fact, they looked forward to them. The nude had been in the Western artist's repertoire at least since the ancient Greeks invented the art form. Most professional artists in the 1880s would have studied anatomy in school and painted nude models in life study classes, learning the rules that separated art from what might have been perceived as pornography. In an artistic rendition, a naked woman had to be hairless. Her genitals were always smooth and sexless, or discreetly covered with a hand or a piece of cloth. A nude figure in a painting should resemble an ancient statue in its lack of realistic anatomical details. Gustave Courbet, a proponent of realism, shocked viewers by painting nude woman as they really looked, complete with hair, wrinkles, and lifelike bodies. Curiously, anatomical reality in art was apparently a horrifying concept to the same men and women who lined up to see bodies at the morgue.

In the academic tradition, nude women in paintings could be only historical or mythological figures, or anonymous types. A nude Eve, Lady Godiva, or Arabian princess was acceptable, as were Henner's playfully erotic nymphs, because they existed in myth or in distant time or space, and were cloaked in classicism or exoticism. Édouard Manet's *Olympia* had offended viewers when it was shown at the 1865 Salon because the woman depicted was a contemporary figure—a courtesan, no less, whom

some of the painting's male viewers might have known in an intimate way.

In *The Nude,* Kenneth Clark establishes an important difference between "nude" and "naked." "To be naked is to be deprived of our clothes, and the word implies some of the embarrassment most of us feel in that condition," Clark explains. But *nude* "carries, in educated usage, no uncomfortable overtone." Clark's distinction works in theory. But nudes were not always as innocent as he suggests.

Though highly idealized, even the most "classical" nudes must have seemed erotic to Salon audiences. Women in the nineteenth century tended to cover their flesh in public with layers of clothing, from buttoned-up gloves to floor-length hems. Salon exhibitions provided easy access to sexual images that were not part of daily life. And artists knew that their nudes, however sanitized or decorous, were titillating. They placed them liberally in their paintings, often in such settings as forests and courtrooms, where it made no sense for their subjects to be naked. During each year's Salon, newspapers would print caricatures of the exhibition's nudes, complete with enormous breasts, vulgar come-hither poses, and lewd captions.

By the time they reached Salle 31, Salon visitors would have seen every manner of nude—bending, sitting, standing, dancing; viewed from front, back, and side. Four of the most acclaimed artists in 1884—Bouguereau, Henner, Puvis, and Benjamin-Constant—had nude women in their paintings. Yet not one of these works raised an eyebrow, for the artists had been mindful of the conventions regarding nudes.

Ralph Curtis walked the Salon circuit, looking at paintings and searching for his cousin. All around, he heard people asking, "Where is the portrait of Gautreau?" Finally he saw Sargent in a hallway. He was trying to hide behind a door, to avoid encountering anyone he knew. Without explanation, he led Curtis to Salle 31.

There was little else of note in the gallery—a few portraits, some landscapes and religious paintings, by artists whose hopes of fame would not be realized. Yet even if there had been another interesting work there, few would have noticed. Anybody who entered Salle 31 had a single purpose: to see the Sargent—or the Gautreau, as they would have called it, for she was more famous than he.

Midway up one wall, Amélie's image was almost life-size, and although she faced sideways, looking off to her left, she appeared quite real; she could have been standing in the room. Her hair was arranged in a chignon, with a few tendrils escaping at the nape of her swan neck. The rosy ear and carmine lips were the only spots of color on the canvas. Amélie's nose was large, as in life, but strangely refined. Her chiseled profile recalled a cameo or an ancient coin. A small, indistinct table supported her right arm. A dark background, devoid of detail, made her flesh look even whiter and made her even more dominant within the frame.

Amélie's shoulders and arms were firm and sculpted, her bosom high and full under the heart-shaped bodice of her form-fitting gown. A jeweled shoulder strap held the left side of her dress in place, while the other strap had fallen precariously, threatening to release one breast from a plunging décolletage.

Amélie's narrow waist offset the sensual roundness of her bosom and hips. Her sleek and simple gown looks elegant to us today, but its close fit would have suggested to late-nineteenth-century viewers that Amélie was not wearing her petticoat, a crucial piece of underwear that any proper young woman would have worn religiously. Although many society portraits at the time fairly dripped with ostentatious displays of family jewelry, there was little here: a diamond crescent in Amélie's hair, a subtly glinting wedding ring. There was little in the way of decorative touches to distract from Amélie's magnificent figure. The lines of her body were so visible, especially in the vicinity of her strapless shoulder, that she might as well have been naked—not nude.

The public's judgment was loud, quick, and definite. What a horror, people exclaimed. She looked monstrous and decomposed, some said. The painting was indecent. Amélie's exposed white shoulders and décolletage—without a breast in sight— disgusted them. And that fallen strap! Was it a prelude to, or the aftermath of, sex? The fact that she was looking away from her audience made her appear blithely indifferent to her shocking dishabille and called attention to her shamelessness. Women were particularly vocal in their disapproval, as if to assert their moral superiority and disparage Paris's famous beauty.

Sargent and Curtis heard the death knell firsthand. Word of the scandal in Salle 31 traveled fast, and the two heard comments of people elsewhere in the Palais. Long before they were even close to Salle 31, many spectators had formed an opinion.

A few artists challenged the mob, calling out compliments— *"superbe"* and *"magnifique"*—and praising Sargent's style and au-

dacity. But the prevailing response was extreme disapproval, even repugnance. The American visitor previously cited was not swayed by any loyalty for his countryman. "Don't like it," he observed beside the entry for *Madame X*.

Even in Sargent's darkest and most insecure moments, he had never imagined a reaction so overwhelmingly negative. Amélie was shocked as well by the reaction to the portrait—perhaps more than Sargent, because while he was somewhat apprehensive about public reaction, she had been so sure of a positive response from her fans. The hecklers attacked artist and subject with equal passion, claiming Sargent was inept and Amélie repulsive.

Madeleine Zillhardt, a friend of Marie Bashkirtseff, was an eyewitness to Amélie's despair on that terrible day. "As for the model, slumped in a corner," Zillhardt wrote, "she cried real tears despite her enamel over her offended beauty." Bashkirtseff commented in her journal that "the beautiful Mme —— is horrible in daylight. . . . Chalky paint gives to the shoulders the tone of a corpse."

The exhibition had found its storm center. A constant uproar emanated that morning from Salle 31, as more and more people rushed to see the painting that was the source of so much derision. After a few hours the crowds began to disperse. Sargent and Curtis left the exhibit to join friends at Ledoyen for the annual Varnishing Day lunch.

At the restaurant they found more crowds, other people who had come from the Salon; a resourceful maître d' auctioned off tables. Even Carolus-Duran, a longtime Salon celebrity, had to fight his way into the restaurant. The choice tables were outside,

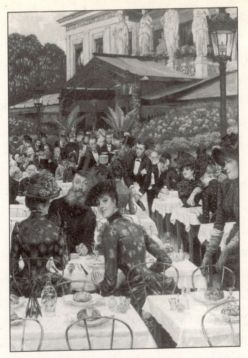

James Jacques Joseph Tissot, *The Artists' Wives,* 1885

Painted the year after the 1884 Salon, Tissot's work conveys the mood of Varnishing Day at Ledoyen, where Sargent lunched after *Madame X* was exhibited publicly for the first time. *(Oil on canvas, 57½ x 40 inches. Chrysler Museum of Art, Norfolk, Virginia, Gift of Walter P. Chrysler, Jr., and the Grandy Fund, Landmark Communications Fund, and an "Affair to Remember" 1982 [81.153])*

and diners determined to see and be seen willingly endured the sun. Diners who were not sheltered by canopies or parasols made themselves hats out of newspapers and napkins—an avalanche, *L'Événement* reported, "of improvised chef's hats."

Sargent and Curtis sat down to Ledoyen's traditional

Vernissage menu of salmon in green sauce, followed by the house specialty, *rosbif à l'anglaise,* roast beef served in the classic English style, with Yorkshire pudding. But one wonders whether Sargent demonstrated his characteristic appetite or joined in the gaiety of the crowd. Impassioned conversations were taking place all around him, as people voiced their opinions about their favorite—and least favorite—Salon paintings. There was high praise for Cormon's cavemen, Chaplin's socialites, Bouguereau's revelers. But for Sargent's Amélie . . .

Ralph Curtis tried to console his cousin, predicting that the afternoon audiences would be kinder. They returned to the Palais after lunch, and Sargent did hear more noncommittal observations, such as "Strangely amazing!" from people who stood before the painting. But he also saw gentlemen idling near the portrait, waiting for young women to enter so they could watch the flush of embarrassment on their innocent faces when they saw the shocking image. Evidently, if *Madame X* was going to be a success, it would be a *succès de scandale,* like Manet's *Olympia.*

Sargent and Curtis left the Palais in the late afternoon, as the Salon was about to close. The artist wanted to pay a call on his friends and patrons the Boits, who, he thought, would be sympathetic to his experiences. Curtis went to Sargent's studio—not such a wise decision, for soon after, a distraught Amélie and her enraged mother appeared at the door. Amélie was "bathed in tears," and Marie Virginie sputtered with fury. She had invested far too much in her daughter to have her reputation destroyed with the strokes of a paintbrush. She had to speak to Sargent immediately.

Curtis convinced her that he was alone at the studio and sent them away. But the indomitable Madame Avegno returned a few hours later to confront Sargent, and demanded that he withdraw the portrait from the Salon. "My daughter is ruined and all Paris mocks her," she told him. "My people will be forced to fight." Members of the Gautreau family would be expected by custom to initiate a duel if someone directed an insult toward one of their own. At the time, duels were not an uncommon way to resolve disagreements; they were often reported in the press. Marie Virginie's next words were meant to carry the greatest weight. If Sargent did not remove the painting from the Salon at once, she claimed, her daughter would "die of grief."

Sargent refused to entertain either accusations or pleas. He had come to dislike Marie Virginie; he had communicated that feeling clearly in an unflattering sketch of her in a letter to a friend. Moreover, he knew that her hatred of the painting was based solely on the negative public reaction that day; previously, she, like her daughter, had expressed nothing but approval of Sargent's portrait. She had been a witness to much of the protracted process of sketching and painting, and had never spoken a disapproving word.

Now that Amélie faced ridicule, everything had changed. When others condemned the portrait, daughter and mother felt compelled to do the same. Amélie had not expected the negative reaction, and she had to act swiftly and carefully to repair the damage. The easiest solution would be for the painting to disappear.

Sargent had definite ideas about the matter and did not hesitate to express them to Amélie's mother. When he had painted

her daughter, he said, he painted exactly what he saw. "Nothing could be said of the canvas worse than had been said in print of her appearance," Sargent insisted. *Madame X,* with its subject's artificial pallor and stylized pose, was an accurate reflection of the real woman. Sargent was intractable, and Marie Virginie left the studio dissatisfied and angry.

Sargent and Curtis stayed up through the night talking. While on the surface Sargent had been unmoved by Madame Avegno's accusations, he told Curtis, her words had wounded his artistic pride. Further, he told his cousin, he wished he could leave Paris for a while. But flight was possibly unnecessary, Curtis replied. Reviews would appear in the newspapers the next day, and there was still hope that his painting had a future.

# Le Scandale

On Thursday, May 1, Sargent woke up to his first bad review. The critic for *L'Événement* wasted no time in lambasting *Madame X*: "Mr. Sargent made a mistake if he thinks he expressed the shattering beauty of his model. . . . Even recognizing certain qualities that the painting has, we are shocked by the spineless expression and the vulgar character of the figure." Criticisms like "spineless" and "vulgar" were distressing to Sargent, who was accustomed to hearing words like "exquisite" and "brilliant" describe his work.

Further bad reviews followed. Louis de Fourcaud, who before the Salon had written favorably about Sargent in *Le Gaulois,*

now said that he could fill ten pages with the angry epithets of viewers in front of the painting. "Detestable!" "Boring!" "Monstrous!" were just a few examples he offered. Sargent's situation was instantly less secure. While his painterly talents—his masterly use of light, his virtuoso brushstrokes—had always been singled out for praise, critics now turned on him. Henri Houssaye, who had been enthusiastic about Sargent's work in the past, complained that *Madame X* lacked technique. He accused the artist of making fundamental mistakes that would have been unacceptable if committed by a student, let alone a prizewinning professional. "The profile is pointed," Houssaye wrote, "the eye microscopic, the mouth imperceptible, the color pallid, the neck sinewy, the right arm lacks articulation, the hand is deboned. The décolletage of the bodice doesn't make contact with the bust—it seems to flee any contact with the flesh." *Art Amateur*'s critic expressed a similar contempt for Sargent's skills as an artist: "This portrait is simply offensive in its insolent ugliness and defiance of every rule of art. It is impossible to believe that it would ever have been accepted by the jury of admission had the artist's previous successes not made him independent of their examination."

The most surprising and most damaging criticism reprimanded Sargent for failing to create a flattering portrait of his subject. Most reviewers agreed that there was a great discrepancy between Amélie's real-life beauty and the unattractive way she came across on canvas, although Sargent maintained that he had painted exactly what he saw. A portrait that was perceived as uncomplimentary was the kiss of death to new business, imperiling an artist's income as well as his reputation. Why, critics asked,

would any prospective client risk looking monstrous or detestable in Sargent's hands, when portraitists such as Charles Chaplin could guarantee an attractive and pleasing likeness? "[Chaplin] is the painter sought out by pretty women," *Le Petit Journal de Paris* observed. "We are sorry that we can't say the same this year about . . . Sargent." Because he complimented his subjects with his paints, some critics deemed Chaplin, who was ordinary on his best day, the better artist.

One critic identified excessive ambition as the weakness that had led Sargent to such disappointing work. While Claude Phillips did not actually compare *Madame X* with *Olympia* in his review, he implied a parallel between the two paintings. "A *succès de scandale* has been attained by Mr. Sargent's much-discussed [portrait]. The intention, no doubt, was to produce a work of absolutely novel effect—one calculated to excite, by its chic and daring, the admiration of the ateliers and the astonishment of the public; and in this the painter has probably succeeded beyond his desire."

In one publication after another, the critics continued with their negative notices. Sargent, surprised and discouraged by the rampant antipathy, considered withdrawing the painting from the Salon. As a first step, he appealed to Bouguereau, one of the elder statesmen of the jury, for permission to remove the portrait so he could retouch it and thereby make it more acceptable to Salon audiences. He wanted to raise the fallen strap, the detail most viewers seemed to have fixated on as the worst offense. But Bouguereau, whose painting of nude Romans frolicking with Bacchus had offended no one, and was indeed earning raves, was

outraged by the very suggestion. A Salon entry could not be removed from its wall or altered in any way. He sternly warned Sargent that challenging the rules would have dire consequences; it would compromise the very integrity of the Salon. It simply wasn't done. *Madame X* would stay where it was, untouched and in full view, until the Salon closed.

By the second week, the painting had become a symbol of the failure of the entire exhibition. An editorial in *L'Événement* invoked Sargent's painting in arguing that artists had made a poor showing. The editorial pointed to distinguishing characteristics of Amélie's portrait, such as her skin color, and termed the painting "hideous" and "nauseating." Instead of faces, it held, artists like Sargent painted "inside-out rabbit skins, greenish, grayish, 'corpse-ish,' moldy. . . . When one stands twenty meters from the painting, it looks like it might be something. . . . They call it 'impressionism,' but when one gets closer and gives it three seconds of . . . attention, one realizes that it is only 'hideousness.'"

These harsh notices had graphic counterparts—venomous cartoons and caricatures of Sargent, Amélie, and the painting. *Le Charivari* ran a caricature that transformed Amélie's bosom into the oversize heart on a playing card, with her fallen shoulder strap especially visible. The artist extended Amélie's nose well beyond its real Avegno length, calling attention to her least attractive feature. The caption read: "New model—the ace of hearts for a game of cards."

The playful and ribald *Vie Parisienne* satirized the painting in everything from mock advertisements to spurious letter campaigns. One article suggested that Amélie's skin, so white and

free of pores, could be used to advertise a blackhead remedy: "Mr. Sargent has offered to let a well known parfumeur use his current painting. The painting will be called: Before and After 'Anti Bolbos.'" Another item, finding a sexual angle to exploit, consisted of fictitious letters from artists defending their own paintings. In his letter, the purported Sargent wrote: "They insist on pretending that I made 'la belle Madame G . . .' less beautiful than nature did . . . that her complexion doesn't have the sparkling transparency that everyone recognizes. Just wait! My painting [is] a mechanical canvas. At six o'clock, for the lucky few, the chains that hold up the bodice come off and the dress falls to expose the most perfect, the most adorable, the most delicate and the most tender base of linoleum that one can possibly imagine. All inquiries should be addressed to the museum attendant."

*La Vie Parisienne* specialized in sexually suggestive illustrations of women, and its Salon issue invited readers to take a close look at the lovely bodies on display at the exhibition. "Ask for the little Salon souvenir! Little ladies in various states of undress. The illustrated booklet comes with the addresses of the models. To rent a magnifying glass, just ask." Despite her status as a married woman, Amélie was presented as one of the near-naked models. A caricature showed her with bosom exposed and, of course, her prominently fallen strap. The first caption line below addressed her directly, exclaiming, "Mélie, your dress is falling off!" Her imagined reply was curt: "It's on purpose. . . . And leave me alone anyway, won't you?"

*Le Gaulois*, somewhat more intellectual in its satire, printed a poem that imagined what Amélie would tell Sargent, if she had

GENRE. — Mélie, tu perds ta rob ! — C'est exprès, là .. Et puis, fichez-moi la paix, n'est-ce pas? Ça ne vous regarde pas.

*La Vie Parisienne*'s caricature of Amélie at the height of the scandal emphasized her exposed bosom and the fallen shoulder strap—and moved it from her right arm to her left. *(Bibliothèque Nationale de France)*

the opportunity. The poem was part of an article entitled "Great Beauties of the Past and Their Painters, à Propos of the Beautiful Madame Gautreau," in which other artists' models, among them Mona Lisa and Madame Récamier, praised the men who painted them. In the poem, Amélie told Sargent that she was ashamed and upset:

THE BEAUTIFUL MADAME GAUTREAU TO MR. SARGENT

*Oh my dear painter, I swear to you*
*That I love you with all my heart,*
*But what a strange expression!*
*But what a strange color!*

*Truthfully, I'm ashamed*
*To see, each day, at the Salon,*
*My friends, with pity on their faces,*
*Examining me from head to toe.*

*"Is it really she?"—"No."—"How should I know?"*
*"It is she, look at the catalogue!"*
*"But then, it's blasphemy!"*
*"Get out! It really is she! So it seems!"*

*It didn't seem so at all, quite the contrary,*
*And I had, I swear to the heavens above,*
*When you did my portrait,*
*Dreamed of something better.*

*It was a mistake for which I must atone.*
*But that's just too bad! Every day I'll go*
*Stand beside my copy . . .*
*And the harm will be undone.*

Over the summer of 1884, newspaper writers in Paris competed to post the cleverest insult. *Le Petit Journal* cautioned, "It is better to have a good portrait in your bathrobe than a bad sketch in a ball gown." Perdican decreed that "since Sargent's portrait we call her only the strange Madame [Gautreau]." In *Le Figaro,* Albert Wolff commented slyly on Amélie's bosom: "One more struggle and the lady will be free."

From this tempest of condemnation and ridicule, a few positive voices did speak up. Several critics expressed admiration for what they saw as the painting's virtues. They looked beyond the debates over Sargent's ability to capture a likeness, or his talent for composing a pleasing image. Recognizing more than a superficial rendering of a pale woman in a black gown, they extolled Sargent for a complex, ambitious, symbolic psychological portrait. In their eyes, *Madame X* was not merely the portrait of a woman: it was a depiction of an entire society. "A painting such as this one is a document," a critic for *La Nouvelle Revue* contended. "A century from now, our great-grandnephews won't be able to imagine a *mondaine* other than this one for the year 1884." A *mondaine* was a woman of the world, and this critic believed that Sargent had portrayed Amélie as the ultimate symbol of that kind of sophisticate.

André Michel made a similar observation about the iconic quality of the painting in *L'Art.* "The critics of the next generation," he predicted, "will be freer to comment on this troubling work. They will look here, no doubt, for a 'document' of the 'high life' of . . . 1884, an image of a woman which an overheated

and contrived civilization, with a taste less for fresh, healthy flowerings than for the blossoms of the boudoir, has been pleased to fashion; and if it is true that each generation remakes in its own image the work of nature, then future critics will see here our Parisian cosmopolitanism manifested in ideal form." Both these critics understood that Sargent's painting of Amélie was really a portrait—and perhaps an indictment—of Parisian society. Her image, arrogant and narcissistic, expressed the dancing-on-the-volcano attitude that would characterize the Belle Époque.

Sargent's friend Judith Gautier, who had been writing art reviews for twenty years, praised him as a "master of his art" in her commentary on the Salon in *Le Rappel.* She described *Madame X* as "the precise image of a modern woman scrupulously drawn by a painter," and commended its " visionary beauty."

But Gautier and others who applauded Sargent's controversial work were unquestionably in the minority. Criticized, dismissed, and lampooned in one publication after another, Sargent was trapped at the center of a nasty scandal that showed no signs of abating. In fact, it was bound to get worse, as foreign journalists carried the news of his failure to their homelands. Word would travel from France to England, the United States, and other countries, undermining the reputation he had worked hard to establish.

Sargent faced a more immediate problem as well. Before the Salon, he had quite reasonably anticipated that he would sell the portrait to Amélie and her husband for a handsome fee. But as soon as there was a whiff of public derision, the Gautreaus made

it clear that they wanted nothing to do with the painting. For the first time in Sargent's career, his business plan had backfired. Instead of achieving his goal of becoming a premier portraitist, Sargent faced the devastating possibility that he was an overnight failure.

# *Calculated Moves*

If Sargent did not act immediately to salvage his career, his dreams of renown and success in Paris would be finished. Once the Salon ended, he reclaimed *Madame X* and returned it to his studio. Looking as if she had never left, Amélie once again dominated the room. But now Sargent was free to do as he wished with the portrait; he was no longer subject to any outside pressure. Amélie and her family had no control over a portrait they did not own—he could change it for his own reasons. He revived the idea he had been considering when he appealed to Bouguereau to let him retouch the work.

Sargent in his studio on the Boulevard Berthier. He had repainted Amélie's right strap to sit demurely on her shoulder. *(Photographs of artists in their Paris studios, Archives of American Art, Smithsonian Institution)*

With a few scrapes and strokes, Sargent removed all traces of the offending fallen shoulder strap. With equal alacrity, he painted a new strap that sat properly on Amélie's shoulder. This simple alteration made the bodice of the dress seem secure. It also made her pose less suggestive and her attitude less devil-may-care. It was as if the fallen strap had never existed.

Sargent had no plans to exhibit the painting, even retouched. Locked in his studio, it existed only for him. But every time he looked at it, the portrait must have been a painful reminder of his failure at the Salon. It also provoked unhappy memories of his infatuation with Amélie and the unfortunate consequences

of their collaboration. He had to change it—to rewrite history, in a sense—before he could attempt to reclaim his life.

And that was his next step. Sargent wanted to leave Paris to gain some perspective. He was scheduled to paint the daughters of Colonel Vickers in rural England in July, but he did not want to spend any more time in France than necessary. He sent a politely flirtatious letter to Henry James in early June, feeding the older man's ego and fueling his obvious desire to grow closer to the artist. "It will be pleasant getting to London and especially leaving Paris," Sargent wrote. "I am dreadfully tired of the people here. . . . I hope you are not going to leave London very soon. I am sure you will be necessary to my happiness there."

Sargent arrived in London on June 10, and for the next month, James filled his calendar with social activities, trying to persuade him to turn his back on Paris once and for all. In contrast to the gossip-mongers in France, Sargent's friends in London were very solicitous as far as the Gautreau portrait. Although news of the Salon scandal had crossed the Channel, it was not something that would have concerned the kind of people, such as rebellious artists like Oscar Wilde, whom Sargent sought as his companions.

Potential clients, however, were more sensitive to the criticisms directed at Sargent. He was having difficulty attracting new business, but luckily, Colonel Vickers did not withdraw his commission. He still wanted Sargent to paint his daughters and welcomed him to his Sheffield estate.

Sargent was daring in his approach to the Vickers portrait. He posed the three sisters in a semicircle, two of them together

and the third apart, their pale faces thrown into relief against a dark background. The bold grouping had psychological overtones reminiscent of his treatment of the four Boit sisters. Colonel Vickers, more than pleased with the portrait of his daughters, hired Sargent to paint his wife and his two sons. Others in the extended Vickers family followed the colonel's lead in commissioning portraits, and ultimately Sargent painted thirteen family members.

They may not have been colorful, dramatic, and intoxicating like Amélie Gautreau and Samuel Pozzi, yet the Vickerses were pleasant people with solid financial portfolios. Sargent came to appreciate their company and happily participated in family dances and picnics. He even joined them in a brief seaside vacation in August.

Sargent's months in England were not carefree. He was in an awkward position on either side of the Channel. Most Britishers, though not the Vickerses, found him too French an artist for their tastes; his expressive and often flamboyant style of painting smacked of frivolity. And the French, in their intractable way, continued to reject him. The Salon disaster had exposed their deep-rooted hostilities toward a painter who was, after all, a foreigner. As critics had predicted, he was no longer a candidate for commissions in the beau monde. With his command of languages and his cosmopolitan ways, Sargent had once seemed at home everywhere he went. But speaking like a Frenchman did not make him one. He seemed to belong nowhere.

Throughout the summer, Sargent felt depressed and uncertain about his future. He contemplated changing professions

upon his return to Paris, which he planned for the end of the year. He was a man of many talents, after all. He might explore music, he told a friend, or even pursue a business career. He was only half joking.

Despite fewer portrait commissions during this period, Sargent was never idle. He painted constantly, experimenting and perfecting his technique. His lack of income did not affect his ability to practice his art, but it did make the logistics of daily existence more difficult. When he returned to Paris in December, he had trouble paying the rent on his expensive studio, which was more suitable for a prosperous artist than for one experiencing hard times. In lieu of monetary payments, Sargent agreed to paint portraits of the wife and the daughter of his landlord, Paul Poirson, a cultivated man and patron of the arts.

In early 1885, when Sargent's financial situation was becoming dire, he received a commission to paint Mrs. Edward Burckhardt, the mother of his friend and former love interest Louise. The occasion sparked a reunion with Louise. In an unsubtle matchmaking maneuver, Mrs. Burckhardt encouraged Louise to step into the painting after Sargent had designed the overall composition.

Louise had changed over the past few years. She was no longer the sweet, demure young Lady with the Rose. Dressed in scarlet from head to toe in *Mrs. Edward Burckhardt and Her Daughter Louise,* she projects an entirely different image. Her evening dress, with its V-shaped décolletage, leaves her neck and arms bare. The scarlet ribbon around her arm contrasts strikingly with her pale skin. A scarlet plume crowns her hair, which is

arranged fashionably in an upsweep. Mrs. Burckhardt, dressed in black and seated in an armchair, gazes to the side, while behind her, Louise stares directly at the viewer—and the painter—as though compelling them to notice her confidence. Her hands, pressed together at the top of the chair, as if in prayer, implore the artist to give her a second chance.

Sargent was more vulnerable now than he had been during the summer of 1881, when Mrs. Burckhardt had launched her matrimonial campaign. But if this commission was her final attempt to ensnare Sargent for her daughter, he was able to resist it. He finished the painting and moved on.

While Sargent appreciated the support of such friends as the Burckhardts, he would not be satisfied with a career spent drifting from one occasional commission to another. He had never subscribed to the starving-artist theory of painting; he had always had a strong business plan, a strategy for how to advance in his profession. A definite course of action seemed to elude him now.

In the spring, Sargent exercised his right to exhibit in the Salon, submitting *The Misses Vickers* and *Mrs. Albert Vickers*. The portraits were accepted and exhibited, and the critics were at best lukewarm about them. In fact, the paintings received very little attention—an insult for an artist whose previous works had been featured on the front pages of newspapers. Many other viewers felt equally lukewarm. Even Vernon Lee said that a painting hanging next to Sargent's at the Salon, Whistler's *Portrait of Lady Archibald Campbell,* "beats John into fits." His close friend thought that Whistler's painting was superior.

In the summer of 1885, Sargent returned to England for

a boating trip through the countryside with Edwin Austin Abbey. The excursion began pleasantly: the weather was fine, and the scenery fresh and interesting to Sargent; this was his first time on the Thames. He was charmed by the sight of Chinese lanterns, which stood out on the riverbank, illuminated against the evening sky.

The trip took an unfortunate turn when Sargent, lulled into a sense of security by the pastoral surroundings, recklessly dove headfirst into the river's murky depths and hit his head on a spike embedded in the riverbed. Despite a nasty injury, he continued to act carelessly. He hit his head a second time and deepened his wound.

Abbey was concerned about his friend's physical condition and his state of mind. He decided that Sargent needed a safe, tranquil place to rest before he did himself any more harm. What immediately came to mind was Broadway, a village in the idyllic Cotswolds, a region celebrated by Wordsworth and others for its bucolic charm.

Literature is filled with legends about wanderers who are transported to magical Shangri-las during troubled times in their lives. This was how Broadway appeared to Sargent. He found himself in a fairy-tale village populated by a number of appealing American and British artists and illustrators, all close friends of Abbey's. At the center of the group was a charismatic American couple, Frank and Lily Millet.

Francis Davis Millet was an energetic Renaissance man who excelled at writing, painting, and collecting interesting people. Lily, born Elizabeth Merrill, was a spirited and imaginative

woman, attractive, intelligent, and extremely nurturing. Along with their two children, Kate and Laurence, and Millet's sister Lucia, they enjoyed a communal existence with their friends, who either lived in neighboring residences or became perennial houseguests. Besides Abbey and the Millets, the Broadway group included the illustrator Frederick Barnard and his family; and the poet and critic Edmund Gosse, his wife, and his sister-in-law, who was married to the painter Lawrence Alma-Tadema. Henry James was a frequent visitor.

In 1885, the Millets lived in Farnham House, a quaint stone structure dating from the sixteenth century. This was the colony's headquarters and the central location for communal activities. The artists cultivated an Elizabethan atmosphere, furnishing their homes with objects from that period, and the women often wore long flowing dresses that evoked the past.

When Sargent arrived in Broadway, Farnham House was occupied by family and guests, so he stayed at a nearby inn. But he spent much of his time with the Millets. He loved the storybook setting, and recorded its details in drawings and paintings. He noted the unusual golden light, warmer and more penetrating than the light in France. He strolled in wild gardens filled with giant lilies, roses, and poppies, and followed paths that led to no particular destination. He breathed clean, herb-infused air, acutely aware of the differences between this countryside and Paris.

He was both pleased and inspired by his surroundings. The colony members became a surrogate family—in many ways more nurturing than Fitzwilliam and Mary Sargent had been when he was younger. Lily Millet was among the attractions for

him, and the crush he developed was not unlike his infatuations in Paris and Brittany. This time, though, the object of his affection was not a femme fatale, like Amélie, or a forbidden passion, like Albert de Belleroche: Lily Millet was a domestic goddess. She spent her time with her children and in her garden, and was the driving force in her community. Sargent, in need of emotional support, found her irresistible.

He tried repeatedly to express his affection for Lily by painting her portrait, but was dissatisfied with his attempts. One day he caught sight of her as she was running out of the house to post a letter, a lavender shawl thrown hastily around her shoulders. Enchanted, he persuaded her to drop what she was doing to sit for him. In no time he captured her lovely face, dreamy, serene, and contented. Her lush body, enveloped by the shawl, is round, soft, and inviting—the opposite of Madame X's, with her severe lines. The portrait, *Mrs. Frank D. Millet,* is inscribed with the artist's simple message: "To my friend Mrs. Millet."

Lily Millet was a safe infatuation for Sargent: she was happily married, and absorbed in her family. He could admire her, spend time with her, even become her close friend. There was no danger of disillusionment, as with Amélie, or intimacy, as with Judith Gautier.

Sargent's Broadway friends had a great taste for fun and games. They would play lawn tennis, romp with the children in games of tag, and dance at riotous birthday parties. Sargent joined them in donning costumes and laurel wreaths to perform in stage presentations and tableaux vivants. Such recreation allowed him to experience the childhood he had missed. In the

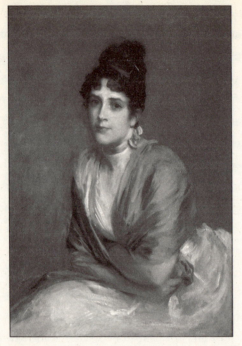

John Singer Sargent, *Mrs. Frank D. Millet,* 1885–1886

Sargent's portrait of Lily Millet, painted during his extended visits to Broadway, communicates her sweet and nurturing spirit. *(Private collection)*

evening, the group would gather for other activities, planned by a different person every night. When it was Sargent's turn, he taught the others how to throw shadows on a sheet and how to cut out silhouettes. An uninhibited Sargent played the piano and sang from the works of Wagner, subjecting his audience to one Teutonic libretto after another, though they begged for lighter material, like "Carnation, Lily, Lily, Rose," a music-hall number that everyone was singing that summer.

This song, the sight of the children playing in the garden, and the memory of Chinese lanterns along the Thames at twilight inspired a painting that would convey Sargent's Broadway experience. He envisioned children holding lanterns among the flowers, their faces illuminated by diffused golden light. Some of the elements—the late-summer light, the fading flowers, not to mention the young, unpredictable children—would be difficult to control.

Undeterred, Sargent selected a spot in the Millet garden to set up his easel. He began with little brown-haired Kate Millet as his model, but replaced her, much to her disappointment, with the Barnard children. They were a little older than Kate, and would have more stamina, and Sargent favored the lighter color of their hair. They were dressed in white gowns, bribed with candy, and positioned near flowers and lanterns. The adults served as Sargent's assistants, set decorators, and appreciative audience.

Every day for weeks, just before sunset, Sargent would drop his tennis racquet, gather his canvas, paints, and young models, and head for the garden. He would work for twenty minutes— the brief period of perfect light—to catch the magic transition of late afternoon into evening. When the sun had set, Sargent and his friends would carry the oversized canvas to its resting place to await the next twilight. He would call the painting *Carnation, Lily, Lily, Rose.*

During this summer, Sargent was unable—or unwilling—to finish the painting. Ostensibly, there was not enough time to complete it, as the daily sessions grew shorter with the waning

light and the children had to wear pants and boots under their gowns because of the cold. But just as significant, Sargent was not eager for his Broadway idyll to end. He was enchanted with the people, the place, the rhythm of life, and wanted a reason to return the following year.

Sargent was transformed by these restorative experiences at Broadway. The world of Amélie, Pozzi, and the other brilliant creatures receded, replaced by the wholesome English countryside. He was eager nonetheless to return to London.

Amélie, unlike Sargent, had no escape route after the Salon and was trying to make the best of circumstances in Paris. She did not die of shame, as her mother had predicted, although the months after the Salon must have been difficult. Endless references to the portrait continued to appear in the gossip columns. In an account of a ball at a baroness's house, *L'Événement* mentioned that "the comtesse Zamoiska, with a neckline 'à la [Gautreau]' had only a thin string of diamonds on black velvet as her sleeves." Perdican, in an item about Sarah Bernhardt in *L'Illustration,* sneaked in a reference to Amélie: "It wasn't the famous chains that hold up—or look like they are holding up—or look like they are letting slip, whatever one wants to say, Madame [Gautreau's] black dress in the famous and widely discussed portrait by John Sargent."

Amélie was used to idolatry, and this kind of attention was humiliating. A few months before the Salon, she had attended every ball, dinner, and concert in Paris. Now, while she was steadfast about upholding appearances, Amélie was selective about her activities, limiting her exposure to only the most im-

portant events. She attended the Grand Prix at Longchamps, the only place to be seen in the month of June. But journalists noticed her standing off to the side, where the horses were weighed, not at the center of the action. For a party hosted by a count, she took no chances in dressing for the evening. No one, she knew, should be reminded of that black gown when they saw her, and reporters, apparently, were not. The writer for *La Gazette Rose* found Amélie "very beautiful in a white satin dress with pearl netting."

With the season closed after the last equestrian events and other celebrations, Amélie returned to Brittany for another summer at Les Chênes. She hoped for a retreat from Paris and the humiliation she had suffered there.

But bad news seemed to follow the Gautreaus. Pedro's second attempt in local politics failed. According to the area newspaper *Le Salut,* the contest was a heated one, and Pedro was rebuffed by the voters of Paramé after he "placed himself everywhere." Because St.-Malo and Dinard were vacation spots for many of the same people who were gossiping about *Madame X* in Paris, Amélie kept a low profile in order to avoid unpleasant encounters. Her name was not mentioned in the coverage of the casino ball in St.-Malo, nor did she make an appearance at the races that season.

The outbreak of cholera in southern Europe that summer occasioned Amélie's first really public appearance: a September charity concert to raise money for victims of the epidemic. Amélie herself organized the event; its success proved that her name and social standing, while tarnished, still had cachet.

Amélie enjoyed being out in society and had no intention of hiding forever. But like Sargent, she needed a strategy for dealing with the effects of the scandal. The gossip would subside if she gave people something else to talk about. It was time to hold her head high, step into the spotlight, and unveil a new image.

Amélie returned to Paris with a mission. She would plunge into the new social season, accept all the usual invitations to dinners, opening nights, and charity balls, and blithely behave as if *Madame X* had never happened. Luckily, the painting was locked up in Sargent's studio, and her hope was that it would stay there so people would forget about it. Meanwhile, her instincts—the same ones that previously had served her well—were telling her to entrust her image to another painter, someone who would create an accurate, and more flattering, tribute to her beauty. It would not be quick or painless—portraits took months, sometimes years, to complete—yet she was willing to be patient, to get it right this time.

She found an artist whose name is lost to us, but who could follow directions without worrying about proving his originality. She asked him to paint her in a manner reminiscent of Thomas Gainsborough, the eighteenth-century English painter whose formal depictions of the aristocracy in such works as *The Blue Boy* defined portraiture in his day. In this portrait of Amélie, painted probably in 1885 or 1886, she stands in a jaunty riding habit, her hair spilling from a feathered derby, one hand clasped to her breast. Her nose, always identifiable, dominates her face. Her jacket and shirt, buttoned and ribboned at the neck, are

proper to the point of being prim. The undistinguished artist failed to come up with one seductive brushstroke.

No surprise, then, that this unremarkable painting—and its creator—dropped into obscurity. It did no service to Amélie either, failing to attract attention as she had intended. The critics had nothing to say, and there was no mention of the painting in the gossip columns.

Before *Madame X,* Amélie's arrival at a party could cause a near-riot in the streets and produce inches of copy in newspapers. And immediately after *Madame X,* she had become used to seeing volumes of negative publicity about herself and the portrait. But the absence of any public reaction to her latest portrait was Amélie's worst nightmare: people were starting to forget her.

# A Woman of a Certain Age

For the three years directly following the 1884 Salon, Amélie sought to keep herself in the public eye. She went wherever it was important to be seen, rarely missing a premiere, a political reception, or a charity gala. But she knew that her look, once her surest claim to fame, did not have the same effect on people as before. Perdican and other columnists were less enthusiastic about her activities, allotting her the same terse lines they gave to other society women.

Worse still, Amélie's thirtieth birthday was approaching—the dividing line between youthful desirability and dreaded mid-

dle age. How could she reclaim her celebrity and make Paris notice her once again?

Unveiling yet another new portrait, Amélie concluded, would be the most effective way to call attention to herself. She had learned an important lesson from her last experience. A portrait painted in the style of Gainsborough, for instance, was out of the question. Anything conventional would be ignored, when what she wanted was to provoke the opposite reaction.

Before she could settle on a style, a concept, or a pose, she had to find an artist. She needed someone who could create the unexpected; this ruled out established portrait painters like Carolus-Duran or Charles Chaplin. She selected instead Gustave Courtois, an artist in search of a big-idea portrait to display at the Salon. The situation recalls that of some years earlier, when Amélie and Sargent collaborated on the ambitious idea for his 1884 Salon submission. Now, however, Amélie was determined to stage-manage the sittings for her own purposes.

She dressed carefully for her first session with Courtois, outfitting herself in virginal white instead of black. Her gown, a confection of soft organza and lace, molded itself to her curvaceous body at the same time it drifted around her like a cloud. She held a wispy shawl in her hands, and one wrist was encircled by a multistrand pearl bracelet with a jeweled clasp. She posed with her head in profile, just as she had in *Madame X,* but this time she turned her face to her right. Her neck was long, her nose prominent, and her hair swept up into a loose chignon.

Inarguably, Amélie was very pretty in Courtois's portrait. It could elicit no nasty comments about her corpselike skin or

haughty gaze. But she had to accomplish more than merely appear attractive. She had to do something to make viewers look twice. So, incredibly, she slipped the left strap of her gown off her shoulder and let it hang. The fallen strap, a deliberate reference to *Madame X,* made her seem even more undressed in this painting than she had seemed in the Sargent.

In his portrait, Sargent had made it appear as if Amélie's shoulder strap had slipped accidentally. But here the effect came across as calculated, as if Amélie and Courtois were trying to instigate a response by showing an instantly familiar, but prettier and more sensual, version of her former self. This time, the fallen strap was Amélie's cry for attention. Immediately after the 1884 Salon, she had wished that everyone would stop talking about her. Now she believed that anything was better than being ignored, even if she had to drop her strap to be noticed.

The painting was exhibited at the 1891 Salon under the title *Portrait of Madame Pierre Gautreau, Wife of the Banker.* One critic called it "a faithful image," but it was not discussed at length—favorably or unfavorably. This year Amélie was just another picture on the wall. She must have been disappointed by the absence of an impact, a disturbing signal that not even her daring display of flesh could make her headline news once again.

Amélie's social life too reflected her change in status. She still preferred the company of famous men to that of her unremarkable spouse when she went out into society. But lately her escorts were not as exciting as they had once been. She was seen at events with elderly diplomats, like Baron Mohrenheim, the Rus-

Celebrities and socialites flocked to the studio of the master photographer Nadar to have their pictures taken. But Amélie, it seems, avoided the camera: only one photograph of her, the date unknown, has been found. Despite her famous profile, prominent nose and all, the absence of color makes her look flat and ordinary. *(Bibliothèque Nationale de France)*

sian ambassador, and Henri Brisson, former president of the Council of Ministers. To call them "distinguished" is being kind. They were bald, grizzled, and wrinkled, not handsome and sexy, like Pozzi, or charismatic, like Gambetta.

There were nights when Amélie had to resort to younger fans for company. In 1892, she appeared at the opera with fifteen-year-old Gabriel Pringue, a friend of her daughter's. Pringue had

been at St.-Malo as a child of four, when Amélie was there as a young woman of twenty-one. Pringue's governess refused Amélie's invitation on his behalf because she knew Madame Gautreau had a reputation and it might be unseemly for the boy to appear alone with her.

After the teenage Pringue had complained bitterly enough, the governess agreed to chaperone them. The three set out in Amélie's carriage; she wore a white gown with simple lines and her diamond crescent in her hair. People stared as the trio walked up the grand staircase, and whispered about Amélie's skin, her hair, her décolletage. Women raised their opera glasses for a closer look and confirmed her identity to their companions. The fact that they had to use glasses indicated that Amélie was right to worry about her standing. When she was at the height of her popularity, no one would have needed binoculars to know she was in the opera hall: a mounting commotion would have announced her presence.

In 1897, Amélie was ready for another portrait. She commissioned Antonio de la Gandara, who specialized in portraits of society women and celebrities including Sarah Bernhardt, Paul Verlaine, and Robert de Montesquiou. Gandara was familiar with *Madame X*—he had exhibited at the 1884 Salon—and he had seen the Courtois. But he had no intention of evoking either of these paintings in his portrait. He studied his sitter with great concentration, determined to find a fresh way of portraying her.

After much thought, Gandara posed his thirty-eight-year-old subject in profile. Unlike Sargent and Courtois, who had emphasized her bosom, he tactfully made her back central to his paint-

Antonio de la Gandara, *Madame Pierre Gautreau,* 1897

Amélie loved Gandara's elegant, romantic, and extremely flattering depiction of her. After his wife's death, Pierre Gautreau sent the portrait and the fan she holds to her American cousins. *(Private collection)*

ing, thus avoiding the question of whether or not her figure was all that it used to be. She wore an opulent white gown, which fell seductively from her bare shoulders and draped her waist with folds of satin. In her right hand was a large feathered fan. Her neck and upper arms, among the first parts of the body to show signs of age, were made to appear firm. Her hair was arranged in a chignon that somehow made her nose seem less prominent. The portrait

was understated and elegant. The Gautreaus preferred it to all the others and hung it in their home on the Rue Jouffroy.

As Amélie turned forty in 1899, the world around her was changing dramatically, bursting with new sights, new inventions, and new pastimes. The Eiffel Tower dominated Paris's landscape. Automobiles cruised Haussmann's boulevards. The Lumière brothers dazzled audiences with their first motion pictures.

But there was nothing new about Amélie. Her copper-colored hair required a henna rinse to keep it that hue. Her aristocratic chin was softening. Her slender body had filled out and looked substantial and overripe. Montesquiou, who had been so enchanted with Amélie when she entered society as an alluring young bride, was one of the first to ridicule her when she showed signs of age. "To keep her figure she is now obliged to force it," he mocked, "Not to the mold of Canova but a corset." The sculptor Antonio Canova was known for his exquisite marble representations of shapely women.

In "Venus," a satirical poem dedicated to Amélie, Montesquiou found other grounds upon which to ridicule her.

*Since she has pink tendrils, a nose that knows no limit,*
*The portrait by Sargent, the unicorn's profile,*
*And at night, she sleeps beneath the high four-poster canopy,*
*With a resounding pillow in Morocco leather,*
*In order to be warned in time, of a mauve hair*
*Just getting ready to come through, on her temple, and it is saved*
*Since she has the golden trowel, decorated with enamel*
*To coat her face, with exquisite workmanship,*

*Of scented and smooth mortars,*
*She still walks around, a fine-looking wreck,*
*And her famous curves leave each night,*
*Gaining in Caran d'Ache and losing some of their Canova.*

Caran d'Ache was the assumed name of Emmanuel Poiré, a Russian who moved to France and gained fame with his satirical cartoons. By mentioning Caran d'Ache and Canova, Montesquiou was commenting that Amélie had lost her figure and was a more appropriate subject for caricatures than compliments. With his barbed reference to her "golden trowel," he was accusing her of putting on her makeup with a shovel.

Perhaps Amélie did have a heavy hand when it came to her toilette. But she was trying to compensate for age, and for the fact that she was the mother of a grown woman. Her daughter Louise, at twenty-two, was as beautiful as her mother had been at the same age, and much more animated. No one ever described Louise as resembling a statue.

Louise's combination of good looks and lively personality attracted the interest of Olivier Jallu, a lawyer who was rising in French politics. They were married in 1901. Amélie apparently did not attend the wedding—her signature is nowhere to be found on the marriage certificate. Yet her absence on this significant day seems not to have affected her relationship with her daughter: Amélie and Louise remained close, and continued to summer together at Les Chênes every year.

After Louise left home to live with her husband in Paris, Amélie and Pedro examined their relationship, which for both

had always been a union of convenience. They had had small estrangements over the years, first spending evenings apart, then taking separate vacations. Amélie routinely traveled to Nice and other fashionable destinations in France, while Pedro retained his taste for South America. He traveled often to Chile, and even wrote a monograph on Franco-Chilean arbitrage, an important study that established him as an expert in the field.

The Gautreaus decided that their separate lives dictated separate residences. In the new arrangement, Pedro remained on the Rue Jouffroy, while Amélie moved into an apartment building on the Rue de la Tour, a narrow street leading to the Eiffel Tower. Her new address was not as prestigious as the previous: the building had an undeniable bourgeois air about it, with its utilitarian entrance and unadorned façade. But there was one good feature—a large courtyard and garden that perhaps reminded Amélie of the Avegno residence in New Orleans.

Essentially single, a woman of a certain age, and the mother of a married daughter who was poised to have her own children, Amélie seemed condemned to the unfortunate status of forgotten matron. More than a decade would pass before she received an unexpected reprieve. In 1905, after refusing many requests to exhibit *Madame X* over the past twenty years, Sargent had finally been persuaded to show the painting at the Carfax Gallery in London. The news reached Amélie, and although she had no plans to attend the show, she must have experienced conflicting emotions when she imagined the public showing: she worried that there might be another controversy, yet at the same time she desired the attention the portrait would bring her.

*Madame X* had developed a cult following over the years, its reputation promoted by insiders who had seen the portrait in Sargent's studio and by the 1903 publication of a book of photogravures of Sargent's works. The Carfax exhibition generated fresh interest in the painting, inspiring a new generation of critics to approach it without the prejudices of the academy or the hypocrisy of the previous years. Roger Fry, reviewing the show for *Athenaeum,* called the portrait a masterpiece.

Kaiser Wilhelm II saw the exhibition and pronounced *Madame X* his favorite painting. He knew Amélie from diplomatic circles and asked her whether she could use her influence to persuade Sargent to send the painting to Berlin for a special exhibition. She and Sargent had not been in touch over the years, and she had no influence over him, but Amélie agreed to make the request, thrilled to be in league with a head of state.

Amélie wrote to Sargent, explaining that the Kaiser, who was "such a dear," thought Sargent's portrait of her "the most fascinating woman's likeness he has ever seen." She hoped Sargent would recognize the importance of the request and make this portrait, as well as other selected paintings, available for an exhibition in Germany.

Sargent replied that he was "abroad and couldn't manage it." But he confessed to a friend that it was simply too much trouble and that Berlin held no attraction for him. Amélie was sorely disappointed that she could not deliver the favor the Kaiser wanted. When she realized that the portrait was coming to be both acclaimed and in great demand, she may have understood that not purchasing it in 1884 was a mistake. If she owned *Madame X,*

she would not have to depend on Sargent's largesse, but would be free to send it to the Kaiser or anyone else who wanted to display it.

Perhaps it was the renewed interest in the painting that inspired Amélie to invite two more artists, and two more portraits, into her life. She arranged to sit for Édouard Sain and Pierre Carrier-Belleuse. Sain, a minor artist who generally did landscapes, painted a charming if conventional portrait, showing Amélie in daytime dress and flowered hat. He posed her looking straight ahead, so her nose was not the identifiable one of previous portraits. The overall effect of Sain's painting was demure but unimpressive. Amélie looked like any attractive Parisian matron; there was little evidence of the arresting beauty.

Instead of painting her, Carrier-Belleuse chose to draw Amélie with pastels, softening her features almost to unrecognizability. The artist was being kind in blurring the lines. By the time his portrait was finished, in 1908, Amélie was almost fifty and needed the help. *Femina,* a French newspaper, used this very drawing to illustrate an article about women aging gracefully—a slap in the face to Amélie, who did not want to acknowledge that she was aging at all.

Amélie realized the portraits were a mistake. The earlier ones, the Sargent and the Courtois, would remind the world of her glorious, youthful self. The later ones, the nondescript Sain and Carrier-Belleuse's hazy pastel, would show all too clearly how she had changed. Either way, the portraits mocked her. With those images in circulation, she would always be competing with herself.

The ultimate insult came when Amélie was vacationing in Cannes. While strolling on the beach, she overheard a conversation between two women who had been watching her for some time. One loudly observed to the other that Amélie's "physical splendor had totally disappeared." The words shook her more than any insult ever had. She was probably stunned at first, then sad and wounded. Amélie retreated into her carriage, lowered the shades, and returned to her hotel. She ordered her maid to pack her bags and hired a private car on a train to transport her to Paris.

Previously, Amélie had delighted in being seen, by everyone. Now she wanted to be left alone. In the hours it took to return to Paris, she made up her mind never again to subject herself to public scrutiny. She would be a recluse.

Amélie became obsessed with avoiding her image. In her homes in Paris and Brittany, she had the mirrors removed from every room, so she would never have to look at herself. The woman who had once lived in front of the mirror, happily attending to every detail of hair, makeup, and wardrobe, could not bear the thought of seeing her own face.

As Amélie withdrew from the world, *Madame X* continued to step out. Three years after the Carfax showing, it traveled to the London International Society. In 1909, as the Kaiser had hoped, *Madame X* went to Berlin. Sargent gave in to the ruler's request after having denied Amélie the satisfaction of making the arrangement.

With every exhibition, the portrait was winning new supporters and growing more renowned. Amélie, by contrast, was fading.

During a routine visit to Paramé, where his family still maintained a home, Gabriel Pringue saw Amélie after she had withdrawn from society. She was no longer the woman who had dazzled an impressionable teenager. Amélie almost never received anyone, and Pringue had not seen her in several years. But on this occasion, while he was visiting Louise, she surprised her daughter and other guests by dispatching a servant to summon him to her room. Perhaps she was making an exception because of a fond memory of her night with him at the opera.

With no idea what to expect, Pringue walked nervously up the stairs leading to Amélie's boudoir. He found her dressed in white from head to toe, surrounded by white furniture. The shutters were closed, blocking the light. The effect was ghostly and disturbing; she looked like a statue. She seemed so otherworldly, in fact, that Pringue was startled when she spoke.

She welcomed him imperiously and kept their conversation formal and distant. When Pringue opened his mouth to pay Amélie a compliment, she raised a finger to her lips in protest and stopped him before he could get any words out. "One must never lie to women, even to please them," she cautioned. After decades of praise and adoration, Amélie could not bear to hear empty flattery, even if it was well intentioned.

At fifty-one, Amélie existed at the center of a small cluster of companions, consisting primarily of her mother and her daughter; her trusted personal maid, Gabrielle; and on occasion, when he was at Les Chênes, her husband. They made her feel comfortable and secure. When Marie Virginie died in 1910, at age seventy-three, Amélie's world grew even smaller. Marie Virginie left her

jewels, laces and silver, and home furnishings to Louise, and her Parlange plantation property to both Amélie and Louise.

One year later, Louise died suddenly in Paris, only thirty-two years old. Losing both her mother and her daughter within twelve months, Amélie must have been devastated. Marie Virginie had been a faithful companion, dedicating herself to her daughter's future when she could have made a life for herself. Louise had been indulgent of Amélie too. She overlooked her mother's inattentions and petty vanities, staying close to her despite her faults. Without Marie Virginie and Louise, Amélie was alone.

Amélie rarely emerged from her self-imposed prison, venturing out only under cover of darkness. Late at night, swathed in white veils, she would walk the beach at St.-Malo, remembering the crowds who once gathered to watch her when she was young and beautiful. The beaches were empty now, with no traces of admirers—or detractors. But even if she had run into people during her midnight excursions, they would likely not have known who she was.

On July 25, 1915, Amélie died in Paris. No cause was noted on her death certificate, but it is believed that she had suffered a serious fever. Soon after she died, her body made a last trip from Paris to Paramé. Although she and Pedro were estranged, he allowed her to be buried in the Gautreau family mausoleum, in a cemetery not far from Les Chênes.

Amélie's will detailed instructions for the distribution of her property. Gabrielle, the faithful maid who stayed with her until the end, was to receive 1,000 francs, a generous amount for a do-

mestic. Amélie left nothing to Pedro. She named two men, Brigadier Amédée Caillaux and Dominique "Henri" Favalelli, as her principal heirs.

Sixty-four-year-old Victor-Amédée Caillaux, who inherited 2,000 francs, listed his residence as the Ministry of Finance in Paris. He gave sworn testimony that he had met Amélie in 1890 and had enjoyed "very friendly relations" with her since then. He said that he saw her every New Year's, and at other holidays.

Henri Favalelli identified himself as a sixty-year-old tax collector. He testified that he had met Amélie in 1906 and that he saw her yearly in the months of September and October. He had seen her more frequently in the past few years, and he offered to produce letters as proof of their relationship. Favalelli inherited everything Amélie owned, including her three-quarter share of the Avegno tract of Parlange plantation. Pedro held the other quarter, which he had inherited from Louise.

Amélie's will was a mystery. These two men seemed to have come from nowhere—had Amélie been so alone in her final years that mere acquaintances took the place of loved ones? Her relatives in America had never heard of Favalelli and were shocked by the prospect of having a total stranger in their midst. But Favalelli and Pedro were not sentimental about their legacies. They had no interest in owning land in America and no affection for Parlange plantation. They sold their property in 1918 to Pelican Realty Company and a man named Thomas Madison Baker for $20,000.

Amélie was condemned to live in the shadow of *Madame X*. Like Dorian Gray, she was tyrannized by her own image, driven

to new levels of vanity in her endless, and ultimately foolish, pursuit of fame and immortality. Sargent's portrait compelled her to be painted over and over, by Courtois, Gandara, Sain, Carrier-Belleuse, and others, first in an unsuccessful attempt to obliterate Sargent's painting, and then in an even more futile attempt to equal it. Both painting and woman were works of art. But *Madame X,* not Amélie, proved the real and enduring masterpiece.

## A Man of Prodigious Talent

Sargent returned to London in the fall of 1885 with vivid memories of the summer and renewed faith in himself and his future. He delighted Henry James by announcing his decision to give up his Paris studio and move permanently to London. His studio on the Boulevard Berthier was taken over by Giovanni Boldini, an Italian artist whose career trajectory would unfold as Sargent had once imagined for himself. Boldini became a portraitist in Paris and elsewhere on the continent, sought after by prominent men and women.

Sargent's family had fallen back into the habit of moving frequently. They wintered in Nice and traveled to Venice, Florence,

and other European cities the rest of the year. While Sargent remained in constant touch with his parents and sisters, he lived on his own, planning trips that did not include them.

In London, Sargent moved into a studio on Tite Street, near James, who was ready as always to take charge of his friend's social life. The Millets and others at Broadway were already talking about the next summer, when the painter would return to finish *Carnation, Lily, Lily, Rose.* Sargent sent lily bulbs to Lucia Millet during the spring so he would be assured of having the right flowers to paint the following summer. It was a practical act that demonstrated how carefully Sargent planned ahead. Whenever possible, he left nothing to chance.

The lily bulbs had a symbolic significance as well. Sargent was putting down roots in a new life. He was unwilling to sever all ties to the past, though, and moved two meaningful canvases to his London studio: a depiction of Albert de Belleroche, and the portrait of Amélie.

*Madame X* was locked away in Sargent's studio, visible only to the artist and his guests, but it remained an obstacle he could not overcome. Prospective clients, afraid he would produce something radical or unflattering, were still reluctant to entrust him with their images. With its taint of scandal, the portrait kept Sargent from receiving the important commissions he needed.

The best way to carry on during this difficult period was to keep painting. Sargent returned to Broadway in the summer of 1886 to finish *Carnation, Lily, Lily, Rose.* He was at once drawn into the Millets' antics and celebrations, including a birthday party for Lily Millet. Edwin Austin Abbey boasted, "We have

music until the house won't stand it," and even stuffy Henry James was persuaded to dance until he was breathless.

Sargent's daily ritual of working on the canvas continued as it had a year earlier. Some observers questioned whether the painting would ever be completed, since Sargent worked and reworked his canvas every night, repeatedly scraping it down "to the quick" and starting over with fresh paint at the next session. But the nightly attacks were purposeful and productive: after five weeks of work, he was finished with the painting.

Measuring 68½ by 60½ inches, *Carnation, Lily, Lily, Rose* depicts two children standing in a lush garden amid a riot of colorful lilies, poppies, roses, and carnations. An affirmation of life, innocence, natural beauty, and spontaneity (even though every effect was meticulously planned), the painting is in every way—artistically and thematically—the antidote to *Madame X*.

At Broadway, Sargent had developed a genuine appreciation for the pastoral, and he expressed that feeling spectacularly in this work. But the painting also signaled the return of sound business instincts. There was a very good chance that the same people who rejected *Madame X* because they thought it was decadent and artificial would find this idyll more to their liking.

Sargent took the painting to London in October, where it joined *Madame X* on his studio wall. He started to move about in society again after his weeks in the country, and often spent time with the progressive young artists of the New English Art Club. While meeting new people, he began to discover that the lingering memory of *Madame X* was working in his favor. Now there were women, especially in America, who liked the idea of ap-

pearing seductive in a portrait and who believed—as Amélie was coming to realize—that any kind of fame was better than anonymity.

Isabella Stewart Gardner, a wealthy American patron of the arts, was one of these women. She had heard about *Madame X*—news of the scandal at the Paris Salon crossed the Atlantic quickly—and was eager to meet the artist who had created the notorious portrait. Gardner, born to a wealthy New York family, was rumored to have climbed out of a convent window to elope with John Lowell Gardner II, called "Jack," the son of a wealthy and aristocratic Boston family. She was a flamboyant society woman who refused to observe the rules of etiquette imposed on ladies of the time: she served tea to her guests—male and female—in her boudoir, she dressed daringly in form-fitting gowns, and she made no secret of the fact that she preferred the company of men to that of women.

In 1863, while in her early twenties, Gardner gave birth to a son, named after his father. Jackie died two years later of pneumonia, and Gardner was instructed by her doctor to take a long trip to lift her spirits. Like Mary Sargent, she hoped that travel would distract her from her grief. She and Jack went to Europe, where she listened to music in Vienna, shopped for gowns at Worth in Paris, and became a connoisseur of fine jewelry in London. Over the next twenty-three years, the Gardners traveled frequently, visiting Paris and London regularly, and venturing farther, to the Holy Land, Cambodia, and Japan.

A fabulous fortune generated by the family shipping business enabled them to indulge every whim. Gardner owned among

other items a necklace strung with forty-four perfect pearls and topped with a giant diamond clasp; she habitually purchased magnificent rubies and other jewels. The Gardner house in Boston, featured in magazines, had a novel glass-roofed atrium and was packed with expensive furnishings.

The Gardners spent lavishly but without any real purpose, until they began collecting rare books and manuscripts. Following the examples of nineteenth-century American millionaires such as the steel magnate Henry Clay Frick and the industrial and banking titan John Pierpont Morgan, they turned their attention to paintings. Gardner liked to be an informed shopper, so before she made any purchases of contemporary work, she would try to meet the artists. Thanks to the *Madame X* business, Sargent was on the list of artists whose work she wanted to see.

In October 1886, while on one of her tours of Europe, she begged her friend Henry James to take her to Sargent's studio to see the famous portrait. As soon as she saw it, she knew she was in the presence of a thrilling talent. She was determined to have Sargent paint her. This woman who gladly disobeyed rules of propriety loved the idea of shocking staid Boston society. If she returned to the States with a portrait as daring and controversial as *Madame X,* it would affirm her as a social maverick. Unfortunately, she was unable to linger in London for a sitting. She arranged for Sargent to paint her the next time she came to Europe.

In May 1887, *Carnation, Lily, Lily, Rose* was shown at London's Royal Academy of Art, at an exhibition much like the Paris Salon. The painting was a smash hit. Critics were charmed by its

dazzling display of color and light. *The Spectator* described it as "purely and simply beautiful," while *Art Amateur* said it was "the talk of all the studios, as it is now the talk of the town." Sargent was paid the highest compliment when the Chantrey Bequest, a fund dedicated to the acquisition of great works of art, paid £700 to acquire the work for the Royal Academy's permanent collection.

Sargent's Broadway friends, many of them Americans, carried the news of Sargent's triumph to their acquaintances in New York and Boston. Henry Marquand, a banker and avid collector of Vermeer, Van Dyck, Hals, and other old masters, who in 1889 would become president of the Metropolitan Museum, had heard compliments about Sargent's work from Lawrence Alma-Tadema and other artists he trusted. He invited Sargent to the United States to paint a portrait of his wife.

Sargent, sensing he was on the verge of recognition in London, was reluctant to accept the job. Half hoping that he would be refused, he named an inflated fee—at a time when artists far more established than he typically made $3,000 for a portrait, he asked for $2,000 to $2,500—and was shocked when Marquand agreed to pay it. Sargent had no choice but to pack his bags and head for the Marquands' summer home in Newport, Rhode Island. He planned to make quick work of the portrait so he could return to London as soon as possible to profit from the success of *Carnation, Lily, Lily, Rose.*

Newport during the 1880s was a popular destination for the rich. Every summer, affluent vacationers from New York, Boston, and other cities would arrive in this picturesque seaside town,

lured by its scenic beaches and exclusive social scene. In the 1850s, in an ostentatious display of fortune, wealthy families had begun building enormous mansions, their summer "cottages." They brought with them massive amounts of luggage and troops of servants, maintained full households, and kept busy social schedules through the season, which sometimes extended into the early fall. Days were devoted to swimming and lawn tennis and arranging extravagant entertainments for friends and associates. One summer, the owners of Chateau-sur-Mer, the first of the monumental Italianate residences bordering posh Bellevue Avenue, hosted a French picnic attended by two thousand guests. It was not unusual at the time for a family to spend as much as $70,000 on a lawn party or a ball.

By the time Sargent arrived in Newport in the early autumn of 1887, new wealth had begun to move in. The Vanderbilts and other self-made barons, who had amassed large fortunes in short periods of time through ingenuity and industry (but also through more questionable means), and who tended to spend their cash as quickly as it came in, were building Renaissance-style palaces even more elaborate than existing mansions. The houses built with new money were deliberately ostentatious, routinely boasting dining rooms large enough for dozens of guests and ballrooms trimmed in real gold leaf.

Sargent's clients the Marquands were, however, long-standing members of Newport society. A local paper announced their guest's arrival: "Mr. J. S. Sargent of London who has become somewhat renowned as a portrait and figure painter is in town and is staying with Mr. H. G. Marquand on Rhode Island Av-

enue." Sargent set up a temporary studio in the Marquands' home and warmed to them instantly. He considered the portrait of Elizabeth Marquand carefully, because he liked her personally and because he knew this was his chance to impress a new audience in a new country. He decided to emphasize the sixty-one-year-old Mrs. Marquand's refinement and dignity, seating her in a tasteful Chippendale chair and having her wear a simple yet expensive-looking gown with a lace shawl and cuffs. He worked on the portrait from late September to the end of October, and as he had intended, the result was quietly glamorous, even noble. The painting was admired by critics and socialites alike.

*Mrs. Henry Marquand* initiated a rapid social and professional ascent for Sargent in America. With the attention he was receiving, he abandoned his plan to rush back to London. American aristocrats, it turned out, appreciated the European flair Sargent demonstrated in his painting. They liked the flashy brushwork, the startling poses. The same affluent men and women who shopped for couture clothes in Paris and commissioned homes resembling Italian palazzos and French châteaus desired the services of an artist who could make them look grand. Observing his portraits, said the English writer Osbert Sitwell, rich people "understood at last how rich they really were."

For the next three months, from November to January, Sargent traveled from Newport to Boston, Boston to New York, and then back to Boston, winning lucrative commissions in each city. Henry James helped him by seizing every opportunity to promote his name. He wrote an article that appeared in the October issue of *Harper's New Monthly Magazine* that celebrated his

friend's virtuoso talent and technical genius. Sargent, James proclaimed for the benefit of upper-class America, was the only artist worth patronizing. The writer praised Sargent's ability to recognize and accentuate the individuality of his subjects. Sargent, he said, saw "each work that he provides in a light of its own" and did not "turn off successive portraits according to some well-tried receipt which has proved useful in the case of their predecessors."

Sargent established himself in the artistic community as well, seeing several Americans who had been students with him in Paris and who had returned home to the East Coast. James Beckwith, his former roommate, was in New York seeking to further his career. Sargent had been approached by so many New Yorkers about commissions that he felt he would have more than enough work to pay the rent on a modest studio. He asked Beckwith to help him locate a suitable space. His new address, on fashionable Washington Square, would be convenient for his high-society clients.

Before Sargent settled in here, the Boits, his old friends and patrons who had been supportive in the early days of his career and throughout the *Madame X* debacle, invited him to visit them in Boston. They hoped he would have the time to paint Mrs. Boit. In November, Sargent put New York on hold and moved to Boston, where he rented a studio, unpacked his paints, and applied himself to painting not only Mrs. Boit and the sons of the magnate J. Malcolm Forbes, but also the irrepressible Isabella Stewart Gardner.

Mrs. Gardner would be a challenge. Unlike Amélie, Gardner was neither young nor exotically beautiful. She was forty-seven,

short, with an unremarkable face. But she was blessed with a voluptuous figure, a tiny waist, and a generous bosom that she loved to flaunt. She encouraged Sargent to devise a pose that emphasized these features.

With Gardner standing in front of an intricate, multicolored tapestry whose pattern framed her head like a halo, Sargent pushed and pulled her into a position that was, in its own way, as forced and artificial as Amélie's in *Madame X*. Gardner faces the viewer in a simple black gown that outlines every curve. She appears to be bending ever so slightly at the waist, an almost indecent move that thrusts her buttocks back and her bosom forward. Her gown's plunging neckline draws the eye directly to her breasts. Gardner wears her signature piece of jewelry: the strand of South Sea pearls that her husband had purchased early in their marriage. A painter might have been expected to place the necklace around her throat to attest to her wealth, but instead Sargent wrapped the priceless pearls around Gardner's waist, to call attention to her figure.

Gardner invited Sargent to stay at her lavish Beacon Street home while he was working on her portrait. He moved in, and although her husband was always there, Sargent's presence set Boston tongues wagging. They assumed he and "Mrs. Jack" were having an affair. She took pleasure in the rumors and did nothing to dispel them—after all, they accorded with the outrageous reputation she cultivated.

Sargent worked through the Christmas holiday and finished the portrait in January 1888. Gardner loved the painting and repeatedly tried to make Sargent agree that it was his best work,

perhaps competing with *Madame X* for his attention. She wanted more than a mere artist-client relationship with Sargent: she wanted to be his patron, muse, and intimate. He was the first painter whose works Gardner wanted to collect. She coveted *El Jaleo,* a painting far too large to fit comfortably in most homes, and envisioned building a Venetian-style palace to house it.

Sargent's success in America culminated with his first one-man show, which opened in January 1888 at Boston's prestigious St. Botolph Club. He selected twenty pictures for the exhibition, including *El Jaleo, Isabella Stewart Gardner, The Daughters of Edward Darley Boit,* and a selection of studies of Venice. The show was an undisputed success, attracting more than thirteen hundred people in its two-week run. That winter, from Back Bay drawing rooms to Cambridge studios, Sargent was the chief topic of conversation among Bostonians. Critics lauded his style and refinement.

Of the works exhibited, Gardner's portrait gained the most notice. The *Boston Herald* called it "the gem of the collection." But Gardner's husband, a plain-speaking man, was not happy. When his wife asked his opinion, he grudgingly admitted: "It looks like hell, but it looks like you." Sargent had captured Isabella Gardner's spirit, but not in a way that pleased Jack Gardner. He was disturbed that men had been making lewd remarks about his wife since the portrait was first shown. At his club, he overheard someone saying that Sargent had painted Mrs. Gardner so that one could "see nearly all the way down to Crawford's Notch," comparing her cleavage to a New England mountain resort famous for its plunging slopes. Gardner, who threatened to horsewhip anyone else who made such a comment, eventually

withdrew his wife's portrait from St. Botolph's and refused to let it leave his home.

Here again were all the ingredients of the *Madame X* scandal, principally a daring and suggestive portrait of a society woman. But things did not play out that way. It appeared that in this case the offended husband was the only person who minded that the painting was a little risqué.

After triumphing in Boston and finishing his other portraits, Sargent returned to his New York City studio at the end of January to start on a new wave of commissions. For four months he painted such luminaries as Mrs. William Henry Vanderbilt and Mrs. Benjamin Kissam. These women were the elite of New York society, grandes dames of prominent families who made Mrs. Caroline Astor's list of the four hundred people important enough to enter her ballroom.

Sargent's professional and personal calendars were booked for weeks. He now had plenty of friends in New York, and he was making new acquaintances every day. Sargent usually got along famously with his sitters, who often became his friends. Even after he left Newport, the Marquands continued to invite him to visit.

Among Sargent's new friends was the architect Stanford White, whose expansive artistic vision enabled him to design everything from picture frames to summer homes for the rich to the Washington Square Arch, a Greenwich Village landmark. Sargent and White had met in Paris and had admired each other's work. White and his partner Charles McKim recommended Sargent to their wealthy clients, convincing them that no mansion would be complete without a portrait by him. Their

firm, McKim, Mead, and White, was in the process of completing blueprints for the Boston Public Library, and White and McKim invited Sargent to design the building's murals.

Sargent returned to England in May 1888. His father, who had suffered a stroke in January, was very ill. Mary Sargent and her daughters fussed over him, and Sargent rented a summer house in the English countryside for himself and his family. His American tour, and all those portraits painted in a concentrated period, had left him exhausted. In England he cleared his head by painting *plein air* pictures, often setting up his easel on a boat and drifting down a river, just like Monet, the artist he admired more than anyone else.

Sargent returned to London in the fall. Word of his success in the United States had reached Europe. He was now able to command fees as high as $3,000 a portrait, a substantial rate for an artist of thirty-two. He was a new man, prosperous, confident, and firmly established in an affluent world—on both sides of the Atlantic—and could enjoy the security, recognition, and comfort he had always wanted. Sargent's international success was confirmed even in Paris, when he was invited to serve, with Monet among others, on the jury for the 1889 Salon.

Four years had passed since the disastrous showing of *Madame X.* Gérôme and Bouguereau still ruled at the academy, but the artistic climate in Paris was less divided as modernist artists made their way to the forefront of the creative world.

Fitzwilliam Sargent lived just long enough to see his son's success. He died in England in April 1889, without realizing his dream of returning to America. After his father's death, Sargent

stepped fully into the role he had been anticipating since his first days as an artist: he became the patriarch and the sole support of the Sargent family. Mary, Emily, and Violet were in his care. Violet, now a young woman, was thinking about love, marriage, and a future of her own, but Mary and Emily would be his dependents, with him for the rest of their lives.

*Madame X* continued to occupy center stage in Sargent's Tite Street studio, watching over an endless procession of lords, ladies, society matrons, and tycoons who came to have their portraits painted by the famed artist. The caricaturist Max Beerbohm depicted the parade of well-dressed women outside Sargent's studio, anxiously awaiting their turn at immortality.

Yet no matter how many women he painted, with their beautiful faces, elegant poses, and fashionable gowns, Sargent kept returning to one image from the past: *Madame X*. In 1901, he painted Ena and Betty Wertheimer, the grown daughters of Asher Wertheimer, a wealthy English art dealer. The portrait shows two lively, dark-haired young women in evening gowns: Betty wears red velvet, while Ena is in white. An X ray of the painting ordered by London's Tate Gallery reveals that Sargent originally painted Betty's strap to fall from her shoulder, just as in *Madame X*. This was probably a playful gesture on Sargent's part. Betty Wertheimer was known to have a good sense of humor, and Sargent always looked for ways to amuse his sitters. Although he repainted the strap, the fact that he painted it fallen suggests his state of mind: *Madame X*'s strap was no longer a painful subject to him, and he was still thinking about Amélie.

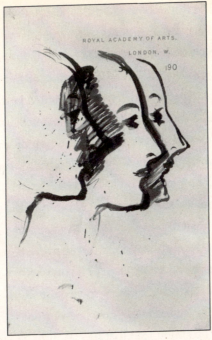

John Singer Sargent, *Three Profiles of Madame Gautreau*, 1906–1913

Sargent was still thinking about Amélie years after he painted her in *Madame X*. He was a successful artist living in London when he sketched these three versions of her unforgettable profile. *(Courtesy Fogg Art Museum, Harvard University Art Museums, Bequest of Grenville L. Winthrop, Photograph by David Mathews. Image copyright © President and Fellows of Harvard College)*

Indeed, sometime between 1906 and 1913, Sargent doodled Amélie's image on a piece of paper. He seems to have been working from memory when he drew her famous profile three times. He crossed out the first one, left the second completely visible,

and blacked out the chin on the third. The drawings were done after Sargent had started exhibiting the painting.

By 1907, Sargent had painted somewhere in the vicinity of 550 portraits. He had been a professional artist for more than thirty years and his enormous body of work included portraits, subject paintings, and landscapes; oils, drawings, watercolors, even sculptures for the massive Boston Public Library project; yet Sargent was best known as a portraitist. While his fervent wish in 1884 had been to join the top tier of French portrait painters, now that he was perhaps the leading portrait painter in the world, he wanted nothing more than to move on to what he considered more creative work. Of the portraits he felt forced to do, he said, "I abhor and abjure them, and hope never to do another especially of the Upper Classes." Sargent derisively spelled the word "paughtrait," and declared "No more mugs!" to whoever would listen.

The more he announced that he was through with portraits, however, the harder people worked to change his mind. One wealthy couple booked a hotel room adjacent to his, hoping to stage a "spontaneous" meeting that would give them a chance to plead their case. Sargent did his best to sidestep such requests, satisfying insistent admirers with quick charcoal drawings in lieu of dreaded oil.

In spite of his wishes and his accomplishments, *Madame X* was still, without question, his most famous work. Museum curators begged him to sell it, but he consistently refused. He sent the painting to exhibitions: it traveled to Italy in 1911, and to San Francisco four years later for the Panama-Pacific International Exposition.

After the San Francisco fair ended in early December 1915, instead of making arrangements to ship the painting back to London, Sargent sent a letter to his friend Edward Robinson, the director of the Metropolitan Museum of Art in New York, mentioning that the portrait of Madame Gautreau was in the United States. Robinson had expressed interest in purchasing *Madame X* a few years earlier, when he was at the Boston Museum of Fine Arts. Sargent was inclined to let the painting stay in America, he wrote, if a museum would be interested in buying it. He asked £1,000 for it—about $5,000, and substantially less than his fee for portraits at the time—stipulating that, "on account of the row I had with the lady years ago . . . the picture should not be called by her name." The Metropolitan accepted Sargent's offer and conditions, and the painting was sent from San Francisco to New York, where it was installed in the museum. There, for the first time, it became known officially as *Madame X.*

Amélie had died the previous July, while the painting was hanging at the Panama-Pacific Exposition. Perhaps it was her death that finally prompted Sargent to let go of the portrait that had been in his studios some thirty years. Sargent's directive to the museum to leave Amélie's name off the painting, however, defied explanation. When he first suggested the idea, Sargent had invoked his old disagreement with Amélie. But she and her family were hardly in a position to make a fuss. Both Amélie and her mother—the family members who had objected back in 1884—were dead. It was doubtful that Pedro, estranged from his wife for more than a decade before her death, cared about her name.

Was Sargent trying to punish Amélie in some way? By removing her name from *Madame X,* he robbed her of a claim to immortality.

Whether his true feelings for his subject had been love, obsession, or disillusionment, Sargent had no reservations about her image. In the letter he wrote offering the portrait to the Metropolitan Museum, he echoed the enthusiasm of a twenty-four-year-old Amélie. *Madame X* was a masterpiece, she had breathlessly declared in a letter. "I suppose," Sargent told the museum director, "it is the best thing I have done."

# Twilight of
the Gods

Sargent was sixty years old in 1916, when he sold *Madame X* to the Metropolitan Museum of Art. He was one of the most famous artists of his time, his works coveted by heads of state, museums, and collectors around the world. Journalists pounced on him for interviews, while museums and art schools, such as the Royal Academy of Art in London, competed for his advice and support. In 1917, he suspended his boycott of portraits to paint John D. Rockefeller and President Woodrow Wilson, having been approached with the argument that he was the only artist accomplished enough to depict the financial titan and the political eminence. England, Sargent's adopted home, paid him

the supreme compliment of offering him a knighthood. But Sargent politely declined, responding that he was "not one of His Majesty's Subjects but an American citizen."

Upholding the Sargent family tradition, he traveled constantly. His yearly routine saw him spend winter, spring, and early summer in London, and move through Europe during the rest of the summer and autumn. His sister Emily was his hostess when he was at home in England and his frequent companion when he was abroad. Mary Sargent had died in 1906, finally liberating her older daughter from the full-time job of keeping her company. For the first time in her life, at almost fifty, Emily was free to pursue her own interests. She chose to spend her time managing her brother's household, and painting—watercolors similar in style to her brother's. Although she and Sargent never lived together, Emily became a welcome fixture in his life. In late middle age, the siblings resumed the close relationship of their nomadic childhood.

Whether at home or abroad, Sargent led an active social life. Like Henry James, he went anywhere and everywhere. The artist rarely declined an invitation to join a dinner party; one hostess observed that she did not need to cultivate any other celebrities when she could get Sargent every day. Sargent's prodigious appetite showed no signs of declining as he grew older. When he deemed the portions at his club too small, the husky Sargent resigned his membership and defected to a club that offered more generous servings.

Throughout the first decades of the twentieth century, Sargent was very much in the public eye, the subject of magazine ar-

ticles, reviews in newspapers and art journals, testimonials, and drawing room conversation. But no matter how often his name appeared in print, he remained extremely private in all personal matters, only occasionally revealing the scantest details by the company he was seen to keep. Unlike many other artists and intellectuals who recorded their every thought and impression, Sargent did not keep a journal. And his letters were notoriously terse. James and other friends often speculated about Sargent's relationships with women. Flora Priestly, a Broadway friend and the subject of several Sargent sketches and paintings, was often suggested as a potential mate because he spent time with her over the years. But like Louise Burckhardt, she was no more than a platonic friend. Sargent admired Priestly, but he never pursued a relationship with her, or, it seems, with anyone else.

In 1918, during World War I, Britain's Ministry of Information invited Sargent to visit the front in Boulogne as an official war artist. He was interested in observing the fighting firsthand, and confessed that he hoped to "have the chance of being well-scared." But Sargent's enthusiasm was tempered by his need to surround himself with his creature comforts. He traveled to the front with painting supplies, a camp stool, and a full wardrobe, and is rumored to have asked a military official if the war would be suspended on Sundays. Here was a man who had spent most of his life in a world built on proper routines and schedules; war was chaotic, unfamiliar.

And yet his experience at the front brought him to create a memorable war painting. He had seen a group of soldiers, blinded by mustard gas, waiting in line at an infirmary for med-

ical treatment. Back in London, Sargent rendered a nightmarish vision of the young victims in a large canvas entitled *Gassed.* With this painting he defied expectations regarding his ability: he could paint not only the socialite but also the soldier, and both in powerful, revelatory detail.

After the war, Sargent divided his time between London and Boston, where, having completed his *Triumph of Religion* murals for the Boston Public Library, he commenced work on decorative murals for the rotunda of the Boston Museum of Fine Arts. Though in his late sixties, Sargent insisted on personally handling every detail involving his art, just as he had as a young man. He maintained his own studio, crated his own artwork, and even helped carry it to the street when necessary.

In mid-April 1925, disregarding the advice of concerned friends, Sargent engaged in this kind of physical activity as he prepared mural decorations for transport from London to Boston. On April 15, he died of heart failure; he was sixty-nine. His death, like his life, was peaceful, even comfortable: he was reading Voltaire in bed when he passed away. His memorial service, held at Westminster Abbey and attended by royalty, celebrities, and prominent figures from the artistic community, was an imposing affair, the first service of its magnitude to honor a modern artist.

In the days and weeks after his death, Sargent was paid the highest compliments in eulogies, obituaries, and newspaper and magazine articles summarizing his many accomplishments. He was so well-known that his passing was reported extensively by a variety of publications. "The man, indeed, was a master," said

London's *Daily Telegraph,* "of whom no unworthy saying or action is recorded." The *New York Herald Tribune* called him a giant, "a figure in modern art comparable only to the great leaders in the old historic periods." Personal reminiscences about him filled the newspapers. A story circulated that when an artist friend of Sargent's died prematurely, leaving a number of unfinished canvases, Sargent quietly completed the works himself, claiming no credit or reward. No one seemed to have anything bad to say about Sargent; in one interview, his manservant, Nicola d'Inverno, who worked for him for twenty years, attending to household and studio duties and posing for nude studies, spoke respectfully of his former employer.

Over the next few years, Sargent's reputation continued to flourish. Already some three months after his death, 237 of his paintings and drawings were sold at auction for £170,000, an unprecedented sum, representing some $8.28 million today. Unlike portraitist Charles Chaplin, famous in life but unknown or even ridiculed later, or van Gogh, who struggled throughout life and was acclaimed a genius only after death, Sargent attained a constant celebrity. He was fully appreciated during his life and then, at least for a period, after his death.

By the 1930s, after forty years of preeminence in England and America, Sargent was falling out of favor. Many critics and collectors had grown tired of the representational art that had been around since the previous century—especially formal portraiture—and were drawn, instead, to more radical and provocative avant-garde movements. New talents like Picasso were using their art to express the chaotic nature of modern life. Many

artists were more interested in painting concepts than people: sometimes their figures were barely recognizable as human. They prided themselves on interpreting reality rather than slavishly reproducing it, and their revolutionary works appealed to art lovers who wanted to be on the cutting edge. Critics who often built their own reputations by identifying and promoting the new and the different, summarily rejected Sargent's portraits as old-fashioned and irrelevant. Roger Fry, who had praised *Madame X* when it was shown at the Carfax Gallery in 1905, now changed his tune: "That Sargent was taken for an artist will perhaps seem incredible to the rising generation," he wrote; Sargent was little more than an "upper-class tourist."

Marginalized by such important commentators, Sargent and his reputation faded; he became a relic of the past. And his friends—all those brilliant creatures—lost their luster over time as well. Dr. Samuel-Jean Pozzi, a man at the height of his sexual and intellectual powers when Sargent painted him, enjoyed a long life, but weakened as he got older. His affair with Amélie must have been short-lived: after the early 1880s, there were no blind items about them in the society pages, just rumors that the still-nominally-married playboy maintained a bachelor's apartment on the Boulevard St.-Germain. While continuing to battle his mother-in-law for his wife's affections, Pozzi entertained a variety of women and consorted with writers and artists such as Guy de Maupassant and Émile Zola.

Searching for excuses to stay away from Paris, Pozzi traveled constantly, attending medical conventions, visiting friends, and shopping for antiquities. An avid collector of coins and antique

sculpture, Pozzi was elected president of the Society of Anthropology of Paris in 1888. He entered politics and won a senatorial seat in the Dordogne, the area where he was born. Even with this demanding schedule of work and play, Pozzi found time to write poetry and exchange ample correspondence with Montesquiou, the early feminist writer Augustine Bulteau, and other friends.

In 1896, Pozzi and Thérèse suspended their ongoing marital war long enough to have another child, their third. Jacques Pozzi was a beautiful baby who charmed everyone with his sweet disposition and playfulness. But as he got older, he developed emotional and mental handicaps, perhaps related to his mother's advanced age at the time of his birth. Because of his unpredictable and sometimes violent behavior, Jacques was institutionalized when still a child.

In 1900, the family moved to a new residence on the Avenue d'Iéna in Paris. The house featured separate entrances for Pozzi and Thérèse—with Pozzi's on the right, Thérèse's on the left—to ensure that they would not encounter each other. Pozzi considered his unhappy marriage and the sad fate of his youngest child the biggest disappointments of his life. Conversely, he had great success with many women and his medical career was a catalogue of accomplishments. While his personal life was deteriorating, Pozzi was considered one of the leading gynecologists, surgeons, and diagnosticians in Paris. He introduced hygienic procedures in the operating room and campaigned for cleaner and more aesthetically pleasing hospitals, at a time when such institutions were filthy and dangerous, and for public services for syphilitic

women, who were generally shunned by society. Pozzi held a pioneering belief that the patient's state of mind was as important as physical well-being, and he decorated the walls of his medical office with original works by contemporary artists to distract patients from their problems and inspire them to think of more pleasant subjects.

Still charismatic in middle age, Pozzi had earned the reputation of "doctor to the stars" because he counted people like Sarah Bernhardt and Alfred Dreyfus among his patients. A 1909 caricature shows him in a tuxedo, standing in the midst of voluptuous opera singers and actresses who call him "Dr. Love." But Pozzi's pursuit of sex grew more desperate as he aged. He founded a private club, the Cercle des Amis de la Rose, to promote sexual adventures. This "Circle of the Friends of the Rose," or "League of the Rose," counted among its members fin-de-siècle swingers who used their intellectual curiosity as an excuse to explore their wildest sexual fantasies. The circle had very strict rules. Married members had to come without their spouses, so that they would feel free to say and do anything without censure or guilt. Participants would play an orgiastic version of Truth or Dare, describing their fantasies and then acting them out for the group.

The League of the Rose was secretive about its membership and its practices. The use of "Rose" in the club's name suggested a connection to the Rosicrucian order, a sect that claimed origins in ancient Egypt and that was promoted in nineteenth-century France by, among others, one Joséphin Péladan. Calling himself "Sâr Merodac" (he had already changed his name from Joseph to

Joséphin), Péladan hosted artistic and cultural gatherings for order members. In 1892 he sponsored a first Rosicrucian salon for the art world. The Salon de la Rose-Croix exhibited spiritually themed paintings, many of them symbolist works, which rejected realism in favor of myth, dream, and sensation. The artists who participated in the six annual salons were all men: one of the order's bylaws prevented women from showing their works.

Mystic orders such as the Rosicrucians were popular in the nineteenth century because they introduced elements of drama and ritual into lives that were ordinary in other respects. Yet many of those who joined were more interested in sex than in mysticism. The fact that Pozzi, famous for having been a great lover, had to resort to organizing sexual encounters among aging intellectuals indicates that his erotic heyday was firmly behind him.

Back in 1886, Pozzi had treated fifteen-year-old Marcel Proust, a family friend, to his first dinner at the Ritz, the meeting place for fashionable Parisians. Years later, Proust used Pozzi as the source for the character Dr. Cottard in *Remembrance of Things Past*. Pozzi, whom Proust had seen change from a virile lothario to a man past his prime (and who had politely refused to issue Proust a note to excuse him from military duty), was depicted as a pompous physician who turned up at every dinner party, desperate for attention.

Pozzi's death was nothing short of sensational. In 1916, he operated on the penis of a man named Maurice Machu. The patient was unhappy with the results of the surgery and believed that Pozzi had made him impotent. He requested a second oper-

ation, but Pozzi refused. On the afternoon of June 13, 1918, Machu rushed into Pozzi's office, shot the doctor, and then turned his gun on himself. Pozzi struggled to stay alive. He managed a few words of advice and encouragement to the doctors who tried to save him on the operating table. He died of his wounds a few hours after being shot, and made the front page of the newspapers.

After his death, Pozzi's family expressed their ambivalence about him by putting up for auction all his belongings, including Sargent's portrait of him. At the last minute, however, his son Jean withdrew the painting, and he kept it for the next fifty-one years, until his death. The entrepreneur and art collector Armand Hammer purchased it for his museum in Los Angeles—a fitting resting place for Dr. Love, celebrity physician.

The other Sargent painting in Pozzi's collection was *Madame Gautreau Drinking a Toast,* which Sargent had completed while working on *Madame X.* Somehow the painting had passed from Marie Virginie's possession to Pozzi's. Did Amélie ask her mother to give it to her lover? Did Pozzi buy it as a souvenir of their affair? This memorial to a young woman at the height of her beauty would have been a magnificent trophy for a man who collected women.

Isabella Stewart Gardner purchased *Madame Gautreau Drinking a Toast* at auction after Pozzi's death. She brought it to Boston, where it now hangs in the Gardner Museum. The museum boasts several other important Sargents, including *El Jaleo.* But it is this valentine to Amélie that adorns the museum's café menu.

Louise Burckhardt, the subject of *Lady with the Rose* and *Mrs. Edward Burckhardt and Her Daughter Louise,* found the husband she wanted, marrying an Englishman in 1889. Louise died shortly after traveling through Europe with her husband on an extended honeymoon. She had no chance to enjoy the long and happy marriage she had imagined for herself after years of spinsterhood.

Although their relationship had not developed further than a platonic friendship, the story of Louise and Sargent continued even after her death. In the 1920s, her sister Valerie, who had inherited *Mrs. Edward Burckhardt and Her Daughter Louise* from her mother, asked Sargent to remove Louise from the portrait; she thought her sister's presence ruined the composition. To illustrate her point, Valerie sent him a photograph of the painting that had been altered to show an empty space where Louise had stood. Sargent was adamant about the artistic integrity of his painting. He refused Valerie's request, telling her that "I cannot consent to do that any more than I would wear my hat in a drawing room or eat peas with a knife." Today, *Lady with the Rose* hangs in the Metropolitan Museum of Art in New York, one painting over from *Madame X.* The unretouched *Mrs. Edward Burckhardt and Her Daughter Louise* hangs in a private collection.

Judith Gautier liked to be surrounded by her portraits. She kept all of them on prominent display, including *A Gust of Wind,* Sargent's romantic and most flattering vision of her. For years after the deaths of Victor Hugo and Gustave Flaubert, Gautier clung to her role as high priestess of the arts in Paris. She contin-

ued to dine out on her association with Wagner and other luminaries, and in 1910 she was the first woman to be elected to the prestigious Académie Goncourt, the board responsible for selecting the winner of the Prix Goncourt, one of France's highest literary awards.

Gautier, the ultimate fan, ended her life in thrall to the attentions of her own obsessive groupie. Suzanne Meyer-Zundel was a colorless young woman from a wealthy bourgeois Alsatian family. She had only one talent, and it was both very strange and very specific: she had developed a reputation in Paris for modeling exotic flowers out of bread crumbs. During a trip to Brittany in 1904, she met Gautier at Le Pré des Oiseaux; she made it her business to never leave her side after that.

Meyer-Zundel moved in with Gautier, who was fifty-nine at the time, and insinuated herself into every corner of her life. When Gautier died in 1917, she left her entire estate to her companion. In 1934, Meyer-Zundel sold Gautier's art collection at auction in Paris. One of Sargent's paintings of Gautier—a Japanese-style portrait in which she poses much like Madame X—was purchased by Jean Pozzi, the doctor's son; the painting has since disappeared. Gautier and Meyer-Zundel are buried in a cemetery in St.-Énogat, near Le Pré des Oiseaux, so close that they are practically in the same grave.

After his intense relationship with Sargent, Albert de Belleroche was determined to become more independent artistically. He was afraid that the more experienced painter exercised too much influence over his work, tying him down to painting when he might experiment with other art forms. Belleroche wanted to

find his own style and medium, separate from Sargent's prefer-
ences. When Sargent invited him on a trip to Palestine, the
younger artist declined, fearing that "a journey like this with Sar-
gent might influence me in my art and affect my individual ex-
pression." It is likely too that Belleroche feared becoming overly
close to Sargent emotionally. He was only nineteen when he met
Sargent, an age when it was not uncommon to be sexually adven-
turous. But it was a dangerous time for two men to explore the
possibility of an intimate relationship, especially after Sargent
moved to London in 1885. The British government had recently
passed the Labouchere Amendment, criminalizing sex acts be-
tween men, and placing sexually active homosexuals in danger.
This law was used against Oscar Wilde for his affair with Alfred
Douglas in 1895.

Over the years, Sargent and Belleroche maintained their
friendship, using each other's studios and corresponding regu-
larly. But they were never as close as they had been during the
summer of *Madame X.* Belleroche pursued other interests and
other relationships. Following the lead of many young artists, he
moved into a studio in Montmartre, opposite the Moulin Rouge,
and painted popular models of the day such as Victorine
Meurent, who posed for Manet's *Olympia,* and Lili, the favorite
of Toulouse-Lautrec. Aggressively asserting his heterosexuality,
Belleroche had a tempestuous ten-year affair with Lili and be-
came a familiar figure in Montmartre's bohemian circles. A gifted
painter who could have led a successful career as a portraitist,
Belleroche in 1900 set aside his easel to spend more time on
lithography. His lithographs, generally romantic depictions of

women, were so finely executed, so painterly in their details, that the artist Frank Brangwyn said of Belleroche that "no one else has succeeded in making lithography the rival of painting."

In 1910, Belleroche ended his affair with Lili to marry Julie Visseaux, the daughter of a sculptor. Lili, disturbed by her lover's betrayal, took to behaving irrationally and unpredictably: she tried repeatedly to break up the marriage. Belleroche and Julie moved out of Paris, out of France, to escape her rage and start a new life. They had three children and lived quietly in the English countryside while Belleroche developed his reputation as a master lithographer.

Until the end of his life, Sargent kept a painting of Belleroche hanging at Tite Street, just as he kept *Madame X.* Today most of Sargent's depictions of his friend are in private collections; the one of Belleroche in a fur hat is in the Colorado Springs Fine Arts Center.

Lily Millet treasured Sargent's portrait of her her entire life. In April 1912, her husband, Frank, on his way home to her after a trip to England (the Millets maintained residences in New York and at Broadway), perished on the *Titanic.* Lily went on with her life, spending more time in the United States and turning her homemaking talents into a livelihood by opening an interior design firm in New York. She died in 1932 at the age of seventy-seven.

Lily bequeathed her portrait to her son, a doctor and Sargent's namesake. When John Millet died in 1976, the painting was left to relatives. In 1996, *Mrs. Frank D. Millet* was purchased by an American family, and it now hangs in their dining room,

not far from a preliminary oil study for *Carnation, Lily, Lily, Rose.* The family was careful to hang the portrait and the oil study out of the way of their children's swinging backpacks. From the moment Sargent finished his tribute to his lovely friend, the portrait has hung in one private home or another—a fitting fate for the woman portrayed as a domestic goddess.

In 1903, Isabella Stewart Gardner realized her dream of opening a museum to showcase her enormous art collection, which included paintings by Rembrandt, Vermeer, and Manet, and hundreds of other works she had spent her life assembling. She had commissioned the architect Willard T. Sears to design her palace. When Fenway Court—inspired by the Palazzo Barbaro in Venice, a fifteenth-century residence on the Grand Canal owned by Sargent's cousins the Curtises—was completed, it featured an enormous indoor courtyard, three floors of galleries, a concert and lecture hall, and lavish living quarters on the fourth floor.

Although Gardner owned numerous paintings and drawings by Sargent, she still yearned for *El Jaleo.* The painting was owned by Thomas Jefferson Coolidge, who had purchased it in 1882. When Coolidge agreed to loan it to Gardner in 1914, she proceeded to design a part of Fenway Court to accommodate it. She hung the enormous painting at the end of a hallway and illuminated it with footlights, creating even more of a stage for Sargent's Spanish dancer. On the floor in front of the painting she placed musical instruments and pottery to add to the theatrical effect. From a distance, as she had hoped, the scene appeared startlingly real.

Coolidge took one look at the display and decided that *El Jaleo* should stay in Gardner's home. Elsewhere in the house, in the Gothic Room, Gardner hung Sargent's portrait of her, the one that had been such a source of embarrassment to her husband. She respected his wish to withhold *Isabella Stewart Gardner* from public view until his death in 1898. Sargent painted Gardner again, not long before her death in 1924. *Lady in White* shows this once vibrant woman reclining on her couch, swathed in white veils, like Amélie at the end of her life, her energy subdued by illness.

Sargent's paintings hung in museums through the 1930s and 1940s, but he was overlooked, considered obsolete if he was considered at all. In the early fifties, a confluence of events thrust him into the spotlight once again. A vivid biography by Charles Merrill Mount, published in 1955, portrayed Sargent's life as colorful and filled with incident, and it generated new interest in the forgotten artist. While Mount had a tendency to make mistakes and to exaggerate for dramatic purposes (Mount is, for example, the only biographer to suggest that Sargent had an affair with Judith Gautier), his lively writing made the artist seem accessible and appealing.

In the early 1950s and through the 1960s, a series of successful exhibitions brought Sargent's paintings back into the public eye. Viewers who lined up to see his works in museums in Chicago, New York, Boston, Washington, D.C., and Birmingham, England—some of whom were seeing them for the first time—were impressed by Sargent's undeniable talents. Instead of dismissing him as old-fashioned, critics now hailed his works as classic, and recognized

his extraordinary combination of unsurpassed technique and penetrating psychology.

By the 1970s, Sargent had made a comeback, and his portraits in particular were held in high regard. When asked to comment on Sargent's work, Andy Warhol, the artist who was the definition of contemporary cool and who, like Sargent, specialized in images of the rich and the famous, said, "Oh God, I wish I could paint this good." Warhol understood that Sargent's subjects, though dressed in the clothing of a different era, were like many of the people he encountered at his ultra-hip Factory, brilliant creatures who used art to make a statement about their wealth and their privileged insider status.

Sargent's star continued to rise, culminating with a blockbuster exhibition that originated at London's Tate Gallery in 1998 and traveled to Washington, D.C., Boston, and Seattle through 2001. Sargent's triumphant tour of America featured 130 of his paintings, watercolors, and drawings, and met with awe and acclaim in every city. The new millennium brought Sargent a highly enthusiastic public, who were dazzled by his bravura painting and did not find it at all politically incorrect to admire his masterly renderings of the wealthy and their elegant, glittering world. In the end, Sargent overcame the death sentence his reputation suffered after his demise. In the words of the art historian Robert Rosenblum, the once forgotten painter was "hot stuff again," and his most famous painting was *Madame X*.

As Sargent's exhibitions attracted huge audiences and his paintings were once again popular subjects of study, art scholars zealously turned their attention to the artist's personal life, deter-

mined to uncover the "real" story of his elusive and ambiguous sexuality. Was he heterosexual, homosexual, or even asexual? Early biographers maintained that Sargent was uninterested in romance or sex because he worked constantly and had no time for anything but his art. Even Stanley Olson, who wrote in great depth about Sargent in the 1980s, suggested that the artist did not conceal his private passions, but simply did not have any.

Other experts, however, Trevor Fairbrother among them, hold that Sargent was a sensualist in his life as well as in his work. Fairbrother argues that biographers and critics have sidestepped the fact that many of Sargent's paintings and drawings are charged with homoeroticism, and proposes that "the visual edge and emotional volatility of his work may have been shaped by his attraction to male beauty." Throughout his career, Sargent frequently drew and painted naked and athletically built men, including his manservant Nicola d'Inverno, numerous Venetian gondoliers, and the models who posed for his Boston Public Library murals. His male nudes hint at a sexual side that he otherwise tried to suppress and keep hidden, as do the portraits born of his romantic crushes of the early 1880s, when he was young and still exploring his desires. The impassioned brushstrokes evident in these works may well indicate deeper—and unfulfilled—longings on Sargent's part.

After decades of study and debate, experts have established that Sargent's portraits were never just pretty pictures. They were always powerful and insightful character studies that exposed the essence of their subjects and the passionate nature of the artist. In Sargent's hands, *Dr. Pozzi at Home* was both ironic and

prescient: Pozzi, the chronic philanderer, was never at home. It is as if Sargent conceived his painting, which hung in the doctor's salon, as Pozzi's perpetual stand-in. In *Lady with the Rose* and *Mrs. Edward Burckhardt and Her Daughter Louise,* Sargent seems to have intuited Louise's sad and tenuous future, just as in *Mrs. Frank D. Millet* he sensed Lily Millet's grace and strength—the traits that later sustained her in the face of personal tragedy.

In *Madame X,* Sargent's greatest psychological portrait, he revealed the unattainable beauty and self-destructive narcissism of both the woman and the decadent society she embodied. "I do not judge, I only chronicle," went Sargent's credo. *Madame X* can, of course, be seen as the abstract and iconic image of dangerous beauty. But the subject of the painting also had great personal meaning for Sargent. On the fateful day at Les Chênes when Sargent determined Amélie's pose, he painted her with her face turned away from him, a disturbing vision of a woman he could never possess and a world he could never inhabit.

# *Afterword*

*Madame X* was described as sphinxlike when she debuted at the 1884 Paris Salon. She had an ineffable quality of mystery and elusiveness—a quality that has made her, in the ensuing century and more, among the most studied of the paintings of a much-studied man. Hundreds of Sargent scholars spend hundreds of hours discussing the portrait's meaning. *Madame X* has been described, analyzed, and deconstructed. Scholars have argued over her position in the Sargent oeuvre, picked apart her every detail, and debated her significance.

In spite of all this attention, however, the story of Amélie's fallen strap was overlooked until 1981, when the Sargent scholar

Trevor Fairbrother uncovered and published evidence that had been buried in nineteenth-century art journals and archives. In an 1889 issue of *Art Amateur,* he saw a passing reference to the fact that Sargent "repainted one part of the picture which gave offense to the lady's friends." The offensive detail, Fairbrother discovered, was the strap of Amélie's dress. He realized that the *Madame X* hanging at the Metropolitan Museum differed markedly from the one that had outraged Belle Époque Paris. There are two known representations of the portrait in its original state—an engraving by Charles Baude that appeared in the Salon issue of *Le Monde Illustré,* and a photograph of the painting at the Salon. Fairbrother called attention to these images and the story they had to tell.

Subsequently, Fairbrother turned his eye to another mystery involving *Madame X.* At the Tate Gallery in London was an unfinished copy of the portrait, which Sir Joseph Duveen had purchased from Sargent's estate in 1925 and then presented to the gallery. The copy had confounded experts for decades. Had Sargent painted it at the same time he was working on *Madame X*? Or had he painted it after the Salon version was finished and exhibited? If so, why would he attempt to re-create a painting he had already completed?

Upon examining the version at the Tate, Fairbrother noted that, while incomplete, it more or less matched the finished *Madame X.* Thus it was not an early, experimental study, but in fact a replica, a copy Sargent may have been rushing to finish and then exhibit at the Salon. Because Sargent left his subject's shoulder bare in the copy, Fairbrother suggested that the artist might

have had second thoughts about the positioning of Amélie's strap and wasn't sure whether to paint it off—or on—her shoulder. Had Sargent finished the copy in time, he might have offered a far less scandalous version of the painting to Salon audiences.

Years after the portrait arrived at its current home in New York, yet another mystery presented itself. Curators at the Metropolitan realized that *Madame X* was not wearing her original gold frame. A photograph of Sargent posing with the painting in his Paris studio in 1884 showed that first frame in glorious detail, a contrast to the simple gilded strip of wood enclosing *Madame X* in her new home.

In 1989, the museum began an extensive inventory, and in the process searched through its vast collection of frames in the hope that the original one for *Madame X* might be there. After a year of studying and measuring hundreds of frames, curators reached the disappointing conclusion that Sargent had removed the original frame before sending the painting to San Francisco in 1915. Perhaps the heavy weight was a problem; the painting was being shipped all the way to America's West Coast. A more appropriate frame than the single wood-strip version was, however, found in the museum's inventory, one constructed between 1892 and 1899 in a lavish period style by the New York framer Thomas A. Wilmurt. This is the frame that *Madame X* wears today.

Even in the case of the most well-known works of art, details are obscured by time and things get lost. With *Madame X,* the frame was lost, the replica was lost, and even the scandal itself was lost, as eyewitnesses died off and the fallen strap was forgotten. Most significant, the person in the painting was lost.

The woman who never worked a day in her life, except as a professional beauty, now works six days a week, putting her best face forward for the thousands who pass through the American Wing of the Metropolitan weekly. *Madame X* has been described as "the face that launched a thousand loan requests." Museums around the world frequently ask to borrow the painting to hang in temporary exhibitions; most of these requests are refused. In a rare exception, she was absent from the Metropolitan for several months in 2002, when she was sent to Jefferson Alumni Hall at Thomas Jefferson University in Philadelphia to take the place of Thomas Eakins's *The Gross Clinic,* which had been loaned for a traveling Eakins exhibition that was then at the Metropolitan.

If *Madame X* were on the market today, the line of suitors would be endless. The works of the artists who were stars in 1884—Gérôme, Henner, Puvis de Chavannes, Benjamin-Constant, Bouguereau, Cormon, and Chaplin—have not had the enduring fame that has been bestowed on *Madame X.* Today, a great Gérôme or a Bouguereau might command a few million dollars. But *Madame X* would be worth tens of millions, for she is a star attraction.

Amélie Gautreau's image is immediately familiar to people who have never entered the Metropolitan Museum. She is the idol of fashion designers who invoke the elegance of her famous black gown when searching for a definition for *chic.* One of her descendants, the artist and designer Angèle Parlange, has paid homage to her with a line of sumptuous fabrics that feature Amélie's profile and a signature X. Parlange's parents live on Parlange plantation, once home to Virginie Ternant Parlange, her

daughter Marie Virginie, and young Amélie. It is still a working farm, and it is just as much a showplace as it was in the nineteenth century.

New Orleans residents continue to fall under *Madame X*'s spell. Several years ago, an Avegno descendant opened a restaurant and named it Gautreau's. Diners there sit beneath framed hotel and restaurant bills from the south of France—all bearing the name Gautreau. An antique dealer, Charles "Chuck" Robinson, has spent ten years restoring 927 Toulouse, the French Quarter house built by Philippe Avegno, Amélie's grandfather, which she inherited from her father and sold in 1884, the year of her great disappointment. This monument to Creole life, complete with its original walled garden, now features a Madame X suite, where a full-size copy of the portrait hangs over the fireplace.

In 2000, the noted doll maker Madame Alexander included a Madame X doll in its limited-edition Arts series. The doll, a brunette with jeweled straps, black gloves, and a train on her dress, is already a collector's item, subject to feverish rounds of bidding on eBay.

*Madame X,* or versions of her, appear widely in the media: on the cover of *The New Yorker;* as embodied by the actress Nicole Kidman posing in *Vogue;* in an episode of the television show *Will & Grace.* Almost 120 years old, *Madame X* was paid a high compliment when she was named "Babe *du Jour*" at popula.com, a website that identifies the best of vintage images and objects. She has also inspired a play by Ann Ciccolella, a ballet score by Patrick Soluri, and a memoir by one of her Avegno relatives, Mettha Westfeldt Eshleman.

Today, *Madame X* shows some signs of age; the cracks in the paint are due probably to Sargent's rolling up the canvas to transport it from Brittany to Paris before it was completely dry, or to his applying quick-drying paints over slow-drying ones. The professional beauty whose fashion choices were reported in the newspapers and who was rarely seen in the same dress twice now wears the same gown every day. She is famous, as she once wished, but no one ever calls Madame X by her true name: Virginie Amélie Avegno Gautreau.

# NOTES

LA LOUISIANE

8  "have seen the last of Mardi Gras": Augusto Miceli, *The Pickwick Club of New Orleans* (New Orleans: Pickwick, n.d.), p. 8.

8  The event was a great success: Robert C. Reinders, *End of an Era* (Gretna, LA: Pelican, 1998), p. 157.

8  The Krewe of Comus resolved: Miceli, *The Pickwick Club of New Orleans,* p. 11.

8  "The city care forgot," the best place, "the most glamorous": Reinders, *End of an Era,* pp. 151–152.

10  one of the unhealthiest cities: Ibid., p. 87.

11   the largest real estate holdings: Robert de Berardinis, telephone interview with the author, July 13, 2002.

13   Ternant home inventory: Brian J. Costello, *From Ternant to Parlange* (Baton Rouge: Franklin, 2002), pp. 65–73.

14   "the Lady of False River": Ibid., p. 56.

15   an extensive library: Ibid., p. 81.

15   one who did not survive: Ibid., p. 83.

16   *"le grand m'sieu":* Ibid., p. 99.

16   "the girls of False River": Ibid., p. 97.

17   Her Acadian grandfather: Ibid., p. 52.

19   "Dixie": www.fortunecity.com/tinpan/parton/2/dixie.html.

20   He and his brother Jean-Bernard: Robert de Berardinis, telephone interview.

21   Major Avegno's "gallant little band": United States War Department, *The War of the Rebellion: A Compilation of the Official Records of the Union and Confederate Armies,* Series 1, vol. 52, Part 1 (Washington, DC: Government Printing Office, 1989), p. 491.

21   "rallied for a moment": *Daily Delta,* April 16, 1862.

21   "where the brave love to die": Ibid.

23   In 1867 she and young Amélie: Theories conflict as to when the widowed Marie Virginie left New Orleans. If she traveled with Jean-Bernard Avegno and his family, she left soon after her husband died, in 1862. She would then have returned to Louisiana a few years later, since she was in New Orleans to sign papers relating to Anatole's will and to bury her younger daughter, Valentine, in 1866. A more plausible theory is that Marie Virginie, Amélie, and Julie Ternant sailed together for France in 1867.

## CITY OF LIGHT

26  "an army whose task": David P. Jordan, *Transforming Paris* (Chicago: University of Chicago Press, 1995), p. 220.

27  the first *grand passage:* "Paris Under Glass," *France Magazine,* July/August 2002, p. 48.

31  Such behavior would have been: Michael Miller, *The Bon Marché: Bourgeois Culture and the Department Store* (Princeton, NJ: Princeton University Press, 1981), p. 20.

31  *filles à la cassette:* George Washington Cable, *The Creoles of Louisiana* (Gretna, LA: Pelican, 2000), p. 26.

32  hot-air balloon escape: http://www.geocities.com/Colosseum/Hoop/4390/history2.htm.

33  But the genealogist Robert de Berardinis: Robert de Berardinis, "'Madame X': Virginie Amélie 'Mimi' Avegno (Mme. Gautreau) and a Family Note to Art History," *National Genealogical Society Quarterly,* 90, no. 1 (March 2002), p. 65.

33  The Communards, as the dissidents: Jordan, *Transforming Paris,* p. 345.

36  "an habitual state of mental derangement": Costello, *From Ternant to Parlange,* p. 113.

41  They would instead share: *Contract de Mariage entre M. Pierre-Louis Gautreau et Mademoiselle Avegno.* Paris, M. Deves, notary, 1878.

## A PROFESSIONAL BEAUTY

48  "genius for grooming," "fragrance of sensuality": Patrice Higonnet, *Paris, Capital of the World,* trans. Arthur Goldhammer (Cam-

bridge, MA: The Belknap Press of Harvard University Press, 2002), p. 115.

48  "In Paris, half the female population": Quoted ibid., p. 115.

49  "There is no falsehood": Baronne Staffe, *My Lady's Dressing Room* (New York: Cassell, 1892), p. 8.

50  "to be seen and to shine": Octave Uzanne, *The Modern Parisienne* (New York: G. P. Putnam's Sons, 1912), p. 170.

50  "spiritualized": Ibid., p. 28.

50  "is even accomplishing" . . . "anathematized": Charles Baudelaire, *The Painter of Modern Life and Other Essays,* ed. Jonathan Mayne (London: Phaidon, 1995), p. 33.

51  "The combined business": Uzanne, *The Modern Parisienne,* p. 27.

53  A famous cartoon: Valerie Steele, *Paris Fashion* (New York: Oxford University Press, 1988), p. 101.

54  "women wore high coiffures," "effervescence": Gabriel-Louis Pringue, *30 Ans de Dîners en Ville* (Paris: Édition Revue Adam, 1948), p. 212. Translation by Mark Urman.

57  "La Belle Américaine": *The New York Herald,* March 30, 1880.

57  "And if I am": Edwin H. Blashfield, "John Singer Sargent—Recollections," *The North American Review,* June 1925.

58  "The mother-of-pearl coloring": Pringue, *30 Ans de Dîners en Ville,* p. 213.

59  "In Saint-Malo–Paramé": Perdican, "Courrier de Paris," *L'Illustration,* August 11, 1883, p. 83.

59  "could not help stalking her": Edward Simmons, *From Seven to Seventy: Memoirs of a Painter and a Yankee* (New York: Harper & Brothers, 1922), p. 127.

THE PUPIL

62   "I learnt my trade": Quoted in John Milner, *The Studios of Paris* (New Haven, CT: Yale University Press, 1988), p. 18.

65   "a Parisian woman never": Ibid., p. 45.

65   *au premier coup:* Richard Ormond and Elaine Kilmurray, *John Singer Sargent: The Early Portraits* (New Haven, CT, and London: Yale University Press, 1998), p. 2.

65   then racing forward: Evan Charteris, *John Sargent* (New York: Charles Scribner's Sons, 1927), p. 28.

66   *"En art, tout":* Ibid.

68   family members believed: Stanley Olson, *John Singer Sargent: His Portrait* (New York: St. Martin's, 1986), p. 6.

69   He wrote that Mary: F. W. [Fitzwilliam] Sargent Papers, 1820–1889, Reel D317. Archives of American Art, Smithsonian Institution.

70   "the land of rocks": Quoted in Charteris, *John Sargent,* p. 22.

71   "makes me shake myself": Quoted in Olson, *John Singer Sargent,* p. 46.

71   "one of the most talented": Quoted in Marc Simpson, *Uncanny Spectacle: The Public Career of the Young John Singer Sargent* (New Haven, CT: Yale University Press, and Williamstown, MA: Sterling and Francine Clark Art Institute, 1997), p. 7.

72   "We cleared the studio": Quoted in Charteris, *John Sargent,* p. 37.

A SMASHING START

78   "the artist is engaged": Lorne Campbell, "Portraiture," *The Grove Dictionary of Art* (online), ed. Laura Macy. www.groveart.com.

79   "increased sense of life and personality": George T. M. Shackelford and Mary Tavener Holmes, *A Magic Mirror: The Portrait in France, 1700–1900* (Houston: The Museum of Fine Arts, 1986), p. 9.

80   The biographer Stanley Olson: Olson, *John Singer Sargent,* p. 57.

81   The next time his name: Ibid.

81   Emily told Vernon Lee: Carter Ratcliff, *John Singer Sargent* (New York: Abbeville, 1982), p. 41.

82   It could hold up to seven thousand: Lois Marie Fink, *American Art at the Nineteenth-Century Paris Salons* (Cambridge, England: Cambridge University Press, and Washington, DC: Smithsonian Institution, 1990), p. 119.

83   Many artists were condemned: Milner, *The Studios of Paris,* p. 51.

83   Edward Simmons, the American: Simmons, *From Seven to Seventy,* p. 127.

84   "Later on came Mme. [Gautreau]": "The Paris Salon and the American Exhibits," *The New York Herald,* May 1, 1890.

84   Gyp, a satirist: Milner, *The Studios of Paris,* p. 53.

85   "To my uneducated eye": F. W. [Fitzwilliam] Sargent Papers, Reel D317. Archives of American Art, Smithsonian Institution.

85   *"un charmant portrait":* Henri Houssaye, *Revue des Deux Mondes,* 1877, quoted in Ormond and Kilmurray, *John Singer Sargent,* p. 42.

88   "one of the best portraits of the Salon": Outremer, "American Painters of the Salon of 1879," *Aldine,* 9, no. 12 (1879), pp. 370–371, quoted in Simpson, *Uncanny Spectacle,* p. 85.

88   "No American has ever": Quoted in Ormond and Kilmurray, *John Singer Sargent,* p. 44.

88   "cordially liked or cordially detested": Quoted in Simpson, *Uncanny Spectacle,* p. 85.

89 "exquisite," "radiant": Henry James, "John S. Sargent," *Harper's New Monthly Magazine,* 75, no. 449 (October 1887), p. 688, quoted in Simpson, *Uncanny Spectacle,* p. 94.

89 "perfect piece of painting": "Special Correspondence: American Artists at the Paris Salon," *Art Interchange,* 4, no. 12 (June 9, 1880), p. 100, quoted in Simpson, *Uncanny Spectacle,* p. 94.

92 "denying himself the true purpose": Anton Kamp, "Recollections of John Singer Sargent," Reel 5002, p. 19. Archives of American Art, Smithsonian Institution.

92 as one model recalled: Ibid., p. 6.

93 "If he didn't play": Quoted in Charles Merrill Mount, *John Singer Sargent* (New York: W. W. Norton, 1955), p. 132.

93 His friend Eliza Wedgwood: Eliza Wedgwood, "Memoir of John S. Sargent" (unpublished).

94 "Beware this people that grow": Perdican, "Courrier de Paris," *L'Illustration,* June 18, 1881, p. 412, quoted in Simpson, *Uncanny Spectacle,* p. 42.

95 "we will have to respond": *Le Monde Illustré,* May 31, 1884, p. 339.

96 Some acquaintances even suggested: Olson, *John Singer Sargent,* p. 88.

97 Their unpleasant conversation: Ibid., p. 90.

BRILLIANT CREATURES

100 At some time, his father: Claude Vanderpooten, *Samuel Pozzi: Chirurgien et Ami des Femmes* (Paris: Éditions In Fine, 1992), p. 21.

103 Bernhardt wittily commemorated: Ibid., p 73.

106 The doctor assured: Olson, *John Singer Sargent,* p. 101.

107 "Dear and extremely rare friend": Montesquiou Papers, NAF 15038F.100. Bibliothèque Nationale de France.

107 "I like to be loved": Letter to Augustine Bulteau, Bulteau Papers. Bibliothèque Nationale de France.

109 "a very brilliant creature": Sargent to Henry James, June 25, 1885, Houghton Library, Harvard University, quoted in Ormond and Kilmurray, *John Singer Sargent,* p. 54.

HEAT AND LIGHT

113 They addressed each other as: Vanderpooten, *Samuel Pozzi,* pp. 145–147.

114 "as beautiful as a bad angel": Joanna Richardson, *Judith Gautier: A Biography* (New York: Franklin Watts, 1987), p. 30.

114 His poetry: Ibid.

115 "it is enough": Quoted ibid., p. 141.

117 "The public is requested": Quoted in Cornelia Otis Skinner, *Elegant Wits and Grand Horizontals* (Boston: Houghton Mifflin, 1962), p. 21.

118 "I have worshipped you": Oscar Wilde, *The Picture of Dorian Gray* (N.p.: Creation Books, 2000), p. 10.

118 Wilde felt no compunction: Albert Boime, "Sargent in Paris and London: A Portrait of the Artist as Dorian Gray," in Patricia Hills, *John Singer Sargent* (New York: Harry N. Abrams, 1986), p. 77.

120 Belleroche, enchanted: Dorothy Moss, "Sargent, Madame X, and 'Baby Milbank,'" *The Burlington Magazine,* May 2001, p. 273.

120 Still a young woman: William Belleroche, *Brangwyn's Pilgrimage* (London: Chapman & Hall, 1948), p. 203.

120  Belleroche suggested Sargent: Ormond and Kilmurray, *John Singer Sargent,* p. 99.

121  The two artists kept up: Moss, "Sargent, Madame X, and 'Baby Milbank,'" p. 273.

121  "Sargent's portraits of Belleroche": Ibid., p. 274.

122  "one of the most original": Quoted in Simpson, *Uncanny Spectacle,* p. 53.

## HIS MASTERPIECE

124  Critics were so hostile that: www.pbs.org/wgbh/cultureshock/flashpoints/visualarts/olympia_a.html.

125  "uncanny spectacle": James, "John S. Sargent," p. 684, quoted in Simpson, *Uncanny Spectacle,* p. 159.

125  "I have a great desire": Charteris, *John Sargent,* p. 59.

126  Madame Allouard-Jouan, a translator: Ormond and Kilmurray, *John Singer Sargent,* p. 62.

126  "Whether he liked it": Quoted in John Milner, *The Studios of Paris* (New Haven, CT: Yale University Press, 1988), p. 181.

126  "Do you object to people": Quoted in Charteris, *John Sargent,* p. 59.

127  He always exercised: Elizabeth Oustinoff, interview with the author, June 13, 2002.

127  The dress's designer: "La Belle Américaine."

128  On the other, anyone: Anne Hollander, *Seeing Through Clothes* (Berkeley: University of California Press, 1993), p. 377.

128  black was coming to be seen: Ibid., p. 376.

133  "the unpaintable beauty": Quoted in Charteris, *John Sargent,* p. 59.

133  "Dear Baby": Quoted in Moss, "Sargent, Madame X, and 'Baby Milbank,'" p. 273.

134  The city was crowded: Ratcliff, *John Singer Sargent,* p. 83.

134  But a recent theory: Ormond and Kilmurray, *John Singer Sargent,* p. 98.

136  "woman in a man": Moss, "Sargent, Madame X, and 'Baby Milbank,'" p. 269.

THE FLYING DUTCHMAN

138  This particular shade of gray: Jacqueline Ridge and Joyce H. Townsend, "How Sargent Made It Look Easy," *American Artist,* 63, no. 685 (August 1999). firstsearch@oclc.org.

138  He knew that this combination: Ibid.

139  He tried his usual approach: Ibid.

139  *"Mr. Sargent a fait":* Letter courtesy Adelson Galleries, Inc.

140  Sargent titled the drawing: Elaine Kilmurray, interview with the author, June 13, 2002.

141  Robert de Montesquiou called it: Richardson, *Judith Gautier,* p. 126.

142  Le Pré des Oiseaux became her home: Ibid.

142  "nun of art": Anita Brookner, *Soundings* (London: Harvill, 1997), pp. 171–177.

143  Charles Mount, a lively: The speculations cited here are from Charles Merrill Mount, "John Singer Sargent and Judith Gautier," *The Arts Quarterly,* Summer 1955, p. 138.

145  in a letter to Madame Allouard-Jouan: Sargent to Madame Allouard-Jouan, n.d. Letter courtesy Adelson Galleries, Inc.

145 "The summer is definitely over": Letter courtesy Adelson Galleries, Inc.

## FINISHING TOUCHES

150 "The only Franco-American": Quoted in Olson, *John Singer Sargent,* p. 106.

151 he only "half-liked it": *Henry James: A Life in Letters,* ed. Leon Edel (Cambridge, MA: The Belknap Press of Harvard University Press, 1980), vol. 3, p. 43.

152 "as one is mesmerized": Olson, *John Singer Sargent,* p. 106.

152 "One day I was dissatisfied": Quoted in Charteris, *John Sargent,* p. 60.

153 "three ugly young women," "dingy hole": Quoted in Ormond and Kilmurray, *John Singer Sargent,* p. 131.

154 "would be even more admired": Perdican, "Courrier de Paris," *L'Illustration,* March 22, 1884, p. 182.

## DANCING ON A VOLCANO

156 "To-morrow is varnishing day": *Marie Bashkirtseff: The Journal of a Young Artist,* trans. Mary J. Serrano (New York: E. P. Dutton, 1919), p. 105.

157 Restaurants even opened: *Paris Notes,* March 2001.

158 The 1880s brought: Roger Price, *A Social History of Nineteenth-Century France* (London: Hutchinson, 1987), p. 52.

159 Tabloid newspapers: Vanessa R. Schwartz, *Spectacular Realities* (Berkeley: University of California Press, 1998), p. 39.

159 In 1869, the crimes of Jean-Baptiste Troppmann: http://www. iht.com/IHT/MB/00/mb022600.html.

159 It was located directly across: Charles Rearick, *Pleasures of the Belle Epoque* (New Haven, CT: Yale University Press, 1985), p. 84.

160 "true spectacle," "living newspaper": Quoted in Schwartz, *Spectacular Realities,* p. 108.

160 "reproduction loyal to nature": Schwartz, *Spectacular Realities,* p. 119.

160 Some of the displays: Ibid., p. 130.

161 The most popular corpses: Ibid., p. 76.

162 The jury would have preferred: Ormond and Kilmurray, *John Singer Sargent,* p. 7.

162 "It would be difficult": *L'Événement,* May 2, 1884.

163 Ralph Curtis, Sargent's companion: Curtis wrote a letter to his parents, detailing his and Sargent's experiences on Varnishing Day. I have used his eyewitness report as the basis for my account. The complete text of the letter can be found in Charteris, *John Sargent,* p. 61.

163 "remarkable," "of rare distinction": Louis Fourcaud, *Le Gaulois,* April 30, 1884.

165 In his annotations: An annotated copy of F.-G. Dumas, *Catalogue Illustré du Salon* (Paris: Librairie d'Art Ludovic Baschet, 1884). Observations regarding various Salon paintings can be found in this catalogue.

165 "the foremost painter": *Armand Dayot, Salon de 1884* (Paris: Librairie d'Art Ludovic Baschet, 1884), p. 22.

168 Marie Bashkirtseff dismissed: *The Last Confessions of Marie*

*Bashkirtseff and Her Correspondence with Guy de Maupassant,* ed. Jeannette L. Gilder (New York: Frederick A. Stokes, 1901), p. 86.

168 The nude had been: David Rogers, "Nudes," *The Grove Dictionary of Art* (online), ed. Laura Macy. www.groveart.com.

169 In *The Nude:* Kenneth Clark, *The Nude* (New York: Pantheon, 1956), p. 3.

172 "As for the model, slumped in a corner": Madeleine Zillhardt *Louise-Catherine Breslau et Ses Amis* (Paris: Éditions des Portiques, 1932), p. 91.

172 "The beautiful Mme ——": *The Last Confessions,* p. 87.

173 an avalanche: *L'Événement,* May 2, 1884.

LE SCANDALE

177 "Mr. Sargent made a mistake": *L'Événement,* May 1, 1884.

177 Louis de Fourcaud . . . "Detestable!": Charteris, *John Sargent,* p. 63.

178 "The profile is pointed": Henri Houssaye, *Revue des Deux Mondes,* 63, no. 3 (June 4, 1884), quoted in Ratcliff, *John Singer Sargent,* p. 84.

178 "This portrait is simply": *Art Amateur,* 2, no. 3 (August 1884), p. 52.

179 "[Chaplin] is the painter": *Le Petit Journal de Paris,* July 20, 1884.

179 "A *succès de scandale*": Claude Phillips, in *Academy,* 25, no. 632 (June 14, 1884), quoted in Simpson, *Uncanny Spectacle,* p. 141.

180 An editorial in *L'Événement:* "Le Fin du Salon," *L'Événement,* May 8, 1884.

180 *Le Charivari* ran: "Le Salon pour Rire," *Le Charivari,* May 1, 1884.

181 "Mr. Sargent has offered to let": *La Vie Parisienne,* May 3, 1884. Translation by Alexandra Tallen.

181 "They insist on pretending": *La Vie Parisienne,* May 24, 1884.

181 "Ask for the little": *La Vie Parisienne,* May 17, 1884. Translation by Alexandra Tallen.

181 A caricature showed her: Ibid.

183 "The Beautiful Madame Gautreau to Mr. Sargent": *Le Gaulois,* May 17, 1884. Translation by Alexandra Tallen.

184 "It is better": *Le Petit Journal,* May 27, 1884.

184 "since Sargent's portrait": Perdican, "Courrier de Paris," *L'Illustration,* May 10, 1884, p. 314.

184 "One more struggle": Quoted in Charteris, *John Sargent,* p. 62.

184 "A painting such as this": "Promenade au Salon," *La Nouvelle Revue,* May–June 1884, p. 603.

184 "The critics of the next generation": André Michel, in *L'Art,* quoted in Ratcliff, *John Singer Sargent,* p. 87.

185 Sargent's friend Judith Gautier: Judith Gautier, in *Le Rappel,* quoted in Ormond and Kilmurray, *John Singer Sargent,* p. 114.

CALCULATED MOVES

189 "It will be pleasant": Quoted in Olson, *John Singer Sargent,* p. 109.

190 He contemplated changing: Olson, *John Singer Sargent,* p. 117.

192 Even Vernon Lee: Quoted in Ormond and Kilmurray, *John Singer Sargent,* p. 132.

193 Literature is filled: I am indebted to Stanley Olson, Warren Adelson, and Richard Ormond for their comprehensive account of Sar-

gent's experiences at Broadway. For more information, see their *Sargent at Broadway: The Impressionist Years* (New York: Universe and Coe Kerr Gallery, 1986).

195  One day he caught sight: Mount, *John Singer Sargent,* p. 112.

198  "the comtesse Zamoiska": *L'Événement,* May 19, 1884.

198  "It wasn't the famous chains": *L'Illustration,* May 31, 1884.

199  "very beautiful in a white satin": "Revue Mondaine," *La Gazette Rose,* June 14, 1884, pp. 286–287.

199  "placed himself everywhere": *Le Salut,* May 14, 1884.

A WOMAN OF A CERTAIN AGE

205  "a faithful image": *L'Art Français,* July 25, 1891.

206  There were nights: Gabriel-Louis Pringue, *Portraits et Fantômes* (Paris: Raoul Solar, 1951), p. 89.

209  "To keep her figure": Quoted in Philippe Jullian, *Robert de Montesquiou: A Fin-de-Siècle Prince,* trans. John Haylock and Francis King (London: Secker & Warburg, 1967), p. 70.

209  "Venus": Montesquiou Papers. Bibliothèque Nationale de France. Translation by Alexandra Tallen.

211  In the new arrangement: After her death, when Amélie Gautreau's will was translated from French into English, her final address was given incorrectly as "Rue de La Cour" instead of Rue de La Tour.

212  Roger Fry, reviewing: Quoted in Trevor J. Fairbrother, "The Shock of John Singer Sargent's 'Madame Gautreau,'" *Arts Magazine,* 55 (January 1981), pp. 90–97.

212  Amélie wrote to Sargent . . . Sargent replied: Quoted in Charteris, *John Sargent,* p. 64.

214  The ultimate insult: Pringue, *30 Ans de Dîners en Ville,* p. 314.

215  During a routine visit . . . "One must never": Ibid.

215  Marie Virginie left her jewels: Costello, *From Ternant to Parlange,* p. 144.

217  Caillaux and Favalelli testimony: Succession of Mrs. Virginie Amélie Avegno Gautreau #2571. Parish of Pointe Coupee, Louisiana, 21st Judicial District Court, October 6, 1916.

217  They sold their property: Costello, *From Ternant to Parlange,* p. 146.

## A MAN OF PRODIGIOUS TALENT

220  "We have music": Quoted in Charteris, *John Sargent,* p. 78.

221  Sargent worked and reworked: Olson, Adelson, and Ormond, *Sargent at Broadway,* p. 69.

224  "purely and simply beautiful," "the talk of all": Quoted in Simpson, *Uncanny Spectacle,* p. 155.

224  Half hoping that he would be: Olson, *John Singer Sargent,* p. 137.

225  It was not unusual: http://xroads.virginia.edu/~MA01/Davis/newport/home/conspicuous.html.

225  "Mr. J. S. Sargent of London": *Newport Journal,* October 1, 1887.

226  He wrote an article: Henry James, "John S. Sargent," *Harper's New Monthly Magazine,* 75, no. 449 (October 1887), pp. 683–692.

229  "the gem of the collection": Quoted in Louise Hall Tharp, *Mrs. Jack* (Boston: Little, Brown, 1965), p. 134.

229  "It looks like hell": Quoted in Olson, *John Singer Sargent,* p. 142.

229  "see nearly all the way": Quoted at Magnetic North, http://www.magnetic-north.com/cover/cov11thru20/cov_14.

234  "I abhor and abjure them": Quoted in Olson, *John Singer Sargent,* p. 227.

235  "on account of the row": Quoted in Mount, *John Singer Sargent,* pp. 328–329.

236  "I suppose it is": Quoted ibid., p. 328.

## TWILIGHT OF THE GODS

237  England, Sargent's adopted home . . . "not one": Charteris, *John Sargent,* p. 220.

238  Upholding the Sargent family tradition: Olson, *John Singer Sargent,* p. 244.

239  He was interested . . . "have the chance": Ibid., p. 257.

240  His memorial service: William Howe Downes, *John S. Sargent: His Life and Work* (Boston: Little, Brown, 1925), p. 102.

240  "The man, indeed," "a figure in modern art": Quoted ibid., p. 107.

241  Already some three months after: Charteris, *John Sargent,* p. 223.

242  "That Sargent was taken": Quoted in Olson, *John Singer Sargent,* p. 236.

243  Jacques Pozzi was a beautiful baby: Laurence Joseph, *Catherine Pozzi: Une Robe Couleur du Temps* (Paris: Éditions de la Différence, 1988), p. 12.

243  While his personal life: Vanderpooten offers a detailed examination of Pozzi's life in *Samuel Pozzi.*

244 The circle had very strict rules: *Misia and the Muses: The Memoirs of Misia Sert* (New York: John Day, 1953), pp. 21–22.

245 and who had politely refused: Jean-Yves Tadié, *Marcel Proust: A Life,* trans. Euan Cameron (New York: Viking, 2000), p. 622.

246 At the last minute: Vanderpooten, *Samuel Pozzi,* p. 517.

247 In the 1920s, her sister Valerie . . . "I cannot consent": Ormond and Kilmurray, *John Singer Sargent,* p. 127.

248 Gautier, the ultimate fan: Richardson, *Judith Gautier,* p. 222.

249 When Sargent invited . . . "a journey like this": *Print Collector's Quarterly,* 12 (February 1926), pp. 34–35, 38.

249 Following the lead: Armstrong Fine Art, "Albert Belleroche." www.armstrongfineart.com/Belleroche-bio.P.htm.

250 "no one else has succeeded": Quoted ibid.

250 Lily went on: Ormond and Kilmurray, *John Singer Sargent,* p. 170.

252 In the early 1950s: For a comprehensive study of Sargent's resurgence in popularity, see H. Barbara Weinberg, "John Singer Sargent: Reputation Redivivus," *Arts Magazine,* 54 (March 1980), pp. 104–109.

253 "Oh God, I wish": Quoted in Trevor J. Fairbrother, "Warhol Meets Sargent at Whitney," *Arts Magazine,* 61 (February 1987), pp. 65–67.

253 "hot stuff again": Quoted in Ruth La Perla, "Preserved in Oil," *The New York Times,* November 7, 1999.

254 Fairbrother argues: Trevor Fairbrother, *John Singer Sargent* (New York: Harry N. Abrams, in association with the National Museum of American Art, Smithsonian Institution, 1994), p. 8.

255 "I do not judge": Quoted in Charteris, *John Sargent,* p. 107.

AFTERWORD

257 In spite of all this attention ... "repainted one part": Fairbrother, "The Shock of John Singer Sargent's 'Madame Gautreau,'" pp. 90–97.

258 Subsequently, Fairbrother turned: Ormond and Kilmurray, *John Singer Sargent,* p. 115.

259 Curators at the Metropolitan realized: Suzanne Smeaton of Eli Wilner & Company called my attention to the story of the frame, which is discussed in detail in Carrie Rebora Barratt, "American Frames in the Metropolitan Museum of Art," in Eli Wilner, ed., *The Gilded Edge* (San Francisco: Chronicle Books, 2000), p. 156.

260 The face that launched a thousand loan requests: Marc Simpson's introductory remarks for a Sotheby's New York lecture series on the artist, May 1997.

260 If *Madame X* were on the market: I am grateful to Warren Adelson for his invaluable observations on this subject.

262 Today, *Madame X* shows some signs: Ridge and Townsend, "How Sargent Made It Look Easy."

# BIBLIOGRAPHY

ORIGINAL DOCUMENTS

Contract de Mariage entre M. Pierre-Louis Gautreau et Mademoiselle Avegno. Paris, M. Deves, notary, 1878.

Succession of Mrs. Virginie Amélie Avegno Gautreau #2571. Parish of Pointe Coupee, Louisiana, 21st Judicial District Court, October 6, 1916.

Journal of Louise La Chambre Gautreau. Archives Municipales de Saint-Malo, France, n.d.

ARTICLES/PERIODICALS

Armstrong Fine Art. "Albert Belleroche." www.armstrongfineart.com/ Belleroche-bio.P.htm.

*Art Amateur,* 2, no. 3 (August 1884), p. 52.

*L'Art Français,* July 25, 1891.

"La Belle Américaine: A New Star of Occidental Loveliness Swims into the Sea of Parisian Society," *The New York Herald,* March 30, 1880.

Blashfield, Edwin H. "John Singer Sargent—Recollections," *The North American Review,* June 1925.

Bowles, Hamish. "The Madame X Files," *Vogue,* January 1999, p. 174.

"Continental Books and Manuscripts," *Sotheby's,* June 2002, pp. 68–69. de Berardinis, Robert. "'Madame X': Virginie Amélie 'Mimi' Avegno (Mme. Gautreau) and a Family Note to Art History," *National Genealogical Society Quarterly,* 90, no. 1 (March 2002), p. 65.

*L'Événement,* May 1 and May 19, 1884.

Fairbrother, Trevor J. "The Shock of John Singer Sargent's 'Madame Gautreau,'" *Arts Magazine,* 55 (January 1981), pp. 90–97.

Fairbrother, Trevor J. "Warhol Meets Sargent at Whitney," *Arts Magazine,* 61 (February 1987), pp. 65–67.

*Le Gaulois,* May 17, 1884.

Houssaye, Henri. "Le Salon de 1884," *Revue des Deux Mondes,* June 1, 1884, p. 63. In Ratcliff, *John Singer Sargent.*

Jordan, George. "John Singer Sargent Captured the Mystique of Madame X," *The Times-Picayune* (New Orleans), June 22, 1975.

La Perla, Ruth. "Preserved in Oil," *The New York Times,* November 7, 1999.

Michel, André. "Le Salon de 1884," *L'Art,* 37 (1884), pp. 13–14. In Simpson, *Uncanny Spectacle.*

Minchin, Hamilton. "Some Early Recollections of Sargent," *Contemporary Review,* June 1925, pp. 735–743.

Moss, Dorothy. "Sargent, Madame X, and Baby Milbank," *The Burlington Magazine,* May 2001, n.p.

Mount, Charles Merrill. "John Singer Sargent and Judith Gautier," *The Arts Quarterly,* Summer 1955, p. 138.

Mount, Charles Merrill. "New Discoveries Illumine Sargent's Paris Career," *The Arts Quarterly,* Autumn 1957, p. 304.

*North American Review,* n.d., p. 642.

*Paris Notes,* March 2001.

"Paris Under Glass," *France Magazine,* July/August 2002, p. 48.

Perdican. *L'Illustration,* May 31, 1884.

*Le Petit Journal de Paris,* July 20, 1884.

Phillips, Claude. *Academy,* 25, no. 632 (June 14, 1884), n.p. In Simpson, *Uncanny Spectacle.*

*Print Collector's Quarterly,* 12 (February 1926), pp. 30–45.

"Promenade au Salon," *La Nouvelle Revue,* May/June 1884, p. 603.

Ridge, Jacqueline, and Joyce H. Townsend. "How Sargent Made It Look Easy," *American Artist,* 63, no. 685 (August 1999). firstsearch@oclc.org.

"Le Salon pour Rire," *Le Charivari,* May 1, 1884.

Sidlauskas, Susan. "Painting Skin," *American Art,* Fall 2001, pp. 8–33.

Starkweather, William. "The Art of John Singer Sargent," *The Mentor,*
October 1924, pp. 3–29.

Stretch, Bonnie Barrett. "Fragments of a Lost World," *ARTnews,* January
1987, p. 122.

*La Vie Parisienne,* May 3, 1884.

Wedgwood, Eliza. "Memoir of John S. Sargent."

Weinberg, H. Barbara. "John Singer Sargent: Reputation Redivivus,"
*Arts Magazine,* 54 (March 1980), pp. 104–109.

BOOKS

Adelson, Warren. *John Singer Sargent: His Own Work.* New York: Coe
Kerr Gallery and Wittenborn, 1980.

Baudelaire, Charles. *The Painter of Modern Life and Other Essays,* ed.
Jonathan Mayne. London: Phaidon, 1995.

Becker, George J., and Edith Philips, eds. *Paris and the Arts,
1851–1896: From the Goncourt Journal.* Ithaca, NY: Cornell Uni-
versity Press, 1971.

Belleroche, William. *Brangwyn's Pilgrimage.* London: Chapman & Hall,
1948.

Birnbaum, Martin. *John Singer Sargent.* New York: William E. Rudge's
Sons, 1941.

Brettell, Richard. *French Salon Artists: 1800–1900.* New York: Harry N.
Abrams, and Chicago: The Art Institute of Chicago, 1987.

Cable, George Washington. *The Creoles of Louisiana.* Gretna, LA: Peli-
can, 2000.

Carter, William C. *Marcel Proust: A Life.* New Haven, CT: Yale University Press, 2000.

Charteris, Evan. *John Sargent.* New York: Charles Scribner's Sons, 1927.

Child, Theodore. *The Praise of Paris.* New York: Harper & Brothers, 1893.

Clark, Kenneth. *The Nude.* New York: Pantheon, 1956.

Collier, John. *A Manual of Oil Painting.* London: Cassell, 1889.

Cortissoz, Royal. *Art and Common Sense.* New York: Charles Scribner's Sons, 1913.

Costello, Brian J. *From Ternant to Parlange.* Baton Rouge: Franklin, 2002.

Cox, Kenyon. *An American Art Student in Paris: The Letters of Kenyon Cox 1877–1882,* ed. H. Wayne Morgan. Kent, OH: Kent State University Press, 1986.

Dayot, Armand. *Salon de 1884.* Paris: Librairie d'Art Ludovic Baschet, 1884.

de Bachelle, Herman. *Old Louisiana Plantation Homes and Family Trees.* New Orleans: Pelican, 1941.

Downes, William Howe. *John S. Sargent: His Life and Work.* Boston: Little, Brown, 1925.

Dumas, F.-G. *Catalogue Illustré du Salon.* Paris: Librairie d'Art Ludovic Baschet, 1884.

Edel, Leon. *Henry James: A Life.* New York: Harper & Row, 1985.

Esten, John. *John Singer Sargent: The Male Nudes.* New York: Universe, 1999.

Fairbrother, Trevor. *John Singer Sargent.* New York: Harry N. Abrams, 1994.

Fairbrother, Trevor. *John Singer Sargent: The Sensualist.* Seattle: Seattle Art Museum, and New Haven, CT: Yale University Press, 2000.

Fairbrother, Trevor. *John Singer Sargent and America.* New York: Garland, 1986.

*Femmes Fin de Siècle 1885–1895.* Paris: Éditions Paris-Musées, 1990.

Fink, Lois Marie. *American Art at the Nineteenth-Century Paris Salons.* Cambridge, England: Cambridge University Press, and Washington DC: Smithsonian Institution, 1990.

Fontanel, Beatrice. *Support and Seduction,* trans. Willard Wood. New York: Harry N. Abrams, 1997.

Gay, Walter. *The Memoirs of Walter Gay.* New York: Privately printed, 1930.

Girouard, Mark. *Life in the French Country House.* New York: Alfred A. Knopf, 2000.

*The Grove Dictionary of Art,* ed. Jane Turner. New York: Grove, 1996.

Hayman, Ronald. *Proust: A Biography.* New York: HarperCollins, 1990.

Hemmings, F. W. J. *Culture and Society in France.* New York: Charles Scribner's Sons, 1971.

Herbert, Robert L. *Impressionism: Art, Leisure, and Parisian Society.* New Haven, CT: Yale University Press, 1988.

Herdrich, Stephanie L., and H. Barbara Weinberg. *John Singer Sargent: American Drawings and Watercolors in the Metropolitan Museum of Art.* New Haven, CT: Yale University Press, 2000.

Higonnet, Patrice. *Paris Capital of the World,* trans. Arthur Goldhammer. Cambridge, MA: The Belknap Press of Harvard University Press, 2002.

Hills, Patricia. *John Singer Sargent.* New York: Harry N. Abrams, 1986.

Hollander, Anne. *Seeing Through Clothes.* Berkeley: University of California Press, 1993.

Hoopes, Donelson F. *The Private World of John Singer Sargent.* Washington, DC: Corcoran Gallery of Art, 1964.

Huysmans, J. K. *Against Nature,* trans. Robert Baldick. Baltimore: Penguin, 1971.

Jennings, Kate F. *John Singer Sargent.* New York: Crescent Books, 1991.

Jordan, David P. *Transforming Paris.* Chicago: University of Chicago Press, 1995.

Joyes, Claire. *Monet's Table.* New York: Simon & Schuster, 1989.

Jullian, Philippe. *Robert de Montesquiou: A Fin-de-Siècle Prince,* trans. John Haylock and Francis King. London: Secker & Warburg, 1967.

Kimbrough, Sara Dodge. *Drawn from Life.* Jackson: University Press of Mississippi, 1976.

*The Last Confessions of Marie Bashkirtseff and Her Correspondence with Guy de Maupassant,* ed. Jeannette L. Gilder. New York: Frederick A. Stokes, 1901.

Lubbock, Percy. *The Letters of Henry James.* New York: Macmillan, 1920.

Lubin, David. *Act of Portrayal: Eakins, Sargent, James.* New Haven, CT: Yale University Press, 1985.

Maillard, Lucien. *Ledoyen.* Paris: L'Avant Mémoire, n.d.

Manson, J. B., and Alice Meynell. *The Work of John Singer Sargent.* New York: Charles Scribner's Sons, 1927.

*Marie Bashkirtseff: The Journal of a Young Artist,* trans. Mary J. Serrano. New York: E. P. Dutton, 1919.

McSpadden, J. Walker. *Famous Painters of America.* New York: Dodd, Mead, 1923.

Miceli, Augusto. *The Pickwick Club of New Orleans.* New Orleans: Pickwick, n.d.

Miller, Michael. *The Bon Marché: Bourgeois Culture and the Department Store.* Princeton, NJ: Princeton University Press, 1981.

Milner, John. *The Studios of Paris.* New Haven, CT: Yale University Press, 1988.

*Misia and the Muses: The Memoirs of Misia Sert.* New York: John Day, 1953.

Mount, Charles Merrill. *John Singer Sargent.* New York: W. W. Norton, 1955.

Munhall, Edgar. *The Butterfly and the Bat.* New York: The Frick Collection, 1995.

Olson, Stanley. *John Singer Sargent: His Portrait.* New York: St. Martin's, 1986.

Olson, Stanley, Warren Adelson, and Richard Ormond. *Sargent at Broadway: The Impressionist Years.* New York: Universe and Coe Kerr Gallery, 1986.

Ormond, Richard, and Elaine Kilmurray, *John Singer Sargent: The Early Portraits.* New Haven, CT, and London: Yale University Press, 1998.

Palffy, Eleanor. *The Lady & the Painter.* New York: Coward-McCann, 1951.

Piper, David. *The English Face.* London: Thames & Hudson, 1957.

Pousette-Dart, Nathaniel. *John Singer Sargent.* New York: Frederick A. Stokes, 1924.

Prettejohn, Elizabeth. *Interpreting Sargent.* New York: Stewart, Tabori & Chang, 1998.

Price, Roger. *A Social History of Nineteenth-Century France.* London: Hutchinson, 1987.

Pringue, Gabriel-Louis. *Portraits et Fantômes.* Paris: Raoul Solar, 1951.

Pringue, Gabriel-Louis. *30 Ans de Dîners en Ville.* Paris: Édition Revue Adam, 1948.

Ratcliff, Carter. *John Singer Sargent.* New York: Abbeville, 1982.

Rearick, Charles. *Pleasures of the Belle Epoque.* New Haven, CT: Yale University Press, 1985.

Reinders, Robert C. *End of an Era.* Gretna, LA: Pelican, 1998.

Richardson, Joanna. *The Bohemians.* Cranbury, NJ: A. S. Barnes, 1971.

Richardson, Joanna. *Judith Gautier: A Biography.* New York: Franklin Watts, 1987.

Ripley, Eliza. *Social Life in Old New Orleans.* Gretna, LA: Pelican, 1998.

Robertson, W. G. *Life Was Worth Living.* New York: Harper & Brothers, 1931.

Rosenblum, Robert. *Paintings in the Musée d'Orsay.* New York: Workman, 1989.

Sagner-Duchting, Karen. *Renoir: Paris and the Belle Époque.* Munich: Prestel, 1996.

Schwartz, Vanessa R. *Spectacular Realities.* Berkeley: University of California Press, 1998.

Shackelford, George T. M., and Mary Tavener Holmes. *A Magic Mirror: The Portrait in France, 1700–1900.* Houston: The Museum of Fine Arts, 1986.

Shand-Tucci, Douglass. *The Art of Scandal: The Life and Times of Isabella Stewart Gardner.* New York: HarperPerennial, 1998.

Shattuck, Roger. *The Banquet Years.* New York: Vintage, 1968.

Silverman, Willa Z. *The Notorious Life of Gyp: Right-Wing Nationalist and Liberated Anti-Feminist in Fin-de-Siècle France.* New York: Oxford University Press, 1995.

Simmons, Edward. *From Seven to Seventy: Memories of a Painter and a Yankee.* New York: Harper & Brothers, 1922.

Simpson, Marc. *Uncanny Spectacle: The Public Career of the Young John Singer Sargent.* New Haven, CT: Yale University Press, and Williamstown, MA: Sterling and Francine Clark Art Institute, 1997.

Skinner, Cornelia Otis. *Elegant Wits and Grand Horizontals.* Boston: Houghton Mifflin, 1962.

Smith, F. Berkeley. *How Paris Amuses Itself.* New York: Funk & Wagnalls, 1903.

Staffe, Baronne. *My Lady's Dressing Room.* New York: Cassell, 1892.

Steele, Valerie. *Paris Fashion.* New York: Oxford University Press, 1988.

Stewart, Mary Lynn. *For Health and Beauty: Physical Culture for Frenchwomen 1880s–1930s.* Baltimore: The Johns Hopkins University Press, 2001.

Tharp, Louise Hall. *Mrs. Jack.* Boston: Little, Brown, 1965.

Upstone, Robert. *Exposed: The Victorian Nude,* ed. Alison Smith. London: Tate Britain, 2001.

Uzanne, Octave. *Fashion in Paris.* London: William Heinemann, n.d.

Uzanne, Octave. *The Modern Parisienne.* New York: G. P. Putnam's Sons, 1912.

Vanderpooten, Claude. *Samuel Pozzi: Chirurgien et Ami des Femmes.* Paris: Éditions In Fine, 1992.

Waddington, Mary King. *Château and Country Life in France.* New York: Charles Scribner's Sons, 1909.

Waldberg, Patrick. *Eros in La Belle Époque.* New York: Grove, 1969.

Weber, Eugen. *France: Fin de Siècle.* Cambridge, MA, and London: The Belknap Press of Harvard University Press, 1986.

Weinberg, H. Barbara. *The Lure of Paris: Nineteenth-Century American Painters and Their French Teachers.* New York: Abbeville, 1991.

Westfeldt, Mettha. *Madame Gautreau.* New Orleans, 1984.

Wilde, Oscar. *The Picture of Dorian Gray.* N.p.: Creative Books, 2000.

Williams, Ellen. *The Historic Restaurants of Paris.* New York: The Little Bookroom, 2001.

Williams, Rosalind. *Dream Worlds: Mass Consumption in Late-Nineteenth-Century France.* Berkeley: University of California Press, 1982.

Wilner, Eli, ed. *The Gilded Edge.* San Francisco: Chronicle Books, 2000.

Zillhardt, Madeleine. *Louise-Catherine Breslau et Ses Amis.* Paris: Éditions des Portiques, 1932.

Zola, Émile. *His Masterpiece,* trans. Ernest Alfred Vizetelly. Strand, Gloucestershire, England: Sutton, 1986.

Zola, Émile. *The Ladies' Paradise,* trans. Brian Nelson. Oxford, England: Oxford University Press, 1995.

Zola, Émile. *Nana,* trans. Douglas Parmée. Oxford, England: Oxford University Press, 1992.

Zola, Émile. *Pot Luck,* trans. Brian Nelson. Oxford, England: Oxford University Press, 1999.

# INDEX

*Page numbers in italics indicate black-and-white illustrations.*

Abbey, Edwin Austin, 153, 155, 193, 220–21
Académie des Beaux-Arts, 63, 231
  and portraiture, 162
Académie Goncourt, 248
Académie Julian, 166
Adelson Galleries, 3
Allouard-Jouan, Madame, 125–26, 130, 145
Alma-Tadema, Lawrence, 194, 224
*Armand Barbès* (hot-air balloon), 32–33
*Arrangement in Black No. 5: Lady Meux* (Whistler), 128
Art, Parisians and, 162
*Art Amateur*, 178, 224, 258
Art movements, nineteenth-century, 75–76

Art students, Paris, 61–66
  women as, 166
  and Amélie Gautreau, 58–59
*Artists' Wives, The* (Tissot), *173*
Astor, Caroline, 230
Ateliers, Paris, 63–65
  of Carolus-Duran, 64–66, 71–73, 76–77
  for women, 166
*Au Bonheur des Dames* (Zola), 28–29
Avegno, Anatole (father of Amélie Gautreau), 7–12, *12*, 17, 19
  and Civil War, 20–21
Avegno, Catherine Genois (mother of Anatole), 11
Avegno, Jean-Bernard (brother of Anatole), 18, 20, 23, 31–33, 105

Avegno, Marie Virginie Ternant
    (mother of Amélie Gautreau),
    17, 19, 22, 23–24, 31–32, 130,
    132
    and Civil War, 20–22
    death, 215–16
    and *Madame X*, 174–76
    move to France, 23, 264n23
    in Paris, 34–35
    *See also* Ternant, Marie Virginie
Avegno, Philippe (father of Anatole), 11
Avegno, Valentine Marie (sister of
    Amélie Gautreau), 19, 23,
    264n23
Avegno, Virginie Amélie, 5, 12, 18, 25,
    31–32
    appearance, 35
    and marriage, 36–37
    social life in Paris, 34–35
    wedding, 41–43
    *See also* Gautreau, Virginie Amélie
        Avegno

Baker, Thomas Madison, 217
Barnard, Frederick, 194
Bashkirtseff, Marie, 156, 166, 168, 172
Bastien-Lepage, Jules, 62
Battle of Shiloh, 21
Baude, Charles, 258
Baudelaire, Charles, 50–51
Beauty, physical, French women and,
    48–52
Beckford, William, 93
Beckwith, James, 71, 72, 96, 227
Beerbohm, Max, 232
Belle Époque
    *Madame X* and, 185
    Pozzi and, 100
    *See also* Paris; Society, Paris,
        1870s–1880s; Third Republic
Belleroche, Albert de, 4, 119–21, 133–
    36, 220, 248–50
Benjamin-Constant, 166, 169
Berardinis, Robert de, 33
Bernhardt, Sarah, 102–3, 113, 207, 244

Binder, George, 22
Birth rate, France, 1880s–1890s, 102,
    156
Black clothing, 128
Blanchard (artist), 111
Blanche, Jacques-Émile, 126
Boit family, 129, 227
Boit, Mrs. Edward Darley, portrait of,
    227
Boldini, Giovanni, 219
Bon Marché (Paris), 28–29, 30
Bonnat, Léon, 72, 79
Books, on health and beauty, 49
Booth, Edwin, 17
Boston, Sargent in, 227–30
*Boston Herald*, 229
Boston Museum of Fine Arts, murals,
    240
Boston Public Library, 231
    murals, 240
Boucicaut, Aristide, 28–29
Bouguereau, William-Adolphe, 169,
    179–80, 231, 260
    *Youth of Bacchus, The*, 166, 174
Brangwyn, Frank, 250
Brisson, Henri, 206
Broadway (England), 193–98,
    220–21
Broca, Paul, 101
*Brooklyn* (Union warship), 20
Bülow, Cosima von, 116. *See also*
    Wagner, Cosima
Bulteau, Augustine, 243
Burckhardt, Charlotte Louise, 95–98,
    191–92, 247
    portrait of, *98*, 128
Burckhardt, Mary Elizabeth (Mrs.
    Edward), 95–98, 191–92
Burckhardt, Valerie, 247, 95–96
Burne-Jones, Edward, 153
Business, art as, 77

Caillaux, Victor-Amédée, 217
Canova, Antonio, 209
Caran d'Ache (Emmanuel Poiré), 210

Carfax Gallery (London), 211–12
*Carnation, Lily, Lily, Rose* (Sargent),
    197–98, 220–21, 251
  exhibition, 223–24
Carolus-Duran, 79, 124, 166, 172
  art principals, 65–66
  atelier of, 64–66, 71–73, 76–77
  *Portrait of His Excellency M.Z.*, 165
  and portrait of Madame Gautreau,
    149–50
  portrait by Sargent, 86–88, *87*
  and Sargent, 71, 86, 88
Carrier-Belleuse, Pierre, 213
Cartier, Jacques, 37
Chantrey Bequest, 224
Chaplin, Charles, 165, 174, 179, 241
Chateau-sur-Mer (Newport, R.I.), 225
*Les Chérifas* (Benjamin-Constant), 166
*Christ in the Tomb* (Henner), 165
Ciccolella, Ann, 261
Civil War, U.S., 19–21
Clark, Kenneth, 169
Collecting, Sargent and, 93–94
Colorado Springs Fine Arts Center, 250
Colors used by Sargent, 138–39
Coolidge, Thomas Jefferson, 251–52
Cormon, Fernand, 165, 174
Cosmetics
  Amélie Gautreau's use of, 52–53
  French women and, 50–52
Courbet, Gustave, 75–76, 168
Courtois, Gustave, 204–5
Creoles, 9
  in France, 31
Critics, and Sargent's works, 85, 88,
    192, 240–42
  in Boston, 229
  *Carnation, Lily, Lily, Rose*, 223–24
  *Madame X*, 163, 177–86, 212
*Crying Nymph* (Henner), 165
Curtis, Ralph, 156, 163, 170, 173–76,
    274*n*163

Daguerre, Louis, 79
*Daily Crescent* (New Orleans), 8

*Daily Delta* (New Orleans), 21
*Daily Telegraph* (London), 241
*Daughters of Edward Darley Boit, The*
    (Sargent), 129, 137, 229
de la Gandara, Antonio, 207–9
*Death of Siegfried, The* (Wagner),
  116
Degas, Edgar, 76
del Castillo, Ben, 69, 72, 85, 125, 152
Department stores, 28–31
d'Inverno, Nicola, 241, 254
*Dr. Pozzi at Home* (Sargent), 117–18,
  254–55
*Don Antonio el Inglés* (Velázquez;
    Sargent copy), 91
Douglas, Alfred, 249
Dress, for Sargent's paintings,
  127–28
Dreyfus, Alfred, 244
Dubroca, E. M., 21
Dubufe, Claude-Marie, 15
Duran, Charles-Auguste-Émile. *See*
  Carolus-Duran
Durand-Ruel gallery, 76
Durel, Amélie, 18
Duveen, Joseph, 258

Eakins, Thomas, 260
École des Beaux-Arts, 62–63, 166
  Sargent at, 72
Economy, French, 158
  beauty industry and, 51
Elisabeth (queen of Austria), 57
"Enfant de la Rue Vert Bois," 161
England
  honors to Sargent, 237–38
  Sargent in, 190–91, 193–98, 231
Entertainments, French, 159–62
Eshleman, Mettha Westfeldt, 261
Eugénie (empress of France), 106

Fairbrother, Trevor, 254, 258
Fallen shoulder strap
  in Courtois portrait of Amélie
    Gautreau, 205

Fallen shoulder strap (*cont.*)
in *Madame X*, 139, 170–71, 182,
188, 205, 257–59
in Wertheimer sisters portrait, 232
False River, 13–14. *See also* Parlange
Fantin-Latour, Henri, 79
Fashion, Parisian, 48–50
Fauré, Gabriel, 93
Favalelli, Dominique, 217
Favre, Jules, 32
Félix (Poussineau), 127
*Femina*, 213
Fenway Court (Boston), 251–52
Flaubert, Gustave, 114
Food, Sargent and, 93, 238
Forbes, J. Malcolm, sons of, 227
Fourcaud, Louis de, 163, 177–78
France
socioeconomic conditions,
1850s–1880s, 156–62
and United States, 94–95
Franco-Prussian War, 32–33, 101
French Quarter (New Orleans), 11
French settlers, Louisiana, 7–8
Frick, Henry Clay, 223
Fry, Roger, 212, 242
*Fumée d'Ambre Gris* (Sargent),
89, *90*

Gabrielle (Amélie's maid), 215,
216–17
Gainsborough, Thomas, 200
Gallard, Dr., 100
Gambetta, Léon, 32–33, 105
Gardner, Isabella Stewart, 222–23,
246, 251–52
portraits of, 227–29, 252
Gardner, John Lowell, II, 222–23
and wife's portrait, 229–30, 252
Gardner Museum (Boston), 246,
251–52
*Gassed* (Sargent), 240
*Le Gaulois*, 181–83
Varnishing Day supplement, 1884,
163

Gautier, Judith, 4, 113–15, 119, 140–43,
144–45, 247–48
and *Madame X*, 185
portrait of, 143–44
Gautier, Théophile, 113–15, 140
Gautreau, Charles (brother of Pierre-
Louis), 36
Gautreau, Louise (daughter of
Amélie), 55, 57, 132, 210
death, 216
Gautreau, Louise La Chambre
(mother-in-law of Amélie), 37,
39–41, 44, 55
ledger initiated by, 41, 43–44, *56*
Gautreau, Pierre-Louis (Pedro), 36–
37, 39, 106–7, 210–11, 215,
216, 217
marriage and wedding, 37, 39–43,
45
and politics, 132–33, 199
Gautreau, Virginie Amélie Avegno, 2–4,
43, 260
aging, 209–11, 213–16
appearance, 52–54, 57–58, 138–39,
209–10
birth of child, 55–56
celebrity status, 55–57, 95
childhood home, *44*, 44–45
compared with Judith Gautier, 144
death, 216–18
and *Madame X*, 185–86, 212–13
as newlywed, 43–45
portraits, 200–201, 204–5, 207–9,
213, 217–18
photograph, *206*
by Sargent (*Madame X*), 126,
137–40, 148–50
romantic connections, 105–6, 205–6
Pozzi, 106–8, 112, 242
at Salon, 84
and Salon exhibition of portrait,
163, 170–76
Sargent and, 123–26, 232–33, 236
separation, 210–211
as sitter, 129, 132

social life, 54–55, 56
    Paris, 43, 45, 129, 147, 154
    St.-Malo, 132
    after Salon exhibition, 197–207
  wardrobe, 52–53, 56–57, 128, 199,
    204–5
    wedding dress, 42
  will, 216–17, 277n211
  *See also* Avegno, Virginie Amélie
Gautreau's (New Orleans restaurant),
  261
*La Gazette Rose*, 199
Genois, Catherine (later Avegno), 11
Genois, Charles, 11
Gérôme, Jean-Léon, 62, 164–65, 231,
  260
*Gloria Mariae Medicis* (Carolus-
  Duran), 86
*Godey's Lady's Book*, 50
Goncourt, Edmond de, 45
Gosse, Edmund, 194
Grand Prix, Longchamps, 199
*Gross Clinic, The* (Eakins), 260
*Gust of Wind, A* (Sargent), 143–44, 247
Gynecology, early studies, 102
Gyp (satirist), 84

Hadden, Harold, 96
Hals, Frans, 50, 134
Hammer, Armand, 246
*Harper's New Monthly Magazine*,
  226–27
Haussmann, Georges, 26–28, 161
*Head in Profile of a Young Man*
  (Sargent), *135*
Helleu, Paul, 94, 134
Henner, Jean-Jacques, 165, 169
Hollander, Anne, 128
Hot-air balloon flight, 32–33
Houssaye, Henri, 85, 178
Hugo, Victor, 114, 115
Huysmans, Joris-Karl, 113, 157

*L'Illustration*, 88
Impressionism, 76

objections to, 162
Infidelity, hour for, 53–54
Institut National des Sciences et des
  Arts, 62–63
*Isabella Stewart Gardner* (Sargent),
  228–29, 252
Isabella Stewart Gardner Museum. *See*
  Gardner Museum

*El Jaleo* (Sargent), 121–22, *122*, 137,
  229, 246, 251–52
Jallu, Olivier, 210
James, Henry, 125, 150–52, 153, 155,
  194, 219, 221, 223, 238, 239
  and Sargent, 189, 220
  and Sargent's career, 226–27
Julian, Rodolphe, 166
Jury, Paris Salon, 82–83, 162

Kane, Harnet, 16
Kidman, Nicole, 261
Kilmurray, Elaine, 135
Kissam, Mrs. Benjamin, 230
Kleptomania, 30–31
Krewe of Comus, 8, 10

La Chambre, Charles-Émile, 39–40,
  132
La Chambre, Louise. *See* Gautreau,
  Louise La Chambre
Labouchere Amendment, 249
Lacroix, Albert, 142
*Lady in White* (Sargent), 252
*Lady with the Rose* (Sargent), 97, *98*,
  128, 247, 255
Landscapes, Sargent and, 86
Langdon, Valerie Susie (Lady Meux),
  128
League of the Rose, 244–45
Ledoyen (Paris restaurant), 84
  on Varnishing Day, 172–74, *173*
Lee, Vernon (Violet Paget), 69, 81, 85,
  126–27, 192
Legrand du Saulle, Henri, 31
Les Chênes, 3, 39, *40*, 129–30, 199

Lesseps, Ferdinand de, 106
Lili (artists' model), 249–50
Literature, Sargent and, 93
Lithography, Belleroche and, 249–50
*Livre mariage*, 40
Loeffler, Charles Martin, 92–93
London
  exhibition of *Madame X*, 211–12
  Sargent in, 153, 155, 189, 221, 231
  Sargent's studio, 220, 221, 232
Loth, Thérèse, 104. *See also* Pozzi,
  Thérèse Loth
Louisiana, French settlers in, 7–8
Ludwig II (king of Bavaria), 57,
  116–17

Machu, Maurice, 245
McKim, Charles, 230–31
Madame Alexander, 261
*Madame Édouard Pailleron* (Sargent),
  89
*Madame Gautreau* (Sargent), *131*.
  *See also Madame X*
*Madame Pierre Gautreau* (de la Gan-
  dara), 207–9, *208*
*Madame X* (Sargent), 1–5, 152–54,
  212–14, 217–18, 220, 232, 234–
  36, 253, 255, 260–62
  critics and, 177–86
  exhibitions, 214
    London, 211–12
    Paris Salon, 170–76
  fallen strap, 139, 170–71, 182, 257–59
  repainted, 188
  frame, 259
*Madame Gautreau Drinking a Toast*
  (Sargent), 130–32, 134, *135*,
  138, 246
Magazines, fashion, 48
Manet, Édouard, 76
  *Olympia*, 124–25, 168–69
Marat, Jean-Paul, wax figure of, 160
Mardi Gras, New Orleans, 7–8
Marquand, Elizabeth, 226
Marquand, Henry, 224–26

Marriage contract, Avegno–Gautreau,
  41–42, *42*
Maupassant, Guy de, 242
Medical advances, Pozzi and, 243–44
*Meeting, The* (Bashkirtseff), 166
Meissonier, Jean-Louis-Ernest, 166
Mendès, Catulle, 114–15
Mental illness, in Trahan family, 17
Merrill, Elizabeth. *See* Millet, Lily
Metropolitan Museum of Art (New
  York), 235–36, 247, 260
Meurent, Victorine, 249
Meux, Harry, 128
Meux, Valerie Langdon, Lady, 128
Meyer-Zundel, Suzanne, 248
Michel, André, 184–85
Milbank, Alice, 120
Milbank, Harry Vane, 120
Millet, Francis David, 193, 250
Millet, John, 250
Millet, Kate, 197
Millet, Lily (Elizabeth Merrill), 193–96,
  220, 250, 255
Millet, Lucia, 220
Miniature portraits, 78–79
*Misses Vickers, The* (Sargent), 192
*La Mode Parisienne*, 48
Mohrenheim, Baron, 205–6
Monet, Claude, 76, 77
Montesquiou-Fezensac, Robert de,
  112–13, 141, 207, 209–10, 243
  note from Pozzi to, 107, *108*
Montmartre, 61–62, 157
  Belleroche in, 249
Morality, French, 157
Morgan, John Pierpont, 223
Morgue, Paris, 160–61
Morisot, Berthe, 76
Moss, Dorothy, 121, 135
Mount, Charles Merrill, 143
  biography of Sargent, 252
*Mrs. Albert Vickers* (Sargent), 192
*Mrs. Edward Burckhardt and Her
  Daughter Louise* (Sargent),
  191–92, 247, 255

*Mrs. Frank D. Millet* (Sargent), 195, *196*, 250–51, 255
*Mrs. Harry Vane Milbank* (Sargent), 138
*Mrs. Henry Marquand* (Sargent), 226
Murals, by Sargent, Boston, 240
Musée Grévin (Paris), 159–60
*My Lady's Dressing Room* (Staffe), 49

Nadar, 206
Nakedness, 169
*Nana* (Zola), 27
Napoleon III (emperor of France), 26, 32
Neuschwanstein, 116–17
New English Art Club (London), 221
New Orleans, 8–10, 17–18
    during Civil War, 19–20
    French Quarter, 11
    Mardi Gras, 7–8
New York City, Sargent in, 230–31
*New York Herald*, 57, 84
*New York Herald Tribune*, 241
*New York Times, The*, 88
*New Yorker, The*, 261
Newport, Rhode Island, 224–25
Newspapers, French, 159
    and Amélie Gautreau's wardrobe, 57
    on Americans, 94–95
    and Pierre-Louis Gautreau's politics, 132–33, 199
    and Sargent's paintings, 88
    *See also* Perdican
*Night in the Desert* (Gérôme), 165
*La Nouvelle Revue*, 184
*Nude, The* (Clark), 169
Nude paintings, 168–69
    Salon exhibition, 163–68, 169

Ocean, as subject of art, 81, 86
Olson, Stanley, 80, 152, 254
*Olympia* (Manet), 124–25, 168–69
Orléans, Philippe d', 27
Ormond, Richard, 135

*Oyster Gatherers at Cancale* (Sargent), 86

Paget, Violet, 69. *See also* Lee, Vernon
Pailleron, Édouard, 89
Paintings by Sargent, 234
    *Carnation, Lily, Lily, Rose*, 197–98, 220–21, 223–24, 251
    *Daughters of Edward Darley Boit, The*, 129, 137, 229
    *Dr. Pozzi at Home*, 117–18, 254–55
    *Don Antonio el Inglés* (Velázquez), copy of, 91
    *Fumée d'Ambre Gris*, 89, *90*
    *Gust of Wind, A*, 143–44, 247
    *Isabella Stewart Gardner*, 228–29, 252
    *El Jaleo*, 121–22, *122*, 137, 229, 246, 251–52
    *Lady with the Rose*, 97, *98*, 128, 247, 255
    *Lady in White*, 252
    *Madame Édouard Pailleron*, 89
    *Madame Gautreau Drinking a Toast*, 130–32, 134, *135*, 138, 246
    *Misses Vickers, The*, 192
    *Mrs. Albert Vickers*, 192
    *Mrs. Edward Burckhardt and Her Daughter Louise*, 191–92; 247, 255
    *Mrs. Frank D. Millet*, 195, *196*, 250–51, 255
    *Mrs. Harry Vane Milbank*, 138
    *Mrs. Henry Marquand*, 226
    murals, Boston, 240
    *Oyster Gatherers at Cancale*, 86
    *Portrait of Carolus-Duran*, 86–88, *87*
    portrait of Fanny Watts, 85
    *Rehearsal of the Pasdeloup Orchestra at the Cirque d'Hiver*, 81
    *Triumph of Religion* murals, 240
Palais de l'Industrie (Paris), 82
Palais du Luxembourg (Paris), 86
Palazzo Barbaro (Venice), 251

Paris, 25–31, 157–62, 209
  art students in, 61–62
  Avegno family in, 23–24, 31–32,
    34–35
  Gautreau residence, 43–45, 44
  Sargent family move to, 71
  social life, 34–35, 43, 45, 56
    fashion and, 48–50
  Ternant family in, 14–15
  *See also* Salon
Paris Commune, 33
Parisian women, 47–54, 65
Parlange, Angèle, 260
Parlange, Charles (husband of Virginie
    Ternant), 15, 19
Parlange, Charles Vincent (son of
    Virginie), 15, 19, 41, 43
Parlange, Virginie Trahan Ternant
    (grandmother of Amélie
    Gautreau), 15–16, 18–19, 41
  and Civil War, 20–21
  *See also* Ternant, Virginie Trahan;
    Trahan, Virginie
Parlange (plantation), 15, 16, 18–19,
    23, 217, 260–61
*Passages* (shopping arcades), 27–28
Péladan, Joséphin, 244–45
Perdican, 59, 94–95, 154, 184, 198, 203
*Le Petit Journal*, 179, 184
*Le Petit Parisien*, 159
Phillips, Claude, 179
Photography, 79
  photograph of Amélie Gautreau, 206
Picasso, Pablo, 241
*Picture of Dorian Gray, The* (Wilde),
    118–19
Pissarro, Camille, 76
Planer, Christine Wilhelmine, 116
*Plein air* painting, 76, 231
Poiré, Emmanuel (Caran d'Ache), 210
Poirson, Paul, 191
Politics
  Pierre-Louis Gautreau and, 132–33,
    199
  Pozzi and, 243

Pontalba, Baroness, 10
popula.com (website), 261
*Portrait of Carolus-Duran* (Sargent),
    86–88, 87
*Portrait of His Excellency M.Z.* (Carolus-
    Duran), 165
*Portrait of Lady Archibald Campbell*
    (Whistler), 192
*Portrait of Madame Pierre Gautreau,
    Wife of the Banker* (Courtois),
    205
*Portrait of the Vicomtesse de V.*
    (Carolus-Duran), 88
Portraits
  Parisians and, 59
  at Salon, 162, 165
  Sargent and, 80, 92, 234. *See also*
    Paintings by Sargent
Portraiture, 65, 77–79. *See also*
    Portraits
Poussineau, Félix, 127
Pozzi, Catherine (daughter of Samuel-
    Jean), 104
Pozzi, Jacques (son of Samuel-Jean), 243
Pozzi, Jean (son of Samuel-Jean), 104,
    246, 248
Pozzi, Samuel-Jean, 4, 99–105, 112–13,
    242–44, 255
  and Amélie Gautreau, 105–8
  death, 245–46
  portrait by Sargent, 117–18
  Proust and, 245
Pozzi, Thérèse Loth, 104, 112, 243
  portrait of, 109, 111
Pozzy, Inès and Benjamin, 100
Le Pré des Oiseaux, 140–43
Pre-Raphaelite Brotherhood, 153
Priestly, Flora, 239
Pringue, Gabriel, 54, 206–7, 215
Proust, Marcel, 245
"Pupil, The" (James), 151
Puvis de Chavannes, Pierre, 167, 169

Raymond, Emmeline, 48
Realism, 75–76

*Rehearsal of the Pasdeloup Orchestra at the Cirque d'Hiver* (Sargent), 81

*Remembrance of Things Past* (Proust), 245

Renoir, Pierre-Auguste, 76

*Return from a Bear Hunt* (Cormon), 165

Reynolds, Joshua, 155

*Ring of the Nibelung, The* (Wagner), 115–16, 117

*Robe d'intérieur*, 53–54

Robinson, Charles "Chuck," 261

Robinson, Edward, 235

Rockefeller, John D., 237

Rosenblum, Robert, 253

Rosicrucians, 244–45

Rossetti, Dante Gabriel, 153

Royal Academy of Art (London)
    *Carnation, Lily, Lily, Rose* at, 223–24
    portrait of Pozzi at, 118

*Sacred Grove, The* (Puvis de Chavannes), 167

Sain, Édouard, 213

St. Botolph Club (Boston), 229

St. Charles Hotel (New Orleans), 9

St.-Énogat (France), 70, 73, 143, 248

St. Louis Hotel (New Orleans), 9

St.-Malo (France), 37–39, 129–30, 143, 199

Salon (Paris), 64, 81–85, 231
    and photography, 162
    and portraits, 162, 165
    Sargent's entries, 85, 89–90, 123–24, 137
        *Daughters of Edward Darley Boit, The,* 129, 137
        *Fumée d'Ambre Gris,* 89, *90*
        *El Jaleo,* 121–22, *122,* 137
        *Madame Édouard Pailleron,* 89
        *Misses Vickers, The,* 192
        *Mrs. Albert Vickers,* 192
        *Oyster Gatherers at Cancale,* 86
        *Portrait of Carolus-Duran,* 88

*Portrait de Mme \*\*\** (*Madame X*), 152–54, 170–76

Salon de la Rose-Croix, 245

Sargent, Emily (sister of John Singer), 68–69, 77, 80, 81, 96, 152, 232, 238

Sargent, Fitzwilliam (father of John Singer), 67–71, 80, 96–97
    death, 231–32
    and son's art, 85

Sargent, Fitzwilliam, Jr. (brother of John Singer), 70

Sargent, John Singer, 2–3, 66–67, 68, 70, 80–81, *91*
    as art student, 71–73
    biography of, 252
    career, 77, 88–90, 97–99, 122–25, 237
        in America, 224–31
        international success, 231–34
        *Madame X* and, 177–86, 220, 221–23
        post–*Madame X*, 189–92
        success, 91–92
    death and memorials, 240–41
    exhibitions, 252–53
        first one-man show, 229
        of *Madame X*, 211–12
        *See also* Salon
    generosity, 94
    London trips, 153, 155
    and Louise Burckhardt, 247
    and *Madame X*, 187–89, *188*
    move to London, 219–20
    as musician, 92–93
    painting technique, 138–39
    paintings, 85–90
    Paris studio, 147–48, 126, 191
    personality, 92–94, 145
    portrait of Amélie Gautreau, 126–34, 137–40, 148–50
        Salon exhibition, 170–76
        sketches for, 130, *131*
    as portraitist, 80
    and Pozzi, 107–12, 117–19

Sargent, John Singer (*cont.*)
 as prospective son-in-law, 95–96
 relationships with men
  Belleroche, 119–21, 134–36,
   248–49
  Henry James, 150–53
  Pozzi, 118–19
 relationships with women, 145, 239
  Louise Burckhardt, 96–98
  Gautier, 142–45
 reputation after death, 241–42,
  252–54
 romance and, 96–98
 Salon entries, 156
 sexuality, 254
 social life, 90–91, 238–39
  in America, 226–27, 230
  in England, 193–98, 220–22
 and World War I, 239–40
 *See also* Paintings by Sargent
Sargent, Mary Singer (mother of John
  Singer), 67–71, 72, 80, 85, 231,
  232, 238
 trips to America, 80–81, 96
Sargent, Mary Winthrop (sister of John
  Singer), 69
Sargent, Violet (sister of John Singer),
  70, 77, 80, 96, 232
Sargent family, 219–20, 232. *See also*
  *individual Sargent entries*
Sears, Willard T., 251
Seurat, Georges, 167
Shopping, Paris, 27–31
Silhouette, Étienne de, 78–79
Silhouette portraits, 78–79
Simmons, Edward, 59, 83–84
Singer, Mary Newbold, 67. *See also*
  Sargent, Mary Singer
Sisley, Alfred, 76
Sitwell, Osbert, 226
Skin-lightening procedures, 52–53
*Slave Market in Rome* (Gérôme),
  164–65
Social commentary, *Madame X* as,
  184–85

Society, Paris, 1870s–1880s, 47–49
 *Madame X* as symbol of, 184–85
Soluri, Patrick, 261
Spalding & Rogers Circus, 17–18
*Spectator, The*, 224
Spitzer, Frederic, 154
Staffe, Baroness, 49
Subercaseaux, Ramón, 89–90
Submission Day, Paris Salon, 82–83

Tate Gallery (London), 258–59
Tea gown, 53–54
Technique, painting, Sargent's, 138–39
Ternant, Claude Vincent, 13–14
Ternant, Julie Euriphile, 14, 17, 24, 31,
  35–36
Ternant, Marie Virginie, 10–11, 12, 14,
  17. *See also* Avegno, Marie
  Virginie Ternant
Ternant, Marius Claude Vincent, 14,
  16–17, 19
Ternant, Virginie Trahan, 13–15. *See
  also* Parlange, Virginie Trahan
  Ternant; Trahan, Virginie
Thiers, Adolphe, 33
Third Republic, 33–34
 socioeconomic conditions, 47,
  158–59
Thirteenth Louisiana Infantry, 20–21
*Three Profiles of Madame Gautreau*
  (Sargent), *233*, 233–34
Tissot, James Jacques Joseph, *173*
*Titanic*, 250
Toulouse-Lautrec, Henri de, 249
Trahan, Joseph Leufroy, 17
Trahan, Virginie, 12–13. *See also*
  Parlange, Virginie Trahan
  Ternant; Ternant, Virginie
  Trahan
Travel, Sargent and, 134, 238
*Traveling Musicians* (Meissonier), 166
*Treatise on Gynaecology, Clinical and
  Operative* (Pozzi), 104
*Triumph of Religion, The* (Sargent),
  240

Trochu, Louis, 32
Troppmann, Jean-Baptiste, 159

United States
    Civil War, 19–21
    and French art, 94–95
    Sargent family trip to, 80–81
Uzanne, Octave, 50, 51

van Gogh, Vincent, 241
Vanderbilt, Mrs. William Henry, 230
Varnishing Day, Paris Salon, 83–85,
        163, 274n163
    *Madame X* exhibition, 162–76
*Vathek* (Beckford), 93
Velázquez, Diego, 66
    *Don Antonio el Inglés* (Sargent
        copy), 91
"Venus" (Montesquiou), 209–10
Verlaine, Paul, 207
Vickers, Thomas, 189–90
    daughters of, 153
    portrait, 189–90
*La Vie Parisienne*, 53, 180–81, *182*
Visseaux, Julie, 250

Wagner, Christine Planer, 116
Wagner, Cosima, 115, 116
Wagner, Richard, 93, 114, 115–17
    Judith Gautier and, 142
Warhol, Andy, 253
Washington Square Arch, 230
Watts, Frances, 85
Wax museum, Paris, 159–60
Wedding, Avegno–Gautreau, 42–43
Wedgwood, Eliza, 93

Wertheimer, Asher, 232
Wertheimer, Betty and Ena, 232
Westminster Abbey, memorial service
        for Sargent, 240
*Whispers* (Sargent), 140, *141*
Whistler, James, 128
    *Portrait of Lady Archibald Campbell*,
        192
White, Margaret (Mrs. Henry),
        148–49
White, Stanford, 230–31
Wilde, Oscar, 118–19, 189, 249
Wilhelm II (Kaiser), 212
*Will & Grace,* 261
Wilmurt, Thomas A., 259
Wilson, Woodrow, 237
Wolff, Albert, 65, 184
*Woman with the Glove, The* (Carolus-
        Duran), 64, 97, 124
Women
    as art students, 166
    French, 34, 47–54, 65
        health concerns, 101–2
    nude, in paintings, 168–69
    Sargent and, 239
World War I, Sargent and, 239–40
Worth, Charles, 127

Yamamoto (Japanese artist), 141
*Youth of Bacchus, The* (Bouguereau),
        166

Zillhardt, Madeleine, 172
Zola, Émile, 157, 242
    *Au Bonheur des Dames*, 28–29
    *Nana*, 27

# ACKNOWLEDGMENTS

Three people are responsible for this book: Mark Urman, my beloved husband, muse, collaborator, and champion; my wonderful mother, Jean Gatto, who gave me my first book and has always believed that I could do anything; and Wendy Silbert, my dear friend and agent, whose boundless enthusiasm and support turned a dream into a reality. I am also deeply indebted to the incomparable Scott Waxman and to Alexandra Tallen, my remarkable researcher and translator.

When I started my research, I was afraid the art world would be closed to me as an outsider. The opposite was true. The people at Adelson Galleries in New York, otherwise known as "Sargent Central," were especially warm and welcoming. My sincere thanks to the delightful Elizabeth Oustinoff for her knowledge and good humor, and to Warren Adelson for his extraordinary wisdom and generosity. I also thank

Richard Ormond and Elaine Kilmurray, authors of John Singer Sargent: The Early Portraits, the first volume of the Sargent catalogue raisonné, for providing an invaluable resource and wonderfully entertaining reading.

I am grateful to Carol Vance Wall for her inspirational thoughts about Lily Millet; Marie-Christine Ruellan for acting as my guide in Brittany; Brian J. Costello and Robert de Berardinis for their study of and astute observations on Amélie Gautreau's New Orleans years; and Kay Rapier (daughter of Mettha Westfeldt Eshleman) for her interest and support.

Thanks as well to Mark Cave at the Williams Research Center of the Historic New Orleans Collection, Linda Hollander, George Jordan, Tom and Ellie Avegno, Stephanie Herdrich, Dr. Valerie Steele at the Museum at FIT, Mario Pereira at the Isabella Stewart Gardner Museum, Carolyn Peter at the UCLA Hammer Museum, Olga Ferguson at the Aberdeen Art Gallery & Museums, Manonmani Filliozat at the Archives Municipales de Saint-Malo, Jean-Pierre Blin at the Conservatoire Municipal Agréé de Musique / Château des Chênes, Julie Zeftel at the Metropolitan Museum of Art, Blair Bunting Darnell, Dana Hartnett, Angèle Parlange, Lucy and Walter Parlange, Charles "Chuck" Robinson, Stephan Houy-Towner at the Metropolitan Museum of Art Costume Library, Lydia Dufour at the Frick Collection, and the staffs of the New York Public Library and the Montclair Art Museum Library.

At Tarcher, my deepest appreciation to Wendy Hubbert, Ashley Shelby, and Meredith Phebus.

Finally, I acknowledge my grandmother Anna Cianci. She did not live to see *Strapless,* but her lovely spirit encourages me every day.

## FURTHER INFORMATION
## FOR THE COLOR PHOTOGRAPHS

Photograph of Avegno sisters: Eshleman Collection, 2001-52-L, The Mettha Westfeldt Eshleman Bequest, The Williams Research Center of the Historic New Orleans Collection.

*Dr. Pozzi at Home:* Oil on canvas, 79⅜ x 40¼ inches. The Armand Hammer Collection, Gift of the Armand Hammer Foundation, UCLA Hammer Museum, Los Angeles.

*Madame Gautreau Drinking a Toast:* (P3w41). © Isabella Stewart Gardner Museum, Boston.

*Madame Gautreau (Madame X):* Watercolor. Courtesy Fogg Art Museum, Harvard University Art Museums, Bequest of Grenville L. Winthrop. Photograph by David Mathews. Image copyright © President and Fellows of Harvard College.

Photograph of *Madame Gautreau:* Scrapbook of photographic reproductions of paintings by John Singer Sargent, p. 49: *Madame X,* albumen print. The Metropolitan Museum of Art, The Thomas J. Watson Library, Gift of Mrs. Francis Ormond, 1950 (192 SA 7 Sa 78 Q). All rights reserved, The Metropolitan Museum of Art.

*Madame X (Madame Pierre Gautreau):* Oil on canvas, $82\frac{1}{8}$ x $43\frac{1}{4}$ inches (208.6 x 109.9 cm). The Metropolitan Museum of Art, Arthur Hoppock Hearn Fund, 1916. (16.53). Photograph © 1997 The Metropolitan Museum of Art.

*A Gust of Wind:* Photograph courtesy Adelson Galleries, Inc., New York.

Courtois, *Madame Gautreau:* Oil on canvas. Photograph by B. Hatala. © Réunion des Musées Nationaux / Art Resource, NY, Musée d'Orsay, Paris.

## ABOUT THE AUTHOR

Deborah Davis is a writer and veteran film executive who has worked as a story editor and story analyst for companies including Warner Bros., Columbia TriStar, Disney, Miramax, and the William Morris Agency. She lives in Montclair, New Jersey.